PRAISE FOR *The Pen and the Brush*

"In a brilliant examination of the work of Balzac, Zola, Huysmans, Maupassant, and Proust, Anka Muhlstein brings to light the many forms of reciprocal exchange among them and their painter friends, both thematic and stylistic, that resulted in a highly original form of pictorial writing—a phenomenon intrinsically tied to its time and place. Her illuminating analysis and deft weaving together of literature and art in *The Pen and the Brush* are sure to change the way we read the nineteenth-century French novel."

— Susan Grace Galassi
SENIOR CURATOR OF THE FRICK COLLECTION

"In nine admirably concise and evocative chapters, Anka Muhlstein surveys a major theme in nineteenth-century cultural history: the relationship between modern novelists and modern painters. Her heroes are Balzac, Zola, and Proust, and she offers insights into the different ways in which each writer engaged with the art and artists of his time. One of the chief pleasures of this book is the diversity and precision of Muhlstein's literary selections and visual references: she spurs the reader to return to familiar texts as well as to discover new ones."

— Colin B. Bailey
DIRECTOR OF THE MORGAN LIBRARY & MUSEUM

"Writing as beautifully about art as she does about literature and history, Anka Muhlstein creates in these pages a salon of brilliant French artists and writers and invites us in as they exchange ideas and profoundly influence one

another. She quotes Zola: 'I have not only supported the Impressionists, I have translated them into literature.'"

—Jean Strouse

"A well-crafted reminder of how in the nineteenth century writing and painting coalesced, like sea and sky. So Balzac and Delacroix, Zola and Manet, Maupassant and Courbet, and especially Proust with his writer Bergotte and painter Elstir: for French writers, artists were 'essential to the plot.' For a writer the task was ultimately how to see, and to see not just one world but many."

—Anthony Bailey

"Anka Muhlstein knows and loves nineteenth-century French painting with a passion, and this she pours into her study of writers who made painting a principal optic for viewing the world. *The Pen and the Brush* is both lively and enlivening."

—Peter Brooks

"A fascinating, instructive, and absorbing read."

"An enlightening exploration of the symbiotic relationship between art and literature."

THE PEN AND THE BRUSH

How Passion for Art Shaped
Nineteenth-Century French Novels

Anka Muhlstein

TRANSLATED FROM THE FRENCH BY
Adriana Hunter

OTHER PRESS
NEW YORK

Production editor: Yvonne E. Cárdenas
Text designer: Julie Fry
This book was set in Galliard with Gabriola.

10 9 8 7 6 5 4 3 2 1

LIBRARY OF CONGRESS CATALOGING-IN-PUBLICATION DATA
Names: Muhlstein, Anka, author. | Hunter, Adriana, translator.
Title: The pen and the brush : how passion for art shaped
 nineteenth-century French novels / Anka Muhlstein ;
 translated from the French by Adriana Hunter.
Description: New York : Other Press, [2017]
Identifiers: LCCN 2016026702 (print) | LCCN 2016026767 (ebook) |
 ISBN 9781590518052 (hardback) | ISBN 9781590518069 (ebook)
Subjects: LCSH: French fiction—19th century—History and criticism. |
 French fiction—20th century—History and criticism. | Arts
 in literature. | Art in literature. | Artists in literature. | Painters
 in literature. | BISAC: BIOGRAPHY & AUTOBIOGRAPHY /
 Literary. | ART / History / Modern (late 19th century to 1945). |
 BIOGRAPHY & AUTOBIOGRAPHY / Artists, Architects, Photographers.
Classification: LCC PQ653.M8413 2017 (print) | LCC PQ653 (ebook) |
 DDC 843/.709357—dc23
LC record available at https://lccn.loc.gov/2016026702

For Louis

Contents

Introduction: Art for All

I have often wondered why nineteenth-century French novelists were so often obsessed with painters and painting, while in the 1700s Diderot was the only writer of his generation to take an interest in art criticism. What a striking contrast that not one well-known novelist of the 1800s failed to include a painter as a character in his work. This is fair enough for Balzac and Zola, who had ambitions to bring every aspect of society to life, but read Stendhal, Flaubert, the Goncourt brothers, Anatole France, Huysmans, Maupassant, Mirbeau, and of course Proust, and you enter a world in which painting is surprisingly important. What is more, all these novelists explored not only how a painter sees things but also how he looks at them, and this produced a new way of writing. "I would just have liked to see you dismantle the mechanism of my eye. I enhance the image, that much is sure, but I don't enhance it as Balzac does, any more than Balzac enhances it as Hugo does," Émile Zola told his protégé Henry Céard, highlighting the visual nature of novels at the time.[1] This was essentially a French phenomenon; it has no real equivalent in England, Germany, or Russia. In the United States, it was not until the end of the century that painting became a literary subject in the work of Henry James. In

England, Woolf would be the first to write about the influence painting had on literature. Why the sudden, widespread interest in France?

I believe that this new way of seeing and writing was facilitated by the creation of museums in France after the French Revolution. Frequent long visits to the Louvre gave a whole cohort of young writers a genuine knowledge of painting, a shared language with their painter friends, and a desire to enrich their own works with this newly acquired erudition. The visual novel dates from this period.

Having easy access to great works by visiting a museum feels so normal to us now that we rarely think of the cultural revolution brought about by the advent of modern museums. And yet what a sea change in behavior this opportunity afforded. Before the Revolution only birthright or unusual personal success opened the door to masterpieces closeted in palaces and mansions, or to galleries of fine paintings acquired by wealthy Parisian collectors. As a result, people were reduced to spending a great deal of time in churches, the only place where anyone was free to admire works of art, at least before or after mass. Italy was especially well endowed in this respect. But appreciating a painting in the gloom of a chapel posed problems, and continued to for a long time: during a visit to Venice, Henry James complained he had to forgo admiring the magnificent work of Cima da Conegliano in the church of San Giovanni in Bragora and the superb Tintorettos in the Scuola Grande di San Rocco because the buildings were so dark. Even today, for want of coins to slip into a lighting contraption, visitors have only a few minutes to contemplate frescoes and paintings. Furthermore, it took

money and free time to travel around Europe discovering the sculptures and paintings of other cultures. Wandering at will and at one's own speed around the Louvre's Grande Galerie was, therefore, a priceless experience—both literally, because admittance was free, and metaphorically.

The most significant phenomenon in the French arts scene in the early nineteenth century was therefore incontrovertibly the public exhibition of a huge number of masterpieces. In 1793, during the Reign of Terror, the Louvre opened its doors to the public under a new name, the Central Museum of Arts. The planned program for each *décade* (the ten-day period with which the Revolutionary government had replaced the seven-day week) was for the first five days to be reserved for artists and copyists, the next two for cleaning, and the last three for the general public. The great innovation, besides the open-door policy, consisted in not simply displaying a variety of works but also arranging them in what was intended to be an educational way. Immediately after the monarchy fell in 1792, the government started confiscating works of art held in monasteries and churches as well as the assets of the first émigrés. At least some of these works would end up in the Louvre. In addition, treasures from the many royal châteaux were transferred to Paris. The surplus of more than one hundred paintings was stored at Versailles in the Superintendency, the administrative building responsible for the upkeep of royal palaces.

The number of works rose spectacularly in 1794 thanks to the military conquests of the Revolution and the French empire, because at the time every victory was followed by systematic pillaging of works of art in conquered

territories. The looting of art predates revolutionary and imperial wars, but the importance, quality, and sheer numbers of works of art seized in this particular period were beyond imagining. Convoys laden with paintings by Rubens, Van Eyck, and Rembrandt appeared in Paris after Brussels was taken in July 1794, and later the fall of Ghent and Anvers provided more Flemish art. Over two hundred paintings were confiscated in the Netherlands. Similar thievery occurred in Germany, and on an even greater scale in Italy. As soon as Bonaparte was made a general and posted to Italy, he appointed specialized envoys to select works of art, manuscripts, and zoological and botanical curiosities, and these remarkable men (Monge, a great mathematician; Berthollet, a genius of a chemist; Moitte, a renowned sculptor; and the botanist Thouin, former head gardener of the Royal Garden of Medicinal Plants, now the Jardin des Plantes) not only succeeded in making sound choices but also proved incredibly talented organizers. The French justified this plunder by claiming that these treasures would now belong to the people rather than to foreign despots.

Thouin ensured that these trophies made a far from discreet arrival: "Should we bring precious spoils from Rome like sacks of coal and have them unloaded onto the quay by the Louvre like crates of soap?...No, the whole population must be invited to join the party...Every class of citizen will see that the government has thought of them, and each of them shall have his own share of such a wealth of booty. They shall see how a republican government compares to a monarchy which makes conquests only to enrich its courtiers and satisfy its vanities."[2]

On July 28, 1798, the entrance of a triumphant parade was marked with great celebrations. A procession of exotic animals—lions, camels, and bears—preceded the four copper statues of horses, the pride of the facade of Saint Mark's Basilica, followed by more than thirty carts carrying large classical sculptures, and lastly the most famous paintings of the Italian Renaissance, Raphaels, Titians, Tintorettos, and a huge Veronese, *The Wedding at Cana*. It has to be said that the organizers were aware of how fragile these works were and did not display them in the open air. Sculptures and paintings were not removed from their cases until they had been allocated a space in the galleries, and the fact that not one of them came to harm during these long journeys, mostly from Italy, considerably impressed the French themselves and foreign visitors.

These consignments continued until the end of Napoleon's conquests. The extraordinary profusion of works of art necessitated a complete reorganization of the Louvre, and this was undertaken under the direction of Vivant Denon, a diplomat who was passionate about art. The inhabitants of the Louvre were firmly asked to leave, and a large proportion of French paintings were sent back to Versailles, where a museum dedicated to the French School was established. Substantial alterations were made at the Louvre, and at times it was closed, but as soon as the doors reopened people flocked to see its treasures. The famous portraitist Mme Vigée Le Brun was quick to visit as soon as she returned to Paris, having fled in 1789 and come back under the Consulate in 1802. She wanted to go alone so as not to be distracted, and was so transported in her admiration of such beauty she did not notice the

staff had closed the doors. She was beginning to think she would have to spend the night amongst the glorious statues, which now looked like terrifying ghosts, when she eventually found a small door on which she knocked so loudly that someone came to let her out.[3] A few months later the Musée du Luxembourg, housing the collection started by Marie de' Medici, welcomed its first visitors. The galleries of the Palais du Luxembourg had been open to the public for a short period in the eighteenth century, but after the comte de Provence, brother of Louis XVI, had assumed ownership of the site, it was closed to visitors. Watteau had to scheme to be admitted covertly to study Rubens's cycle of Marie de' Medici. A third major museum, the Musée de l'Histoire de France, was set up at Versailles by Louis-Philippe in 1830.

This sort of public access was completely unprecedented in Europe. German princes and English aristocrats had always allowed people to visit their collections, but visitors usually had to be recommended. Mme Vigée Le Brun was disappointed that in London's museum the only exhibits were minerals and stuffed birds, brought back from Captain Cook's scientific expeditions.[4] The National Gallery opened very modestly in 1824 with a collection of thirty-eight paintings purchased from John Julius Angerstein, a London banker. Even when some European galleries were, in principle, open to everyone, the public had to comply with restrictive rules: for example, the requirement that visitors should have clean shoes if they were to visit the public rooms in Vienna's Imperial Palace implied they could afford a hansom cab if not a private carriage, and were therefore relatively far up the social scale.

If France had heeded calls to restore great quantities of plundered artworks to conquered countries after the fall of Napoleon in 1815, the Louvre collection would have been seriously depleted. The French state fought back so energetically that the museum managed to keep almost half the works it had acquired. Several pillaged states lacked the funds to finance repatriations. Some of the smaller Italian states agreed to sell their works of art, and many settlements were reached: Florence relinquished a number of Cimabues but would not back down on the return of some highly prized marble tables. The negotiations were brutal, the general public took great interest in them, and they did nothing to dent the museum's reputation.

The generation of French writers that reached adulthood during the Restoration (among them Vigny, Balzac, Hugo, Gautier, and Dumas) witnessed a period of extraordinary artistic effervescence, and for at least some of them this compensated for the lack of thrilling imperial conquests. This exciting period was due not only to the opening of the museums but also to the close friendships between painters and writers. Bohemian artists had elected to live in the Doyenné quarter of Paris to the south of the place du Carrousel, an area that Balzac would describe in *Cousin Bette*. It was a neighborhood condemned to be demolished, and a whole colony of artists set up home there, drawn by the modest rents. "An encampment of picturesque, literary bohemians [lived] a Robinson Crusoe existence [there],"[5] in the words of Théophile Gautier; it became a retreat for writers, artists, and musicians. Interestingly, many writers

such as Gautier, Vigny, Musset, and Eugène Sue spent time as pupils in artist's studios, and painters reciprocally mingled in the literary groups that grew up around the Romantic movement. The name Jeunes-France (Young-France) was coined for all these creative types who distinguished themselves as much by their choice of clothes as their talent, and who regularly met at Victor Hugo's house. Between them they constituted what amounted to a federation of the arts.

Eugène Fromentin was both a painter and a writer, Victor Hugo a commendable draftsman. Eugène Sue painted a few sea views, and although he soon abandoned the paintbrush for the pen, he remained close to his master, Gudin, a great specialist of seascapes, and was a dear friend of the famous caricaturist Henri Monnier. Théophile Gautier's first ambition was to be a painter but, discouraged by how difficult it was, he turned to writing. The Goncourt brothers thought they would make careers as watercolorists. It is hardly surprising then that painters' studios saw frequent visits from all these writers. "Poets make friends with musicians, musicians with painters, painters with sculptors...the one replies in madrigals to what the other gave him in vignettes."[6] When confronting the Classicists in the furor surrounding Victor Hugo's controversial play *Hernani*, Hugo's friends were "called to arms from the world of literature and music, and from the studios of painters, sculptors, and architects."[7] The critic Sainte-Beuve commented with some distaste on the existence "of a society of young painters, sculptors and poets...who depend far too much on the advantages of partnership and camaraderie in artistic matters."[8] Puccini's very popular opera *La*

Bohème, which was based on a novel by the contemporaneous Henri Murger, brought to life all the turbulence and energy of this world by depicting the interwoven lives of four artists: a painter, a poet, a musician, and a philosopher. All these young artists endlessly visited each other, and would meet, for example, at Achille Devéria's studio, where Balzac, Hugo, Musset, Lamartine, Liszt, and Sir Walter Scott all posed at one time or another. This constant intimacy explains why novelists of the period so frequently featured their artist friends in their work, and why they were influenced by the way these friends looked at the world. Painting had become an almost inevitable literary subject, particularly as curiosity about art was now something of a social phenomenon.

Everyone visited the Louvre, especially artists—both masters and pupils. Beginners spent whole days in its galleries, because at the time their craft was learned by copying. The museum also attracted the inquisitive and the idle. It was warm in winter, thanks to its modern heating system; there was always something exciting to look at, and it was a respectable place to meet a lady, as she could stroll alone in the galleries without provoking comment. Finally, it was a draw for the uneducated, who clutched a booklet that listed the subject of each painting and gave a few explanations. The general enthusiasm had reached every stratum of society. German and English tourists were amazed by the number of visitors, and claimed to be offended by how filthy and vulgar they were. In 1819 a Prussian diplomat, Karl August Varnhagen, enjoyed everything he saw at the museum but regretted the presence of "fishwives, soldiers and peasants in their clogs," and he justified his contempt

by quoting Goethe: "Works of the mind and art are not for the mob."[9] Baudelaire was more indulgent, laughing about two soldiers staring at a picture of a kitchen. An error in the catalogue listed it as one of Napoleon's battles. So where's the emperor? one of the men wondered. You idiot, his friend replied, can't you see they're making soup for his return? And the two men walked on, as pleased with themselves as they were with the painter.[10] Wilhelm von Humboldt, brother of the famous explorer, Alexander von Humboldt, and himself founder of the Humboldt University of Berlin and a driving force in setting up Germany's museums, was full of admiration and even went so far as to recognize that the only way to safeguard ecclesiastical treasures was to transform them into works of art by exhibiting them.[11] This enthusiastic response from foreign visitors may not have justified France's looting but it certainly bore witness to the extensive interest generated by the museum and, more particularly, by the way it was organized. The galleries in various European châteaux—particularly in Germany—that were set aside for works of art and were opened selectively to anyone who asked had none of the Louvre's educational ambitions, and their curators blithely juxtaposed curios, objets d'art, paintings, and sculptures.

According to Balzac, Parisians had a boundless appetite: "these eyes consume endless exhibitions of masterpieces…twenty illustrated works a year, a thousand caricatures, ten thousand vignettes, lithographs, and engravings."[12] It would, in fact, have been impossible for French writers to have been indifferent to the audacity and constant change in painting at the time. How could they

have failed to be enthusiastic about Géricault and Delacroix, then Courbet, then Manet and the Impressionists? And appreciating their contemporaries did nothing to stop Balzac, Flaubert, Baudelaire, Zola, or Proust from profoundly admiring art from previous centuries. Parisians were not alone in opening their eyes; during the French Restoration a great many Americans came to Paris, drawn by the capital's thriving arts scene. Among them, Samuel Morse, who would go on to invent the famous code and who had great ambitions as a painter, virtually took up residence at the Louvre, spending hours perched on an impressive scaffolding to get a closer look at the paintings. In the end he decided to paint the Salon Carré but to fill its walls with his favorite paintings, thus creating what amounted to his ideal museum. The result was a huge, six-foot-by-nine-foot canvas featuring thirty-eight paintings, including the *Mona Lisa*. He took the painting back to America to exhibit it, but, unlike the Louvre, he charged admission.

The notion that art belonged to the people was now entrenched in the French collective consciousness, and the working classes continued to visit the museum throughout the nineteenth century. It is no coincidence that in Zola's *The Drinking Den* (*L'assommoir*), written in 1877, he has Gervaise's wedding party spend the end of the day at the Louvre. Zola was very aware that the museum, along with the regular Salons, had become a part of Parisian life like parades and races. Of course, he did not claim that the populace experienced any artistic sentiment or could offer any serious judgment of the works on display. "Shopkeepers in silk dresses and workmen in jackets and round

hats gaze at these pictures hanging on walls the way children look at the illustrations in a new book...But this is no less a gradual education of the masses. You cannot stroll amidst works of art without taking a little bit of art away inside you. The eye develops, the mind learns to judge. This is still better than other Sunday entertainments, shooting galleries, skittles and fireworks."[13]

A great many writers suggested themselves to me to illustrate the extraordinary transformation brought about by this fascination with art among the French. I have focused on five—Balzac, Zola, Huysmans, Maupassant, and Proust—first out of personal choice but also because these chosen authors each in his own way truly invented a visual style of writing. Equally significantly, the gallery of painters they dreamed up allowed them not only to air their views on the art of their day, but also to depict the complex relationship between artists and the general public. There is a whole world of possibilities between Balzac's genius, Frenhofer, who despairs of ever convincing his fellow artists of his vision, and Proust's master, Elstir, who has the patience to explain his art like an optician offering a myopic customer lenses of different strength until he can see clearly.

1 Balzac's Paintbrush

Balzac was fifteen when he and his family moved to Paris in 1814. Two years later, he enrolled at law school while taking a post as clerk in a firm of attorneys-at-law. He was so exuberant and so entertaining that the head clerk would sometimes send him a note requesting him not to come to the office because there was so much to do. This suited him perfectly, and he spent many days visiting the Louvre just in time to see the museum before the defeat of 1815 forced its curators to hand back more than half the collection to despoiled nations. He thus acquired a remarkable knowledge of its collections, and his interest in painting never wavered. He was the first novelist to grasp how much of a painter there is in any writer, and he justified this insight at length. In his preface to *Eugénie Grandet*, a novel he characterized as a painting on an easel, Balzac goes so far as to describe himself not as a writer but a literary painter, and does nothing to hide the difficulties this entails: "if he is to depict figures who appear at first glance but whose every detail and half shade requires the deftest of brushstrokes; if he is to re-create all the gray shadows and every play of light in these paintings ... surely [the literary painter] needs a great deal of preparation, an unusual degree of attention, and, for portraits like these,

all the acuity of an antique miniaturist."[1] He makes a similar point in a letter to Mme Hanska, the Polish countess he adored and whom he married the year of his death. In the letter he says of his novel *The Middle Classes* (*Les petits bourgeois*) that he feels he can "make it a nice painting in the tradition of the Dutch School, but I want a Raphael-style face in the middle of it."[2] He does not spontaneously make literary references, then, but pictorial ones, and his appraisals of his own work are almost always based on pictorial comparisons and metaphors. Balzac's style is often compared in the writings of Félix Davin,* his alter ego, to "sketches, views, portraits, interiors or landscapes." The novelist himself uses terms like "thumbnail sketches, easel paintings, or large canvases" to present certain compositions. Lastly, in the preface to *A Daughter of Eve* (*Une fille d'Eve*), when he asks for his work to be judged only as a whole, he again defines his writing in painterly terms: "The differences in tone, nuance, color, and outline which differentiate the six parts of this work might, at some later stage, be noticed, appreciated..."[3] At least, that is what he hoped.

Like painters, writers have to achieve an equilibrium between details and the whole. And it is exactly this concern that preoccupied Baudelaire in his comments on Balzac in "Théophile Gautier." "His immoderate taste for detail, which derives from an immoderate ambition to see everything, and allow everything to be seen, to anticipate everything, and allow everything to be anticipated, actu-

* Félix Davin was a journalist very close to Balzac. He signed the prefaces to the *Philosophical Studies* and the *Studies of Manners*, texts that were probably penned by Balzac himself, or at least strongly influenced by him.

ally meant he had to draw the key lines more emphatically, in order to salvage the perspective of the whole,"[4] and to avoid burying the reader in the profusion of details. Interestingly, Delacroix criticized Balzac precisely for this accumulation of detail, which hindered the reader's access to the whole.[5] Delacroix noted in *The Peasants* (*Les paysans*) "still the same Lilliputian details which [Balzac] believes give each of his characters something striking."[6] The main thrust of the book was obviously lost on him. He was probably not sufficiently drawn to it to immerse himself in it as a whole, or perhaps Balzac's demonstration of his extensive and very exact knowledge of art irritated him. It is true that Balzac rather enjoyed exhibiting his familiarity with not only Italian Renaissance art and Flemish painters but also contemporary painting; and his command of the subject yielded a surprising abundance of pictorial citations. Plenty of painters passed less severe judgment on Balzac, but it is worth noting that they were not always his exact contemporaries. Cézanne, for example, so admired Balzac's descriptive powers that he admitted, of the tablecloth at the banquet in *The Wild Ass's Skin* (*La peau de chagrin*), "my whole life I wanted to paint that snowy tablecloth."[7]

Paintings often sowed the seeds for the novelist's narratives. Baudelaire related an anecdote circulating in Paris: "One time, when Balzac saw a beautiful painting, a very melancholy winter scene steeped in fog, dotted with shacks and scrawny peasants, he studied a little house and the thin trail of smoke coming from it, and cried, 'Isn't it beautiful, but what do they do in that shack? What do they think about, what are their problems? Did they have a good

harvest? They probably have debts to pay.'"⁸ From there we can imagine the whole story taking shape in his mind. More specifically, we know that two very realist paintings—one by Gros, the other by Meynier, both depicting Napoleon visiting the battlefield at Eylau and stopping beside a horrifying heap of bodies—were the inspiration for *Colonel Chabert*. In this novella Balzac imagines the eponymous hero buried under a heap of corpses; he is left for dead and reappears in Paris some ten years later, to the despair of his wife, who has remarried. *Séraphita*, the strange story of an androgynous creature, was conceived when he saw Théophile Bra's *Sépharin*, a sculpture representing an angel of ambivalent gender. One could also speculate that the story of the young woman who goes mad during the Berezina crossing in *Adieu* was inspired by the many engravings featuring the crossing of this half-frozen river during Napoleon's retreat from Moscow. Balzac's recollections of various portraits also had a direct effect on how he conceived his characters' appearance. A number of painters appear to have fixed different physical types in his mind.

In his masterly study of painting in Balzac's work, Olivier Bonard identifies all the old men in the novelist's oeuvre who are indebted to Rembrandt for various features: Guillaume, the draper in *At the Sign of the Cat and Racquet* (*La maison du chat-qui-pelote*), has tiny green eyes, no eyebrows, and flat, well-combed hair; the moneylender Gobseck, who appears frequently in *The Human Comedy*, also has small eyes, no eyelashes (the general absence of eyelashes in old men actually derives from Gerard Dow's *The*

Moneylender), no eyebrows, and flat hair; the antiquarian in *The Wild Ass's Skin* and the Baron du Guénic in *Béatrix* both have very small eyes, no eyelashes or eyebrows, thin lips, and gray beards trimmed to a point, and both wear black velvet. Colonel Chabert is not as well dressed as these elderly gentlemen but with his ratty black tie and the black shadow cast over his forehead by his hat, he reminds us of a Rembrandt character who has stepped out of the frame. This sense of an unframed portrait is revisited with Frenhofer, the great artist in *The Unknown Masterpiece* (*Le chef d'œuvre inconnu*). Frenhofer has the advantage of being a contemporary of Rembrandt's, so that his black doublet, his heavy gold chain, and "his collar, dazzling in its whiteness and worked into points like fish knives" are unsurprising accoutrements for his character; but in describing him, Balzac goes so far as to say, "he might be taken for a Rembrandt painting walking silently without its frame through the dark settings that this great painter appropriated."[9] Sometimes, though, the painting is given a new frame: In *The Wild Ass's Skin*, the young Raphaël studies an unusually well-dressed old man, "a sort of doll, so full of life, [he] seemed to Raphaël to have all the charm of an apparition, and he gazed at him as he would at a smoke-damaged old Rembrandt that had recently been restored, varnished, and put into a new frame."[10]

Raphael is another painter constantly used as a reference by Balzac, not for his male characters but his young women. "In order to create a lot of virgins," he says in the foreword to *The Human Comedy*, "you have to be Raphael. In this regard, literature may well rank below painting."[11] Balzac's pretty young ladies—innocent or otherwise—

are, like the draper's daughter Augustine Guillaume, all Raphaels: "No flicker of irritation could spoil that ingenuous face or the calm in those eyes immortalized before their time in Raphael's sublime compositions: she had the same grace, the same tranquil demeanor as those now proverbial virgins."[12] Balzac does not differentiate much between them: they all have "a perfect oval that would drive Raphael mad,"[13] and every elegant Parisian woman "seems to have something dignified and serious about her like Raphael's madonnas in their frames."[14] Modeste Mignon has "the oval face so often chosen by Raphael for his madonnas, [and it] is distinctive for the restrained, virginal color of her cheeks, soft as a Bengali rose, over which the long lashes on her diaphanous eyelids cast shadows intermingled with light."[15] Needless to say the young lady in question is not short of admirers. Even when smallpox has robbed them of their freshness, these women can sometimes preserve this Raphael-like aura. Véronique Sauviat, for example, still had "a celestial face, worthy of Raphael, crusted over by the illness as that great master's paintings are by the passage of time."[16]

Unlike Modeste, Véronique—the heroine of *The Village Curé* (*Le curé du village*)—has a secret life full of pain and forbearance. In fact, Balzac does not always see peaceful virtue in madonnas: Esther, the beautiful courtesan in *Lost Illusions* (*Illusions perdues*), also has the obligatory oval face and represents Jewish beauty, but here again there are few specific details. Even little Olympe Bijou, who is sufficiently depraved to brighten old Hulot's days at the end of *Cousin Bette*, "displayed the same sublime face Raphael used for his virgins, eyes whose innocence was

saddened by endless toil, dreamy black eyes edged with long lashes...an almost sickly porcelain complexion, but a mouth like a half-open pomegranate, an alluring bosom, full curves, pretty hands, elegantly white teeth, and thick black hair."[17] But Raphael, or a deliberate reference to him, ought to suggest a character's innocence, and when Diane de Cadignan wants to hide her eventful past from Daniel d'Arthez, the virtuous man she hopes to seduce, it is no accident that she wears a dress inspired by one of this painter's works: "She had chosen a blue velvet dress with wide, trailing white sleeves, a clearly defined bodice, and one of those under-blouses in slightly gathered tulle, edged with blue, coming up her neck and covering her shoulders, like those worn in portraits by Raphael."[18] Even before addressing d'Arthez, she wants to create an impression of ingenuousness if not naïveté.

One could be forgiven for thinking that these countless references to Raphael were something of a tic if Balzac's texts did not contain other evidence of his genuine knowledge of painting. In *Cousin Pons*, for example, he develops a veritable treatise on art. The work of Sebastiano del Piombo, who combines Venetian colors with Florentine composition, is analyzed in great detail, but Balzac concludes by advising the reader to go to the Louvre to see the artist's portrait of Baccio Bandinelli. He must have been very sure he would be understood by his readers, who were probably as passionate about art as he, so much so that a character occasionally clarifies an allusion by mentioning a tiny detail noticed in a painting. A striking example is the way the journalist Blondet warns off the innocent d'Arthez, now in love with the beautiful Diane, Princess

of Cadignan, who has ruined more than one suitor. "Give yourself body and soul," he tells him, "but keep hold of your money, like the old man in Girodet's *Déluge*."[19] You have to have a good mental picture of the painting to remember the red moneybag that the old man clutches in a dark corner of the canvas.[20] Another illustration of this genuine knowledge of paintings appears in *The Peasants*: as a finishing touch in describing a horrible old woman, "a hideous black parchment, endowed with movement," he adds, "her likeness is found only in David's painting of the Sabine women,"[21] which does indeed feature a wizened old woman as a secondary character.

Balzac is not satisfied with merely naming a variety of painters left and right. In his text he also often conjures up paintings, not necessarily actual works but sometimes invented ones, by positioning his characters or evoking an interior, much as a painter would. Sometimes he states this quite openly, as with his description of Elie Magus, an art dealer who appears in several novels in *The Human Comedy*: "There, like a living painting among those motionless canvases, was the diminutive old man, wearing an ugly little frock coat, an ancient silk vest, and filthy pants, with his bald head, sunken cheeks, the sprouting white hairs of his quivering beard, his menacing pointed chin, unfurnished mouth, and eyes as beady as a dog's, his bony fleshless hands, the obelisk of his nose, and his cold rough skin, as he grinned at these beautiful creations painted by geniuses! Even among three million, a Jew will always be the greatest spectacle humanity has to offer."[22] At times, as Bernard Vouilloux points out,[23] he puts particular emphasis on the pose. In *The Ball at Sceaux* (*Le bal de Sceaux*), for

example, the young heroine Émilie de Fontaine is at the ball watching "the vast animated canvas" around her, and notices "a woman who seemed to have been put into one corner of the painting quite deliberately, in the best possible light, apparently out of proportion to the other characters"; then a young man catches her eye, "put there so that the painter could paint his own portrait…and nothing about him betrayed the fact that he had turned his face at a three-quarter angle and slightly inclined his head to the right like Alexander, like Lord Byron and several other great men, with the sole aim of attracting attention."[24] In other passages Balzac is more precise and mentions the actual portrait that inspired him: the writer Nathan "usually keeps one of his hands tucked into his open vest, in a pose made famous by Girodet's portrait of Chateaubriand," or in *A Woman of Thirty* (*La femme de trente ans*), Victor d'Aiglemont stops before Napoleon in the same pose Gérard gave to General Rapp. The references can also be more subtle, like the description of Balthazar Claës's house, which puts particular emphasis on how soft the light is: "the daylight subdued by four red walls with narrow white stripes adopted a pink glow which lent faces and every last detail a mysterious grace and a fantastical quality… Sunbeams fell across the house obliquely, wrapping around it like a scarf, cutting across the parlor, expiring in a peculiar sheen on the paneling along the walls that backed onto the courtyard, and enveloping [the] woman in the scarlet zone projected by the damask curtain draped along the window."[25] The room is dominated by a Titian portrait, and this fact alone is enough to underscore the unexpected and very Venetian softness of the light.

On the subject of Titian, it is worth acknowledging the great freedom Balzac allows himself in his references to this painter. To Balzac, Titian is the painter of warm colors and sunny light. It is hardly surprising that he mentions Titian in the novel *Honorine* when describing the young eponymous heroine out of doors: "the sun filtering through the acacias' slender foliage surrounded Honorine with a fluid yellow halo that Raphael and Titian alone knew to paint around the Virgin."[26] The passage about Flicoteaux, the restaurant in the Latin Quarter of Paris, is more surprising: "for thirty years [potatoes] have been served here with the blond coloring so loved by Titian, and dotted with chopped greenery."[27]

In *Eugénie Grandet,* where the family home is characterized by an absence of light, Balzac uses the palettes of different painters to describe their world. As one might expect, there is nothing soft or appealing about Grandet's house, the literary symbol of avarice. Balzac depicts a dark gray-and-brown interior peopled by creatures who drift among worn pieces of furniture and have no experience of clearly defined colors: everything in their world is whitish, yellowish, grayish, every color takes on pejorative connotations. Mme Grandet, who is yellow as a quince, wears the same greenish dress throughout the year; Grandet himself wears only brown frock coats and a yellow-and-puce-striped vest; their servant Nanon, with her brick-red coloring, wears clothes of no defined color; their guests appear in russet-colored shirts and jabots that are more gray than white, and one of them, the notary Cruchot, looks like a rusted nail. This is very different from any world lit by Titian. We are in fact stepping into a nocturnal canvas that

would be too sinister to suggest the Dutch school, were it not for the astonishing lighting effects invented by Balzac.

Grandet's miserliness means there is only ever one source of light: his candle. Should he leave the room for a while—to go patch up the crooked tread in the staircase, for example—then the place is lit only by the fire in the hearth. If a half-open door allows him to catch sight of Nanon sewing in the kitchen, he makes her come into the living room and tells her to snuff out her candle and let her fire die down. With Grandet's comings and goings, the reader sees a succession of different "views" of the house. The last in the series shows an effort at gaiety: "As it is Eugénie's birthday, let's light the torches,"[28] the miser says, lighting the room with just two candles in the branches of his candelabra. In this passage there is no reference to paintings or painters but a very successful instance of literary painting, more successful even than the determined effort Balzac made to write with a paintbrush in *The Girl with the Golden Eyes* (*La fille aux yeux d'or*), as we shall see later.

Balzac's invented paintings are another curiosity.[29] In *Béatrix* there is a meticulous description of a fictional painting by Félicité des Touches, a literary woman of about forty. She is in love with the young Calyste du Guénic and is wary of a new potential rival, Béatrix de Rochefide. She tries to preempt things by describing Béatrix to the young man: "Nature has given her...the thick angel-like hair so cultivated by Girodet's brush and that looks like streams of light." Girodet serves many times as a painter of blond women who, in Balzac's physiognomy, are often hard and selfish. The strange thing about this passage is that Balzac switches painters mid-portrait:

Although not irreproachably beautiful or pretty, she can, if she chooses, make an indelible impression. She need only wear cerise velvet with plenty of frothy lace and put red roses in her hair, and she is divine. If by some artifice she could wear clothes from the days when women wore pointed corsets with a ladder of fine, thin ribbons rising from the generous fullness of brocade skirts with deep gathering, when they framed their faces with ruffs and hid their arms in slashed sleeves with lacy cuffs from which their hands emerged like a pistil from a calyx, and when they swept the countless curls of their hair over a bun threaded with gemstones, Béatrix would compare favorably with the ideals of beauty dressed in that fashion. [And] Félicité showed Calyste a handsome copy of a Mieris painting of a standing woman in white satin.[30]

No one has ever found a Mieris painting featuring such a woman. It is therefore highly likely that Balzac fabricated this model, but, by using a known painter's name, he gave his fictional character more credibility.

When Raphaël visits the antique dealer's museum-shop in *The Wild Ass's Skin* and is dazzled by the masterpieces that surround him, he makes a very unusual remark: to show his admiration for some of the paintings, he compares them to literary works. He stops before "a Gerard Dow which looked like a page from Sterne...dark works by Velázquez with coloring like a poem by Lord Byron."[31] Here is proof that Balzac felt very strongly that at the highest level of artistic expression literature and painting were interchangeable.

One of the strangest, if not the most improbable, of Balzac's novels, *The Girl with the Golden Eyes*, involves a young woman, Paquita, confined against her will by the marquise de San Réal, who harbors a violent passion for her. During a walk in the Tuileries Gardens under her duenna's watchful eye, Paquita spots the famous dandy, Henri de Marsay. Love at first sight on both sides. Using the most outrageous strategies, she manages to sneak Marsay into the house while the marquise is away, and there, in a room where everything—the perfumed air, the thick carpet, the divan covered in cushions, the red and white roses—inspires voluptuous delight, she experiences a man's passion. When the marquise returns she discovers this betrayal and stabs the unfortunate Paquita.

This novel constitutes the third episode in *The Thirteen* (*L'histoire des treize*), but whereas the first two are dedicated to composers, Hector Berlioz and Franz Liszt, the third is offered to *Eugène Delacroix, painter*. The two men knew each other but it was neither a particularly close nor warm acquaintance. Delacroix had plenty of reservations about the novelist, while Balzac wholeheartedly admired the painter, so much so that, inspired by Delacroix's brio, his mastery of color, and his taste for the exotic, Balzac wanted to try his hand at writing in the manner of Delacroix. One of the singularities of the novel, however, is that it opens with an extremely melancholy picture of the Parisian population. Everything in it is black, gray, ashen, in complete contrast to the scenes of passion—set against backgrounds in white, red, and gold—that take place in the residence where Paquita is kept captive. Delacroix is therefore not the only inspiration for Balzac,

whose aim as he wrote the book was to be first and foremost a painter.

The prologue is both a painting and a caricature: a terrifying canvas of the proletariat, workmen "whose faces, worn from rubbing…, turn gray as the plaster on a house that has been subjected to every kind of smoke and dust, [and whose moments of rest] are a wearying debauchery, brown of skin, ashen with drink, or yellow with indigestion";[32] and a brutal caricature of the bourgeoisie. Attorneys, doctors, speculators, and magistrates "all eat immoderately, play and stay up late, and their faces grow fuller and flatter and redder."[33] In this opening, Balzac propels the reader into the world of Honoré Daumier and Henri Monnier, the great caricaturists of the day, men he unreservedly admired and who were often approached to illustrate his novels. This is a far cry from Delacroix.

Nevertheless, Balzac connects this prologue to the rest of his story by imperceptibly transforming the gloomy grayness in which the destitute wallow into the warm, golden, oriental atmosphere that bathes the more fortunate in the world. The East is suddenly conjured in its mysterious splendor: whenever a bourgeois character begins to rise up the social scale, he "reaches out to the East, takes the shawls snubbed by the Turks and the Russians…even goes harvesting in the Indies."[34] Still clearer is a reference to Parisian women who "stay hidden, like rare plants that unfurl their petals only at particular times of day…, a happy little tribe who live the oriental way."[35] We are now entering a world resolutely influenced by Delacroix. Balzac had seen and been struck by his *Women of Algiers in Their Apartment* at the 1834 Salon. He even

announced to his adored Mme Hanska that he would happily have bought it for her, had he had the funds. Was this interior, guarded by a tall black slave girl and into which Delacroix had taken certain risks to venture, the trigger for Balzac's imagination, did it lead him to describe Paquita's captivity where she is watched over by a she-devil of a duenna, "a hyena some jealous fool had put in a dress"?[36] Not only can the prisoner never go out alone but she is forbidden, on pain of death, to open the door to a single visitor. When she does manage to receive Marsay, it is thanks to the devotion of her mulatto slave. A character made to play Othello: "No African face ever better expressed vengeance, speediness to suspect, promptness in executing his thoughts, all the strength of the Moor and his childlike thoughtlessness."[37] But the background canvas changes when Marsay comes on the scene. We go from Africa to the East, from the rooms of the *Femmes d'Alger* to the *Death of Sardanapalus*, the vast canvas (approximately thirteen by sixteen feet) in which Delacroix uses a swirl of color for his imagined sacrifice of women, horses, and slaves ordered by the inflexible and all-powerful prince. And it is no accident that the reader gains access to Paquita's apartment at the same time as Marsay, who is described by Balzac as an oriental despot.

Balzac does not describe Delacroix's painting here, but alludes to it, especially in the emphasis he puts on Marsay's overweening pride, which echoes Sardanapale's omnipotence as he gazes impassively at the slaughter around him. How does Henri de Marsay, the illegitimate son of an English lord and a Parisian girl, brought up by a spinster — "an ugly, deaf, and boring little old bonnet"[38] — come

to resemble an Eastern despot whose opinion of himself was "not like Louis XIV's, but like that of the proudest of caliphs, pharaohs, and Xerxes, who believed they belonged to a divine race".[39] No wonder he is tormented by a longing to visit India, "where the spring goes on forever...where a man can have all the trappings of a king without eliciting endless comment as he would in inane countries that strive for the bland illusion of equality."[40] There is nothing to justify his imperturbable composure, but Balzac sees in it the secret of his success with women. Marsay is *The Human Comedy*'s boorish seducer par excellence, because "women are phenomenally drawn to these people who call themselves *pachas*, who seem to have a retinue of lions and torturers, and operate amid an apparatus of terror."[41] In the various novels in which he makes his ruthless appearance, he is happy to ruin his selection of mistresses indiscriminately, traveling about "nonchalantly...like all animals which, aware of their strength, walk with their own peace and majesty,"[42] while remaining an elegant role model for young arrivistes. In *The Girl with the Golden Eyes* he is endowed with harmful, occult powers thanks to his monstrous egotism on the one hand and, on the other, his association with the Thirteen, a secret society that recognizes no laws or customs. So he launches himself into a fantastical adventure which Balzac makes no attempt to render credible. In order to have access to Paquita he agrees to cross Paris blindfolded at the mercy of his guide's dagger. Once ushered into her room, he shows no fear even though death seems to hover over his cavorting with this mysterious girl, who is by turns threatening and terrified that she will be assassinated if their liaison is discovered.

The setting in which Paquita and Marsay's lovemaking takes place is also oriental. He enters her rooms through a side door hidden behind a tapestry (the last allusion to the apartment in the *Femmes d'Alger*). There he finds a proper Turkish divan, "in other words a mattress laid directly on the ground, but a mattress as wide as a bed, a divan fifty feet around, in white cashmere...the headboard of this vast bed rose several inches above the many cushions that embellished it still further with their tasteful charms...the carpet looked like an oriental shawl, displaying the same designs and evoking Persian poetry where it had been worked by the hands of slaves...the only table in the room had a length of cashmere for a covering."[43] And, not forgetting his ambition to paint a Delacroix in words, Balzac writes at length about the colors and their symbolism. Paquita's room is bathed in red, gold, and white tones which, in Balzac's mind, suggest inexpressible desire: "the soul has an indefinable connection with white, love is happiest in red, and gold puts passions to their best advantage."[44] In fact the reader soon grasps that there could be another more violent interpretation. The red of love is indistinguishable from blood because "voluptuous pleasure leads to ferocity,"[45] the white with which the "virginal but not innocent" Paquita likes to surround herself is not entirely pure, and gold is the color of avarice and ambition. The girl appears "in the midst of a hazy atmosphere laden with exquisite perfume...dressed in a white peignoir."[46] She fancies dressing Marsay in a red velvet robe. The walls of her boudoir are entirely covered with red cloth, and the ceiling with its gold cornicing is dazzling white, the curtains are of muslin from the Indies lined with

pink taffeta and edged with dark red fringing, and the couple's embraces here are "an oriental poem filled with light from the sun that the Persian poets Saadi and Hafiz put in their lilting strophes." Perhaps so, but what dominates the entire novella, which does indeed end with Paquita's bloody death, is the transition from the scarlet of passion to the scarlet of death.

When Paquita cries out a woman's name during their second night of lovemaking, Marsay becomes convinced he is not sole master of Paquita's heart, and is enraged. Therefore, she must die. But he wants to prepare his revenge, and with the help of his fearsome ally Ferragus he fine-tunes his criminal plan. When the two accomplices come to the door of the house the following morning, they gather from the screams coming up the chimney that they have been beaten to it by the marquise in her demented jealousy. Once inside, they witness a ferocious killing.

The murder scene is excessive in its blood-soaked frenzy. The cushions are splattered with blood, the tenting on the walls has been ripped by bloody hands. "Paquita must have tried to climb to the ceiling. Her bare feet had left marks along the back of the divan. The way her body was hacked apart by dagger wounds...demonstrated how frantically she had fought for her life."[47] But the dominant image is of the marquise: "The marquise had hair ripped out, she was covered in bite marks, several of which were bleeding, and her torn dress left her half naked, her breasts scratched. She looked sublime in this state. Her avid, furious face inhaled the smell of blood. Her panting mouth was half open, and her nostrils alone could not cope with her powerful inhalations. Some animals, when provoked,

will launch themselves on their enemy, put it to death, and then, in the calm of victory, appear to have altogether forgotten about it. There are others that prowl around their victim, guarding it, afraid it will be taken from them, and—like Homer's Achilles—they circle Troy nine times, dragging their enemy by the feet."[48]

This evocation is so surprising, so outlandish, that it conjures delirious images rather than acting as a realistic, concrete description. And yet it is impossible not to detect a striking influence from the paintings and drawings of Delacroix. This last scene could not have been written if Balzac had not spent a long time contemplating *Liberty Leading the People*, one of the painter's most famous works. In it, the woman who represents freedom stands bare-breasted above the dead in the same pose as the marquise with her torn clothes standing over Paquita's body. The bayonet that Liberty holds in one hand, the red of the flag she brandishes in the other, remind us of the bloodied dagger the marquise is still holding, but surely it is the surprising analogy of the murderess as a big cat that gives this passage its beauty and power. This is a far cry from the figure of Liberty but still in the realms of Delacroix, who was a passionate observer of wild animals.

Balzac, as I have said above, was not an art critic but a fervent art lover who often allowed himself to be carried away by this passion. The décor in Paquita's boudoir accurately mimicked the living room at his small house in Passy, and gives us an idea of the excesses he favored. The fact that Balzac was an ardent enthusiast, as well as a collector often

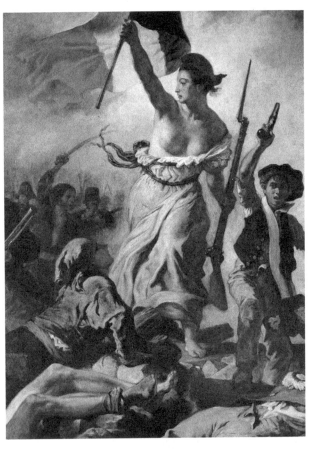

EUGÈNE DELACROIX *La Liberté guidant le peuple* 1830

frustrated by his lack of funds, was all part of his legend. When he was ill and had only months left to live, he was still struggling to perfect the furnishings and decoration of the house on the rue Fortunée where he was to move with Mme Hanska, whom he had at last married. He succumbed to a sort of obsessive accumulation of things that he himself might have described as *bricabracomania*. If the attributions of the masterpieces he found on his visits to dealers and antiquarians were often fanciful, the fact remains that painting afforded him genuine happiness, and he could not separate his aesthetic experiences from his artistic pursuits: he was the first novelist to try to pictorialize language.

This obsession with works of art was widespread in his writing, appearing in many different forms. His texts are riddled with references to Raphael, Correggio, Leonardo, Guido Reni, Dow, and Rembrandt, among many others, but Balzac is not satisfied with merely citing names at random, he gives very precise details about specific paintings, proving he has seen and studied them. Such familiarity clearly came from spending a great deal of time at the Louvre.

Later Balzac would use engravings and prints as and when he needed to perfect his descriptions. Having forgotten to acquire any images of Russian uniforms when he was in Saint Petersburg, he asked Mme Hanska, who was still living in Poland at the time, to obtain "color engravings…of regiments during the war between Russia and France,"[49] which would be indispensable for his description of the battle of Eylau in *Colonel Chabert*.

As for his contemporaries, he had fun including them in narratives. Thanks to his customary freedom, Gros;

Gérard; Girodet; Chaudet, the sculptor who made the statue of Napoleon that topped the Vendôme column; and Bouchardon, the creator—amongst other works—of the Four Seasons Fountain on the rue de Grenelle, appear as characters in various novels, either as instructors at the École des Beaux-Arts or as champions of young protégés. Gros—"although not very giving"—pays for his pupil Joseph Bridau's supplies in *The Black Sheep* (*La rabouilleuse*), and forms a partnership with Gérard to make sure he receives the cross at that year's Salon. Delacroix is always referred to admiringly. Opening a Balzac novel is like walking into a museum, but a museum where the artists (and sometimes even their models) often step out of their frames to come into the story. Balzac would not be the powerful novelist he is had he settled for describing paintings and not created his own huge gallery of painters.

2 The Painter and Society

Balzac had no friends who were painters and never attempted to sketch a portrait or a landscape himself, or to daub paint on a canvas. By contrast, his contemporaries, Théophile Gautier and Victor Hugo, had real talent for painting or drawing and could have devoted themselves to the fine arts. Balzac did not have their technical know-how, and had never done any art criticism, happy merely to comment on the Salons in his letters to Mme Hanska. He never took part in the squabbling among different schools, but found painters themselves extraordinarily interesting.

The Goncourt brothers and Zola each dedicated an entire novel to a painter character. Flaubert and Maupassant also demonstrated their interest in painting, but they too invented only one painter each. Balzac, on the other hand, was not satisfied with a single specimen. He created ten of them, all different in the way they conceived their art, their ambitions, and their success. There are more painters than writers in Balzac's work. He has a scattering of journalists and poets in several of his novels, but came up with only one great writer, Daniel d'Arthez. (I am not including Nathan, who appears in *Lost Illusions* and *A Daughter of Eve* and whose "quill took its ink from an

actress's well."[1] This character is more journalist than novelist. He is short on resolve and patience, and wastes his talent.) Interestingly, Balzac made d'Arthez a cold, gray, virtuous character when all his painters are jolly, attractive, unpredictable, and often practical jokers.

Of the ten fictional painters in *The Human Comedy*,* only Joseph Bridau and Frenhofer are truly obsessed with issues of artistic creation. The focus with all the others has more to do with how they conduct their careers, a subject sometimes complicated by their family problems, and with how they cope—or fail to—with the opinions of the public or their peers.

The Vendetta features a rare character, a woman painter, whose name—Ginevra di Piombo—evokes the famous Venetian Sebastiano del Piombo. It is the tragic story of a young woman who stands up to her father to marry the man she loves, Luigi Porta, even though he reveals he is "her family's enemy" according to the terms of the implacable Corsican principle of reciprocal revenge by crime—the vendetta that gives the novel its title. Luigi Porta is the only surviving member of his family, which was massacred by the Piombos. At sixteen, he enlists in Napoleon's army and has no intention of bowing to the Corsican code of honor by trying to kill the head of the Piombo family. Injured at Waterloo and exiled, he hides

* Bixiou, who appears in several novels, Joseph Bridau (*La rabouilleuse*), Dubourdieu (*Comédiens sans le savoir*), Frenhofer (*Le chef-d'œuvre inconnu*), Pierre Grassou (*Pierre Grassou*), Léon de Lora (*Un début dans la vie, Comédiens sans le savoir*), Ginevra di Piombo (*La vendetta*), Schinner (*La bourse* and other novels), Servin (*La vendetta*), and Sommervieux (*La maison du chat-qui-pelote*).

in the painter Servin's studio, where Ginevra, a pupil of Servin's, discovers him. This is when the story begins.

Servin, a well-known painter, is married—a sign of indisputable respectability—to a general's daughter, and was the first to come up with the idea of opening a studio to initiate young ladies from rich, well-regarded families in the art of drawing and painting. He swiftly becomes "specialized in women's painting, like Herbault in hats, Leroy in fashions, and Chevet in food."[2] As a patriot, he is loyal to the Empire under the Restoration, and takes it upon himself to hide the young man in a closet "where they throw broken plaster casts, and paintings condemned by the teacher"[3] at the back of the room in which the young ladies work. Grasping the layout of the studio is therefore essential to understanding the story.

Depictions of studios were pictorial rather than literary subjects at the time, and the description of Servin's studio is probably the first if its kind in a novel.[4] Balzac proves very attentive to distinctive characteristics of the lighting in this huge space in the attic of the house, and is certainly sensitive to its unusual atmosphere, "a peculiar blend of ornamentation and nudity, poverty and luxury, care and negligence," a feeling created by the frames with no canvas and canvases with no frame, by the mannequins and dusty plaster casts, and by the morbid inclusion of an image of Niobe hanging from a nail, showing "her grief-stricken pose…one hand [thrust out] like a poor woman's begging for alms, and there were a few écorchés figures, yellowed by smoke, that looked like limbs torn from their coffins the day before."[5] The presence of death on these premises foreshadows the drama that will unfold.

Ginevra, whose easel stands right next to the small closet, notices the sound of the young man's breathing and makes sure she is the last to leave so she can sneak a glance at the sleeping stranger. She is struck by his beauty, such beauty that it alone would have been enough to stir feelings in her. But Ginevra is an artist, and she immediately transposes the injured man's features so that "the image engraved on her memory was a man's face as gracious as Endymion's in the Girodet masterpiece she had copied a few days before."[6] This is an example of a work of art acting as the trigger for the action of a novel, and also an instance of "love blossoming from a sort of aesthetic fascination, and the allure of a face, the first image of desire, could be gauged here as a resemblance to certain faces and effects used in art."[7]

Ginevra takes to staying behind after the other pupils have left, and she hears the young man's story. First, she learns that he is Corsican like herself; he still speaks the island's language. His devotion to Napoleon matches hers and that of her parents, who owe everything to the emperor. She is moved by the young man's account of his misfortunes during Napoleon's last campaign. Over the course of their long conversations after the studio has emptied at the end of each day, they gradually realize they are in love. Until then she has lived in perfect symbiosis with her parents, but when her father hears that she wants to marry a Porta, he is driven mad by rage and jealousy, and categorically forbids the union. Ginevra stands her ground. Now over twenty-five, she can marry without his consent. And so she does, but the young couple has "no fortune other than their love." How will they live? Essentially, from her

paintbrush, because it is terribly hard for an officer to find employment in the Paris of the Restoration. Making the most of his fine handwriting, Porta finds work transcribing documents for attorneys and notaries, while Ginevra specializes in copying old paintings, and builds a clientele among junk shops. But competition grows fierce, and her customers, wanting to diversify, start asking for more than just copies. Ginevra has never tried to make her name as a "genre" painter and so finds herself in financial difficulty, particularly as Luigi is suffering because of a drop in fees for his office work. So begins the downward spiral. Unable to sell her canvases because her clients are hardly willing to touch paintings by artists with even a degree of notoriety, Ginevra secures menial work coloring engravings thanks to Elie Magus, one of the dealers she knows well. The birth of their son further aggravates the little household's problems. Soon it is not so much a question of hardship as destitution, which leads inevitably to tragedy. The child dies, then his mother, and the father commits suicide. In Balzac's world, talent and courage are powerless against "those who do not adhere to society's customs," or at least this is true of women: other young artists who have the advantage of being male come off better after refusing a conventional way of life or marriage.

One of the main characters in *At the Sign of the Cat and Racquet* (*La maison du chat-qui-pelote*) is a painter, but the novella's subject has less to do with how he practices his art than the difficulties an artist has in being understood. The starting point for *At the Sign* is strictly pictorial, and, as with *The Vendetta*, the plot is triggered by the memory of a work of art. This novella opens with a description of an

old house on the rue Saint-Denis seen through a young man's eyes. This young man—with pleating in his coat not unlike antique draperies, with his curly Caracalla-like hair spread over his shoulders, and with his elegant shoes and white gloves—seems out of place in such a working-class neighborhood. He himself looks like a work of art. He stands motionless, studying the facade of a shop with almost suspect intensity. His eye lingers first on the garret, where three apprentices appear at a dormer window, "three cheerful faces, all round and pink and white... reminiscent of the chubby angels' faces dotted about the clouds, attending the eternal Father"[8] in so many religious paintings; on the third floor he tries to probe through the small panes of green-colored glass to the mysteries of a bedroom; the windows on the second floor are adorned with little red muslin curtains which do not interest him, but he sees—and is seen by—the owner of the house, M. Guillaume, a merchant draper who is "by some miracle, standing on the doorstep to his store," and is described with the minute attention of a miniaturist, betraying Balzac's admiration for Rembrandt's portraits of old men. "He wore wide black velvet breeches, woven silk stockings, and square shoes with silver buckles. His frock coat with its square panels, square skirts, and square collar [was] embellished with large buttons in white metal rubbed red with wear. His gray hair was so perfectly flattened and combed on his yellow scalp that it made him look like a plowed field."[9] This is the beginning of the novella, but it is not the beginning of the story.

Thanks to some backtracking, the reader learns that the young man's interest was aroused some time earlier when

he walked along the same street and saw what he thought was "a sight to transfix every painter in the world. The shop was not yet lit and formed a block of darkness, at the end of which the merchant's dining room could be seen. An astral lamp shed the sort of light that lends such grace to paintings of the Dutch school." The lamp illuminates the draper's family meal, including M. Guillaume, his wife, his two daughters, and his apprentices. The passerby's acute awareness of the lighting and the beauty of one of the girls (he would "willingly [compare her] to an exiled angel remembering the heavens") is certainly proof of an artist's eye, and we do indeed discover that the mysterious young man is a painter recently returned from Rome, his eyes sated on Raphael and Michelangelo: "Abandoned for months to spirited Italian passions, his heart longed for one of those modest and contemplative virgins whom he had, unfortunately, only ever found in paintings in Rome."[10] The face of this girl, who has caught his attention, exudes an admirable air of innocence. It is enough to make Théodore de Sommervieux—for that is the young man's name—fall hopelessly in love. The result is to be two paintings, a portrait of this girl he does not know and a depiction of the shop. And the reader then realizes that the meticulous description of the house that bears the sign of the cat and racquet, the house that opens the novella is a sort of appraisal of his painting by the artist. It is hardly surprising that he dwells so long on his description of the shop's sign featuring a cat playing *pelote* (the game that would later give us tennis) with a gentleman in an embroidered frock coat, the work of a long-dead artist whom he believed to be wittier than a good many living painters.

Sommervieux is in a very different situation from Ginevra in *La vendetta*. Despite her twenty-five years, Ginevra has no professional experience when she abandons her family to follow her Luigi. How can she possibly have put herself forward for the Prix de Rome?* No woman has ever been accepted as a candidate. The only career she can envisage is as a portraitist, but so long as she lived with her parents she had no need to earn a living, and her father would probably have been against the idea anyway. Although Sommervieux may not yet have known success, he is familiar with the world of art, and what better proof than the friendship Girodet shows him? Girodet reappears in Balzac's work, then, and no longer simply as the author of *Endymion*, but as a character. This incursion into the novella by a living artist whom Balzac greatly admired is enough to give the fictitious character more substance.

It is Girodet who forces the door to Sommervieux's studio, where the young man has shut himself away for several months, obsessed with his portrait of the beautiful stranger and his painting of the shop. What will he exhibit at the Salon? This annual exhibition organized in the large square gallery of the Louvre was a prerequisite for all artists at the time. There was no other way for them to show their work and gain recognition. Sommervieux shows the two pictures to Girodet, who, before swooning with admiration, immediately surmises, "You're in love." But he thinks the paintings too unusual, too profound to be

*Winners of the Prix de Rome were given a scholarship that allowed them to study in Rome for three or five years.

subjected to public scrutiny. The ambitious and impatient young man pays no attention to the master's advice and exhibits both canvases.

Tremendous success. The public, "sometimes wise *en masse*," clusters around them. "They were to die for, as the ladies say." Despite astronomical offers, Sommervieux refuses to sell them or even allow engravings to be made of them. Rumors of this triumph spread all the way to the draper's own house, thanks to his cousin, Mme Roguin, who is true to her bourgeois aspirations and attends the Salon, unlike Mme Guillaume, who stays chained to her shop counter. Mme Roguin persuades Mme Guillaume to allow her younger daughter, the pretty Augustine, to accompany her on a visit to the Louvre. The two women are separated in the crush and Augustine ends up alone in front of her own portrait; she recognizes herself and realizes that the young man she has noticed outside her house is responsible for it.

Augustine is bowled over by the portrait. Her initial reaction is fear: "A shudder made her quiver like a silver birch leaf." The painter, who spends every day standing guard in the gallery, slinks up to her and whispers in her ear that he loves her. Horrified, light-headed from the heat and the profusion of pictures, stifled by the thronging crowd, she loses all self-control. She feels she is burning, as if she has "a furnace inside her," and is afraid she has been possessed by a demon "of whose terrible traps she had been warned by the thundering voices of preachers,"[11] or is going quite mad. Her reaction is not unlike that of a primitive convinced a photograph of his face has stolen his soul. But her terror is mingled with "an unfamiliar

pleasure." She pulls herself together and wisely advises Mme Roguin against trying to elbow her way to see the portrait. Nevertheless, they are both jostled toward the second of Sommervieux's paintings. A surprised Mme Roguin recognizes the shop and naturally tells the Guillaumes about it afterward. M. Guillaume almost chokes laughing: "How very funny it must be to see a painting of something we come across every day on our street!"[12] His apprentice, Joseph Lebas, points out that it might help him sell a few extra bolts of cloth. Is there any need to expand on that? Lebas is the son-in-law of M. Guillaume's dreams.

Back at home, Augustine regains her composure, but the incident has transformed her. Flattered and moved by the handsome young man's attention, she swiftly succumbs to love. She and Sommervieux succeed in outwitting Mme Guillaume's watchful eye. All obstacles merely heighten the feeling they have for each other. Soon they are deliriously in love, and Augustine opens up to her dismayed parents: first, her father announces that, in order to be happy, a girl must marry a man of her own class, "neither the husband nor the wife should know more than the other, because, first and foremost, they must understand each other,"[13] and besides, artists were generally destitute, spendthrift, and bad sorts. Mme Roguin, whose husband is a notary and looks after the young painter's affairs, restores calm in the family by introducing an irrefutable argument: Sommervieux's paintings sell for six thousand francs, and he already has twelve thousand francs a year; what is more, he is about to be made a baron, and the emperor himself has made him a knight of the Legion

of Honor. "There is so much vanity in man's heart" that M. Guillaume is eventually worn down and agrees to his younger daughter's marriage. The eldest will marry the sensible apprentice.

The second part of the novella is entirely given over to the catastrophe of this love match. One year of furious passion—always a prelude to the greatest disappointments in Balzac's world—is followed by a period of complete misunderstanding between husband and wife. Balzac is not depicting an artist at work but showing the incompatibility between an artist and someone blind to the arts. Balzac himself stays neutral, because this is a hopeless situation. Sommervieux wants to bring his wife into his world, but when he shows her his sketches, she is impervious to their beauty. Like her parents, she cannot tell the difference between a masterpiece and a dud. And her kindness and virtue hold no weight against this indifference, this complete absence of sensitivity.

Soon their life together is not enough for Théodore. He wants to go back to his old habits, his friends and his work, to get back into the world where he can show off his wife as well as his paintings. There has always been a contrast between the Guillaumes' world (one Augustine has not altogether left behind), a closed world where wealth is not flaunted but kept hidden behind casement windows armed with "thick iron bars" and behind threatening dark walls, and Sommervieux's world, which revolves around exhibition; and this contrast intensifies. During their honeymoon, the couple kept the portrait in their conjugal bedroom, but Sommervieux now takes it back. He wants it to be seen: his taking the picture is a symbol for the

breaking off of marital intimacy, and the painting plays an important role in the ensuing events.

Now back in society, Sommervieux seduces or allows himself to be seduced by the beautiful duchesse de Carigliano, who is thrilled to have lured the famous artist to her salon. Not only does she get her way, he goes so far as to give her the portrait. There is now little chance of the painting's being cloistered: even the duchess's boudoir, a place where she enjoys being seen, is open to her guests. And, because she understands the artist's weaknesses only too well, she inevitably chooses to hang the canvas in the sumptuous gallery in her house. Augustine has no idea of this and it is only when, in her disarming simplicity, she turns to the duchess to learn the secrets of her seductiveness that she sees her portrait. The duchess is touched by the young woman's distress and returns the picture to her. Augustine feels that this portrait is her soul and the symbol of her husband's love; it belongs to her, and when she takes possession of it again, instead of putting it in the most public place in her apartment, she puts it back in her bedroom—and this provokes Sommervieux's fury.

To make matters worse, his vanity is cut to the quick by the fact that the duchess was happy to give up the painting. Enraged to a "demented state," he tears the canvas and breaks up its gold frame. Not long after this, Augustine dies of a broken heart. This is not the supernatural world of *The Wild Ass's Skin*, and yet how can we fail to marvel at the power of a single work of art? Surely there is something magical about a painting that so completely possesses both husband and wife.

Sommervieux will no doubt recover and have a satisfy-

ing career, but Balzac is not sufficiently interested in him to follow this up. It is a third young painter, Schinner, who gives Balzac an opportunity to describe the life of a successful artist. Schinner is also happy in love and, as with Ginevra and Sommervieux, love blooms from just one look, but it is the look of a painter's eye. Perched on a ladder, Schinner is studying a painting he has barely finished when he loses his balance. The noise of his fall alarms his neighbors, a mother and daughter who live in the apartment beneath his studio. They race upstairs to help:

> He soon regained consciousness and saw, in the glow of one of those old Argand oil lamps, the most enchanting girl's face he had ever seen, one of those faces often taken for a whim of the paintbrush, but which suddenly realized before his eyes all the theories of an ideal beauty that each artist conjures for himself and which forms the basis of his talent. This stranger's face belonged, so to speak, to the finely honed delicate type of the Prudhon school, and also had the poetry that Girodet gave his fantastical figures. The freshness of her temples, the regularity of her eyebrows, the clean lines, the virginity clearly imprinted on every feature of that physiognomy made this young woman an accomplished creation.[14]

Yet again we witness a sense of wonder at a face whose perfection seemed to be the preserve of art, and yet again "aesthetic fascination" induces the beginnings of love.

After a few inevitable eventful episodes, Schinner—who at twenty-five is not a novice but one of the most sought-after artists in France and a role model to his young colleagues—marries his pretty savior, and their home proves

so happy and peaceful that Balzac does not trouble himself with it but glosses over their story. What interests him about Schinner is his career, a career we follow through *The Human Comedy*. There is little detail about his technique except that it can be identified by his magnificent, powerful use of color. He is a master; the government has given him thirty thousand francs to decorate two galleries in the Louvre; he runs a highly reputed studio at the École des Beaux-Arts, lavishes advice on his former pupils, and, more importantly, finds them work. Having completed large decorative canvases for the comte de Serizy's château, he recommends to the comte the very young Bridau for the framings, arabesques, and other accessories. The banker Nucingen calls on him to decorate the residence he gives to the beautiful Esther, the courtesan he adores, and Schinner is sufficiently influential to persuade them to accept a painting by his former pupil, Pierre Grassou, proof of his kind nature, because he has a dim view of the latter's talent but gives in to the pity inspired by his persistence and his poverty.

Schinner symbolizes the artist who brings together talent and patience. His only fault is that he is too perfect and too peaceful to be an entirely credible person, particularly as the ease of his success and the absence of any personal or professional conflict mean his is not a captivating character. One of his pupils, Léon de Lora, whose equally successful career is barely sketched, is more entertaining, if only because he represents the painter as joker. He does not seem to take himself all that seriously, despite all his commissions. He adores word games, loves taking people for a ride, and enjoys partying. He is certainly a

very able painter, but there is some doubt that he is a great painter. He lacks the obsessive sense of work that *needs* to be done.

None of these artist characters allows us to explore the secrets and anxieties of the creative process. Balzac seems primarily interested in the artist's place in society and by more practical concerns: How does an artist start his career? How does he make a living? What role do masters and fellow artists play? And, finally, how does he organize his family life? In this regard, Balzac paints a very precise picture of artists' circumstances in the first half of the nineteenth century. His reflections on the significance of art and on the education of the general public expand when he creates the characters Pierre Grassou, Joseph Bridau, and particularly Frenhofer, who, each in their own way, confront the mystery of artistic creation.

3 Ambitions, Success, and Defeat

T he three painters mentioned above — Grassou, Bridau, and Frenhofer — are all passionate about their art, but they represent three such utterly different conditions of the profession that there is little common ground among them. Grassou is an artisan, Bridau an excellent artist, and Frenhofer a genius.

Pierre Grassou has a blind belief in the value of hard work; he is resolute and persistent. He shuts himself away in his studio for months on end. Indifferent to all sensual pleasures, he sustains himself on bread and walnuts. He studies the great masters, takes advice meekly, and loves his craft. Only, it has to be said, Grassou has no talent. Balzac certainly feels "there can be no great talent without great strength of will,"[1] but will alone is not enough either. Still, the novella which bears his name and in which he is the central character is not devoid of interest, because Grassou's career affords insights into the art market, the taste of the petite bourgeoisie of the day, and the all-too-common tragedy of an unproductive artist.

One need only step inside Grassou's studio, which is "tidy as a grocer woman's bedroom,"[2] to grasp that he is meticulous and not very skilled. He studied under Servin, Schinner, and Gros — and here again a historical character

gives the story substance—but they were disheartened by his lack of gusto, originality, and humor. Grassou was born to be a "virtuous bourgeois," but when Schinner tries to discourage him, Grassou digs in his heels. He earns a living selling little genre pieces—Flemish interiors and pretty naturalistic landscapes—and his buyer is of course Elie Magus. Every time a painting changes hands in *The Human Comedy*, Magus, a Jew as cunning as he is knowledgeable, will be somewhere nearby. Magus decides to do Grassou a favor and puts him in touch with a family that wants to be immortalized. M. Vervelle, a man who has made his fortune selling bottles, is described as "a walking pumpkin on turnips inaccurately called legs," flanked by his wife, "who looked like a coconut," and his "young green asparagus"[3] of a daughter; and this description owes a lot to one of Balzac's favorite caricaturists, Henri Monnier, and to his fondness for a very free, spontaneous sort of humor when he indulged himself with "those extravagances that painters have fun drawing at the foot of their lithography plates."[4] Grassou allows himself no jokes at all and reassures his customers with his serious attitude, the sense of order around him, and especially with the fact that, when Vervelle inquires about his finances, he tells him he not only has savings but that they are held with the notary, Cardot, who happens to be the Vervelles' family notary. In Balzac's work, having a notary in common always indicates an affinity close to actual friendship.

After making inquiries about the artist with the notary, M. Vervelle invites Grassou to his house in the country, where he claims to have gathered a magnificent gallery of paintings, works by Rubens, Gerald Dow, a Titian, some

Rembrandts. Intrigued, Grassou accepts the invitation. He is immediately honored with a visit to the gallery, which houses "a hundred and fifty paintings, all varnished and dusted, some of them concealed behind green curtains not to be drawn in the presence of young ladies."[5] The painter stands "dumbfounded and slack-jawed" when he recognizes canvases he himself sold to Magus. He explains the hoax to his host, who, far from feeling mortified for being fooled, takes Grassou in his arms, offers him his daughter, and exclaims delightedly, "I'll double her dowry, for this means you are Rubens, Rembrandt, Terburg, and Titian!"[6] So Grassou marries Mlle Virginie, is highly regarded as a portraitist in the bourgeois world, and, with his exemplary good taste, he gradually replaces his father-in-law's daubs with genuine masterpieces; but this happily married man is eaten away by one "fatal thought: artists make fun of him, his name is a term of contempt in studios"[7] and critics take no interest in his work.

Grassou is a painter and a connoisseur but he is not an artist. The artist is his friend Joseph Bridau, whom we meet for the first time when he bursts into Grassou's studio during a sitting with the Vervelle family. These good people are alarmed by his appearance: "he was in a dark mood and rushed in like a thunderstorm, his hair buffeted by the wind; he showed them his great ravaged features, his lightning bolt eyes peering in every direction."[8] Bridau has a typical artist's face, "always startling…his looks above or below the accepted range for what imbeciles would call ideal beauty. Few of those figures, so sublime in their prime, ever stay beautiful. Besides, the blazing beauty of their faces is never fully understood."[9] Bridau's superiority

is instantly highlighted when Grassou encourages him to make corrections to the portrait in progress. He is a great artist, Grassou explains to the Vervelles, who are terrified at the prospect of this fierce creature ruining their likeness.

Joseph Bridau is one of the central characters in *The Black Sheep*, and is the only artist in *The Human Comedy* whose whole life is described: not only the birth of his vocation, his apprenticeship, his intellectual development, his fears and doubts, but also the ups and downs of his family life, his friendships and love affairs. In this instance, Balzac is handling a multifaceted character, and, as it happens, a particularly endearing one.

Joseph is the younger son of a widow whose late husband was a high-ranking official on Napoleon's administrative staff. She lives modestly on the rue Mazarine, in the immediate neighborhood of the École des Beaux-Arts, and the thirteen-year-old Joseph—who dreams only of drawing—sneaks into one of the studios. The sculptor Chaudet, another historical figure, is touched by his enthusiasm, and arranges for him to be given paper and pencils and left to do as he pleases. His work is so good that the art master at his school tells his mother it would be a shame not to develop such genuine talent. Encouraged, Joseph then announces that he wants to be a painter. Where M. Vervelle has no real knowledge but boasts of his love of the arts, having grasped the fact that taste is a means of rising up the social scale, Mme Bridau is far more reactionary and does not even try to understand the arts. She is merely horrified that, instead of setting his sights on a job at the ministry, Joseph wants to turn himself into a painter, "a career fit for a tramp."

But Joseph will not be dissuaded. As if to underscore his worth, Balzac introduces contemporary painters into his story: Joseph is supported by Gros, who is famous for his talent as a painter and a teacher, and who pays for Joseph's materials; by Regnault, a painting teacher at the Beaux-Arts school; and by Gérard, nicknamed "the painter of kings and the king of painters"; and he works fervently, living off bread, milk, and brie cheese so as to cost his mother nothing. He hones his skill so effectively that, before the age of twenty, he secures a commission—thanks to Gérard—to make copies for La Maison du Roi to be hung in various royal buildings (novice painters relied on copying work to survive). He also depends on support from a group first of masters and later of peers. As an indication of his achievements, Bridau is eventually admitted to the informal group of the great intellectuals in *The Human Comedy*, the *Cénacle*, which brings together writers, artists, and scholars, all men characterized by their earnestness and virtue.

Although a prankster and easygoing, Bridau is a thoughtful man. He is a reader, and Balzac is at pains to point out that a painter's work is conducive to reflection: "Painters spend days on end in silence in their studios, carrying out work that to some extent leaves their thoughts free; they are rather like women; their minds can focus on life's minor incidents and assimilate their hidden meaning."[10]

Anyone with good judgment and taste appreciates Bridau, but he still does not have the success of a Schinner or even a Sommervieux, and there are two reasons for this. The first is that he does not appeal to the bourgeois; "This creature, which is where all the money is nowadays,

never unties its purse strings for talents that are open to debate, and Joseph could see he was up against the classics, the Institute, and the critics associated with those in power."[11] He therefore has few commissions, and Grassou sympathizes, well aware he himself is daubing nonsense that appeals to the bourgeoisie while great painting is suffering. The second reason lies in Joseph's very nature. In Balzac's view, a degree of asceticism is essential for artists to realize their full potential: love and passion make poor companions with creative genius. Joseph, it seems, is too impressionable:

He could have carried on with the great masters of the Italian school: he has the drawing skills of Rome and the color of Venice; but love is killing him and affecting more than just his heart: love casts its arrows into his brain, disrupting his life and making him zigzag in the most peculiar way. If his mistress of the moment makes him too happy or too miserable, this affects what he submits for exhibition, sending either sketches in which the color obscures the image, or paintings he tried to finish under the weight of imaginary heartbreak, paintings in which he was so preoccupied with the line that color, which was readily available, does not feature at all. He constantly disappoints both the public and his friends...When he gives his full measure he elicits admiration, he savors it, and is then shocked not to be congratulated for the failed works in which his mind's eye can see everything that is missing for the public. He is capricious in the extreme, and his friends have seen him destroy a finished painting which he deemed too manicured. "It's overdone," he said, "too schoolboy." Sometimes original and sublime,

he has all the sorrows and delights of a nervous disposition in which perfection transmutes into illness.[12]

Moreover, Balzac puts him into a difficult family: his lowlife of a brother torments and ruins their mother, so Joseph has the constant anxiety of keeping an eye on the poor woman. When both mother and brother are dead and he is released of this double burden, he achieves a state of calm, but all through his youth he was not free to abandon himself entirely to his passion or subject himself to the absolute tyranny of the creative process. He also always lacked the concentration afforded by a strong will and an irresistible longing to work, something inevitably bound up with a degree of selfishness. Balzac felt that a combination of *the doing* (a facility of expression and technical skill) coupled with an ability to conceive a work of art made *the complete man,* but this was not enough; there still needed to be *the will* if a real work of art was to be produced.[13] Lack of will is Joseph Bridau's fundamental problem, but it does not stop him from being happy.

A good marriage to the daughter of a millionaire tax collector gives him a comfortable life: he continues producing magnificent paintings and helping other artists but he is not a member of the Institute. He lacks official recognition. He appears to cope without it with no sign of bitterness, and the last image that the reader has of Joseph Bridau is of a painter in his studio, roaring with laughter among friends.

This is very different from Frenhofer, the central character in *The Unknown Masterpiece,* Balzac's major work about art, artists, and the creative act. This book is not

at all concerned with public opinion or the artist's place in society, nor even the price of artwork, and this may be why Balzac chose to give the novella an almost abstract feel by rejecting his usual context of contemporary society and setting his story in the seventeenth century. Its protagonists are one fictitious painter, Frenhofer, and two real ones, Nicolas Poussin and Pourbus, Marie de' Medici's portraitist.

Grassou, as we have seen, is a copyist, a man who wants to earn his living from painting and finds a way to achieve that: "Inventing in any sphere means dying a slow death; copying means living."[14] Meanwhile, Bridau could be a great painter but is hampered by the fact that in the early stages he does not give himself fully to his art, and when he is finally free to do so, he is thwarted by his striving for perfection, which becomes an unhealthy obsession, and he ultimately abandons his grand ambitions and settles for being simply happy. Frenhofer, on the other hand, is a genius whose superiority is recognized by his peers. He is actually described as "strange, as if somewhere inside this bizarre character there was a demon operating through his hands."[15] He has the features Balzac tends to give his geniuses, whether artists or scientists: "a bald, curved, protruding forehead overhanging a squashed little nose and sea green eyes with a supernatural spark."[16] When he is impassioned he appears with "his hair awry and his face ablaze with supernatural exaltation." But the key to this character is his concept of art, which consists in a pursuit of absolute Beauty, a natural ideal. The aim of art, he says, "is not to copy nature but to express it...[painters should persevere] until nature is reduced to revealing its naked

truth and its true spirit."[17] Nothing besides his art matters to him. He has no interest in fame or fortune, or even friendship. Ultimately, he allows himself to be sucked into an obsession in which his genius is eventually coupled with madness in this search for the divine nature of beings.

The novella begins with Frenhofer visiting Pourbus, the painter attached to Henri IV's court, in his studio, a handsome space lit by glass panes in a vaulted ceiling. "Concentrated onto a canvas on the easel which still had only three or four white lines on it, the light did not reach right into the dark depths of this vast room's corners." This Rembrandt-style lighting creates an aura of holiness around this secluded studio where few are admitted (Poussin, a young unknown at the time, manages to gain entry only by slipping in behind Frenhofer). Pourbus has just finished a painting of Mary of Egypt, and Frenhofer embarks on an energetic critique of it, putting his advice into action as he makes corrections to the work. The young visitor, Nicolas Poussin, seems appalled by the old master's severity. Frenhofer pays no attention to him and gives the two younger men a real tutorial. He criticizes Pourbus for

hovering indecisively between drawing and color, between the meticulous composure, the stiff precision of German old masters and the dazzling energy, the joyful abundance of the Italian masters... Your face is neither perfectly drawn nor perfectly painted, and every bit of it shows traces of this miserable indecision. If you were not feeling strong enough to meld the two rival methods together with the flames of your genius, you should have opted unequivocally for one

or the other, in order to achieve a unity that simulates a life-like condition…Because you have created something that looks more like a woman than a house, you think you have achieved your aim [and] you believe you are wonderful artists…you tire too quickly.[18]

These are not empty words. Frenhofer wears down "plenty of pencils, [covers] plenty of canvases" to grasp what he calls "the flower of life" captured by Raphael and Titian, and he is still not satisfied. He admits he has spent ten years working on a magisterial portrait of woman, a work no one has seen. His jealousy of the image he has created is so fierce that he vehemently refuses to show it. The door to his studio is barred and he is in despair because he has lost his model. Poussin immediately comes up with the plan that will gain him admittance to the holiest of holy places in painting: he offers Frenhofer his own model, Gillette, the woman he loves, but in exchange he asks to see the finished portrait. Frenhofer accepts the deal.

The young woman is extraordinarily beautiful and very reticent. She feels the offer is a betrayal on her lover's part, and this creates a further complication. Gillette does not like posing for Poussin because she feels that, when he is painting, he looks at her without thinking of her. She feels more like an inanimate object than the object of love. Nevertheless, she agrees to go to Frenhofer's studio. Unlike Poussin's, the old man's eyes are so far from indifferent that he defines himself more as a lover than as a painter. Gillette's beauty reignites his urge to complete his work. "The old man's rejuvenated eyes…so to speak undressed the young woman by imagining her most secret curves."[19]

He swiftly finishes the painting and opens the door to his studio.

But the visit descends into disaster: all that Poussin and Pourbus can see in the picture are "haphazardly accumulated colors contained by a multitude of peculiar lines, creating a wall of paint"[20] in which only one marvelously realized foot can be identified. Confronted with their incomprehension, their inability to understand that reality and art are not interchangeable, Frenhofer suddenly becomes aware of the vanity of his work and therefore his whole life, and realizes how impossible it is to translate his concept of art into any sort of understandable form. He loses heart and commits suicide, destroying the painting.

The catastrophe that ends Frenhofer's story is one that in Balzac's work dogs all geniuses, men obsessed by their art or their scientific curiosity. These men succumb to the ravages of a thought process taken too far. Perhaps we should see the origins of this idea in Balzac's own anxieties when he was crushed by nights spent working and haunted by the dangers with which his over-fertile imagination threatened the balance of his mind. In Frenhofer, "the creative principle itself is threatened, sapped, and ultimately destroyed by an overabundance of talent and imagination."[21] The destructive forces that fell Frenhofer do not come from the outside world, from the ordeals that all artists have to confront, but from within himself.

What makes this novella so poignant and of contemporary relevance is that many artists recognized themselves in Frenhofer. When Cézanne's painter friend, Émile Bernard, read the story to him, Cézanne jumped to his feet and came to stand before him, jabbing his index finger at

his own chest to mean that he, Cézanne, was this imaginary hero. A few years later he admitted to a journalist interviewing him that he often stood staring at one of his paintings such a long time that he felt his eyes would bleed: "I must be a bit mad. Obsessed by my work like Frenhofer." When Cézanne announced that "pure drawing is an abstraction, line and shape do not count,"[22] he sounds very much like Frenhofer. And, like Frenhofer, he always declared a painting finished with considerable reluctance. Later still, Picasso, who illustrated the novella, was delighted that the studio he was about to move into at 7, quai des Grands-Augustins, was in the exact building Balzac had in mind when he wrote *The Unknown Masterpiece.*

Balzac was obviously interested and intrigued by the artist's profession, and this is proven by the very different painters he introduced in his work, as I have cited above, and by his examination of the hazards of a painter's calling and the challenges of the creative process. But there is more than that: his thoughts about painting are revealed in his own style. The influence of painting on writing style would increase over the course of the century. It would go on to appear in the works of a great variety of writers, most notably Zola's.

4 Zola, the Painter's Friend

Émile Zola was forty years younger than Balzac. He was twelve when the older novelist died. Balzac's most important works date back to the Restoration and the July Monarchy; Zola's to the first thirty years of the Third Republic, which was founded in 1870. Between the two periods lies the Second Empire, during which France underwent an industrial revolution and shifted from a mostly rural and artisanal population toward a commercial and industrial society. The developing railways, increased mechanization, and a population influx into cities contributed to an acceleration in the pace of life. In the late nineteenth century the art world also experienced a transformation: it became far more active and more innovative, and also rather quarrelsome. This shift in mood nourished a growing mistrust and misunderstanding between the conservative bourgeoisie and contemporary artists, some of whom were, quite justifiably, seen as revolutionary; these included the naturalists, who abandoned historical painting in order to depict peasants and factory workers, and the plein air painters, precursors of the Impressionists, who deserted their studios to paint nature without gods, nymphs, or mythical heroes. In Balzac's day, painting did not provoke such violent reactions as it did in the ensuing

generations, when writers engaged determinedly in the polemics sparked by exhibitions, and none did so as continuously or with as much intelligence and energy as Zola. He saw this role as a sort of mission because, as he said in his essay on contemporary criticism, "the general public, which is alarmed by originality, needs reassurance and guidance."[1] Even though Zola was a very influential art critic, he was first and foremost a great writer, and his enduring interest in art along with his knowledge of the art world left a mark on his literary work.

Unlike Balzac, Émile Zola always lived among painters, and had done so since childhood. He lost his father when he was seven, and was raised by his mother in difficult circumstances. Thanks to a scholarship, he was accepted as a boarder at the Collège in Aix-en-Provence, the town where his father, who was of Italian descent, had settled to oversee the construction of a canal which would supply the city with water. The young Zola's friendship with two fellow pupils—Paul Cézanne and Baptistin Baille, a future lecturer at the prestigious École Polytechnique—brightened these years made tough by the dirt, bad food, cold, bullying, and lack of freedom that went hand in hand with boarding school life. Cézanne was a year older, bigger, stronger, and wealthier (his father was a banker), and he took Émile under his protection, which was of great benefit to this shy, puny boy who was the butt of his classmates' jibes. In contrast to the other pupils, whose only aspiration was to lounge around on café terraces and play cards, the three friends escaped to the countryside whenever they could. Cézanne never set out without his "powder flask and his box of color cartridges," while Zola "always had

a book of poetry in his pocket."[2] They walked for hours; if it was hot they would take a dip in the river Arc, which ran through a series of *gours*, pools deep enough for swimming; but mostly they talked, they talked endlessly. Years later, in 1866, in his dedication to Cézanne of his *Salon de 1866*, Zola reminded his friend that "we have been talking about art and literature for the past ten years."[3] Cézanne shared Zola's enthusiasm for the Romantic poets and gladly saw himself as a poet, while Zola enjoyed drawing and actually won the drawing prize at their school. But Cézanne's passion for depicting the world around him soon asserted itself. On their outings he was constantly stopping to draw things, and he revisited some favorite haunts years later: in a letter to Zola dated June 20, 1859, he sketched three young boys playing at the river beneath a large tree; one wore a straw hat, another was swimming with his head above the water, and the third was doing a sort of somersault—only his backside and feet were visible. The image needs no explanation.

A few years later, Zola was still trawling back through the memories and reminded Baille that the hot-tempered, violent one, the live wire with the mood swings, beaming with joy or roaring with fury, was Cézanne. He, Zola, ever conscious of his mother's financial difficulties, was more sensible, even criticizing the older boy for being spendthrift, which provoked a comically aggressive response from Cézanne: "If I die tonight, you wouldn't want my parents to inherit, would you?"[4] he growled, thereby reducing his level-headed friend to silence.

So Zola learned to look—and to look with a painter's eye—at a young age. As F. W. J. Hemmings points out in

his biography of Zola,[5] the description of a house in Balzac's work always steers us toward imagining its occupant, whereas Zola paints a picture of the house itself. One could also say that when Balzac refers to the ocean, as he does in *Father Goriot* (*Le Père Goriot*), it is to imagine the mysteries of the deep and their potential riches: "But Paris is truly an ocean. Try sounding it, you will never know its depth...you can always find virgin areas of it."[6] And he grants his hero, the young Rastignac, fifteen months to "fish for fortune" there. For Zola, on the other hand, the ocean is primarily a color, a vast expanse of blue. In *The Kill* (*La curée*), Paris looks like an ocean to Aristide Saccard and his first wife because they see the higher ground of Montmartre as "an ocean of houses with bluish roofs like hurrying waves filling the vast horizon."[7] It is in comparison with Balzac that we can gauge the visual power of Zola's imagination. Zola is carried away by the image, Balzac by the mystery.

Zola left Aix at eighteen when he moved to Paris with his mother. He maintained close contact with Cézanne and Baille, and the friends' letters were as free as conversations, sometimes in verse—they liked to dash off pastiches of Musset, whom they greatly admired—sometimes in prose, occasionally in Latin. Cézanne, as we have seen, illustrated his, and they are especially entertaining. Zola put great store by his friendships, "in order to form an association...a powerful, tightly packed bundle for the future, to give each other mutual support, whatever lies in store for us."[8] In the meantime, life in Paris was not easy. Zola was not a good pupil and failed his *baccalauréat* (because of his French!). His friend Paul Alexis remembered how the examination process went:

The science section: superb! Physics and chemistry, natural history: very good! Pure mathematics, algebra and trigonometry: good! Nothing but straight A's! There is already no doubt these examinations are a success. It is only a matter of which grade. Zola winks at a classmate, who gets up, leaves the examination hall, and runs to tell the boy's mother it is a triumph. Finally, he comes to the last teacher, responsible for interviewing him about living languages and literature.

"Now then! A little history first," says the examiner. "...Tell me, sir, in what year did Charlemagne die?"

Clearly distressed, Zola hesitated and eventually stammered a date. He was only five hundred years out. He had Charlemagne dying in the reign of François I.

"'Let's move on to literature,' the teacher said tartly." And Zola was failed.[9]

He then had to resign himself to earning a living working as a customs official: "Since I have been in Paris, I have not had a moment's happiness," he wrote to Cézanne on February 9, 1860.[10] The next two years were indeed miserable, dull, and discouraging.

In the end Zola boldly changed tack. He resigned and found work in a brand-new advertising department set up by Louis Hachette, who was not only a bookseller but also an editor and book distributor. Here he learned the ways of modern publishing and established professional connections with some of the most remarkable writers of his day, including François Guizot, a historian, highly regarded philosopher, and former minister to Louis-Philippe; Alphonse de Lamartine, the poet and politician; Jules Michelet, author of a monumental history of France

in sixteen volumes and a no less exhaustive history of the Revolution; and finally Ernest Renan, a historian of religion whose *Life of Jesus* (*La vie de Jésus*) caused a scandal because he cast a critical eye over his subject. Zola was responsible for sending out press releases about new works by these writers, and he made it his duty to visit them beforehand, thereby compiling a useful address book. Two years later he launched himself into journalism, essentially as an art critic. The name of his first article, "Mes haines" (My Hatreds), is enough to give an idea of his verve and acute ear for publicity.

At twenty-five, Zola wanted to be a writer and saw himself as one, but it was his taste in art that set him apart and gave him his own place in the artistic avant-garde of the day. Cézanne, who soon joined him in Paris, spurred him on, guided him, and introduced him to the group of young artists who would breathe new life into painting in France. First he presented him to Pissarro, whom he had met at the Atelier Suisse (Swiss Studio), nicknamed "the sanctuary of art and carousing."[11] This institution was neither a school nor Swiss but simply a large studio directed by Charles Suisse (commonly known as le Père Suisse), a former model of David's. For a modest sum, painters and illustrators could use the services of a live model and work in complete freedom, and this may be what fostered the studio's often turbulent atmosphere. Cézanne was quickly drawn to other artists such as Renoir; Daubigny, who became a critically acclaimed landscapist; Bazille, a very talented painter who enlisted during the Franco-Prussian war and was killed in action; and finally Guillemet. Guillemet was an ardent revolutionary in his youth, and in 1866 he

wrote in a letter to a friend: "We are painting on a volcano, the '93* of painting will sound its grim knell, the Louvre will burn, museums and antiques will disappear...to arms, we must feverishly grasp the dagger of insurrection, we must demolish and build! Courage, brothers. We must close ranks, we are too few not to fight the common cause—we are being thrown out the door. We shall slam the door in their faces."[12] This frenzy appealed to Zola, and the two men became close friends. Guillemet certainly calmed down with age, but their friendship lasted. Guillemet had a fine career as a landscape artist and was always respected by his colleagues. He was closely associated with Manet, having posed for him behind the two women in *The Balcony*, and it was Manet who introduced him first to Cézanne and then to Zola. Guillemet remained Zola's most faithful friend, providing him with a wealth of detail for *The Masterpiece* (*L'œuvre*) and giving him inspiration for the raging tirades of the novel's revolutionary artist, Gagnière.

Zola's apprenticeship in Parisian life thus took place among artists, painters, and sculptors in an ambience of warm friendship. "I mingled with a whole group of young artists, Fantin-Latour, Degas, Renoir, Guillemet, and still others, whom life has dispersed, scattering them at various levels of success...Yesterday I went to the 1866 Salon with Manet, Monet, and Pissarro, whose paintings had been harshly rejected."[13] Here Zola is referring to the annual exhibition of paintings and sculptures organized by the Académie des Beaux-Arts. The *Cénacle*, the

* '93 alludes to the Reign of Terror, which started in 1793.

intellectuals' club dreamed up by Balzac in *Lost Illusions*, brought together a painter, Joseph Bridau, a writer, Daniel d'Arthez, and a scientist, the doctor Horace Bianchon, while the group that gathered around Zola comprised only one literary figure, himself. "I am surrounded by nothing but painters here," he wrote to the poet Antony Valabrègue, one of his friends in Aix, "I have not a single literary man with whom to talk."[14] It would take Zola much longer to gain access to literary salons and befriend his fellow writers.

For now, though, Zola held get-togethers every Thursday. Even before he achieved a degree of financial comfort, he had taken to inviting the whole pack once a week, and these gatherings were conversation enough for him, because—although they always revolved around painting—he found the discussions and comparisons stimulating. Delacroix, Courbet, and Manet met with their unanimous approval but that did not preclude some animated debates. Zola would write a few years later in *L'œuvre* that each of them was in pursuit of something new. They fought against the musty atmosphere of studios that the sun never reached: "Do you understand, perhaps what is needed is the sun, fresh air, a clear young style of painting [to grasp] things and people as they are in true light."[15]

In fine weather, these young men were keen to escape into the countryside around Paris. In the summer of 1866 the entire group spent several weeks in Bennecourt, a village on the right bank of the Seine, and they whiled away the evenings in heated conversations that went on until midnight. "We smoke pipes while gazing at the moon. We

call each other idiot and cretin for the tiniest difference of opinion."[16] The poets defended Romanticism, and the painters were fervent (*enragés*) realists.[17]

It was at around this time that Zola forsook his first infatuations (particularly with Greuze) and became enthusiastic about the new school of plein air painters who were not yet referred to as the Impressionists. He became a regular at the café Guerbois on the rue des Batignolles, where he would meet Degas, Renoir, Fantin-Latour, and Bazille. Not only did Zola spend time with all these young painters. He also visited them in their studios, watched them work, and, when needed, posed for them.

Fantin-Latour and Bazille each featured him in a group portrait in 1870. He had first posed for Cézanne in 1861, and the sessions were far from uneventful: on one occasion in Paris, Cézanne—frustrated with his work—flew into a temper, ranted, threatened to give it all up and go back to Aix, and eventually hacked through the canvas. Zola calmed him as best he could and took him out for lunch. He knew Cézanne well enough not to be offended by this outburst. "Proving something to Cézanne would be like persuading the towers of Notre-Dame to dance a quadrille...he is made from one solid, immutable lump...Paul may have the genius to *be* a great painter, but he will never have the genius to *become* one. The least obstacle makes him despair."[18] Of course Cézanne never went back to the painting, but Zola would not forget the artist's hopeless, exasperated struggles. He himself also experienced doubts and hesitations but always persevered with his work. Zola never gave up. Cézanne would not paint his friend until 1869; he made him pose sitting

PAUL CÉZANNE *Paul Alexis Reading a Manuscript to Émile Zola* 1870

cross-legged on the ground "like an Arab," as he liked to say, listening to a reading by one of their friends, the novelist Paul Alexis, who was also from Aix.

Zola's eye was now becoming increasingly sharp. He quickly identified the best among contemporary artists, and could well understand that the general public would not warm to them without a period of adaptation. In a letter to the writer Antony Valabrègue (of whom Cézanne would make a handsome portrait), he explained: "Each school has the monstrous conceit of making nature tell lies in accordance with specific rules."[19] And he added: "Our fathers made fun of Courbet and we go into ecstasies about him; we make fun of Manet and our sons will be enthusiastic about him."[20] He needed only to glimpse a Monet to be struck by it and to announce that he did not know M. Monet and had never seen his paintings but felt he was like an old friend; he immediately recognized Pissarro's talent, as he did Jongkind's, Boudin's, and Sisley's. He energetically championed Cézanne when he was spitefully attacked in *Le Figaro*, and his frequent interventions earned him the gratitude of these young painters. Zola's opinion was beginning to matter, and his regular column in *L'Événement* meant he could throw himself into the battle for art. This cheap daily had just been launched by Hippolyte de Villemessant, who already owned *Le Figaro*. Villemessant first entrusted Zola with a regular piece entitled *Livres d'aujourd'hui et de demain* (Books of Today and Tomorrow), then for reports of the Salons, and set his salary at five hundred francs a month. Zola threw himself into his work for

L'Événement with remarkable energy, and Cézanne reminds us how important the newspaper was with a pictorial allusion: he made his own father pose reading *L'Événement.*

Zola was familiar with all the current trends because he had so much behind-the-scenes experience of the profession; he was well aware that, for all these unknown artists, the press wielded considerable power, and he was certainly not lacking in nerve, relentlessly challenging the juries of the Salon exhibitions. "So far, where the artists that Cézanne had introduced to Zola were concerned, the writer was the painters' friend. Now that Zola was the critic of the group, it was the painters who were becoming the writer's friend."[21] The situation had been reversed. The Salon gave young artists their only opportunity to display their work to the public, so it was crucial to be accepted by the jury. The official jury, though, was not made up of the avant-garde but represented the tastes of the established bourgeoisie. They were having trouble enough accepting Delacroix and Corot, and clearly showed antipathy toward Courbet and Millet. Obviously they were not ready to open the door to these slapdash young artists who claimed to be changing the face of painting. The jury's decisions provoked appalling rows every year, and of course their job was not easy: judging thousands of paintings in the space of a few days was arduous—Zola gives a detailed description of the process in *L'œuvre*—but the "officials" were incontrovertibly hostile toward modern painting, and this prejudice justified Zola's course of action. Citing the fact that, despairing after one of his canvases was rejected, a painter had committed suicide, he commenced his campaign against the jury.

His first articles, signed "Claude," were unusually aggressive: "It is of course understood that the Salon is not an exhaustive and complete representation of French art in the year of our Lord 1866, but it is most definitely a sort of stew cooked up and simmered away by twenty-eight cooks appointed especially for this delicate task."[22] He had no hesitation in attacking by name the jury members he deemed to be the most blinkered. Letters of protest piled up on the editor's desk at the newspaper. People gathered outside its offices to tear up copies. No matter. Nothing could have better served the young painters' cause than a bit of scandal and a lot of publicity.

In 1866, then, Zola was seen as an influential art critic, and he was held in increasing affection by the painters he admired. And rightly so. Zola's articles had gone a long way "to encourage and bring together these landscapists besotted with light, water, the gleam of foliage, women in colorful dresses, and snow on village roads: the initiators of Impressionism. He had brought their names and their works to the public's attention . . . and his articles had made an essential contribution to the impetus of this new movement in painting."[23] Zola did not defend only his friends. The most striking text of his career as a critic is the superb column he devoted to his admiration for Manet at a time when they had not yet met.

"I am so sure that M. Manet will be one of the masters of tomorrow that I would believe I was making a sound investment, if I had the money, were I to buy all his paintings today. In ten years' time they would sell for fifteen or twenty times the price . . . M. Manet has a place marked out for him at the Louvre, like M. Courbet,"[24] he announced

in one column. Manet wrote to thank him that very day, and suggested they should meet. They got along so well that two years later, there was a remarkable exchange of favors: Zola dedicated his novel *Madeleine Férat* to the painter, and Manet painted a magnificent portrait of the writer. Zola is depicted leaning on a table on which Manet has prominently placed his article printed in a slim, blue, bound pamphlet. On the wall hangs a recognizable reproduction of *Olympia*, the painting that provoked a fervid scandal at the 1865 Salon but that Zola considered Manet's masterpiece.

As if to illustrate the complex inspirations that influence an artist, Zola described this same painting in a few lines in *Thérèse Raquin*, the story of a crime. A young man has to go and identify a friend's body at the morgue and is spellbound by the corpse of a twenty-year-old girl, "a heavy, sturdy working-class girl who seemed to be sleeping on the stone slab; her fresh, plump body gleamed white through the most delicate of soft hues; she wore a half smile, her head gently inclined, and offered up her breasts provocatively; she would have looked like a languishing courtesan were it not for the black line around her neck creating a necklace of shadow."[25] The black line, probably evidence of strangulation, clearly evokes the black velvet ribbon around Olympia's neck. Another detail common to the painting and the novel and charged with symbolic importance is the cat (which, according to Mallarmé, highlights how much Manet was influenced by Baudelaire). In the painting this black cat stands aggressively with its tail held high, and in the novel it becomes Thérèse's pet cat, François. As soon as the lover arrives in Thérèse's household, the cat

EDOUARD MANET *Portrait of Émile Zola* 1868

EDOUARD MANET *Olympia* 1863

undergoes a transformation: "with his coat standing on end and his legs stiffened, [he] maintained a warlike pose; his claws out, his back raised in mute irritation, he followed his enemy's every move with spectacular composure. Solemn and motionless, he watched the lovers with his great round eyes. He seemed to be studying them attentively, unblinking, lost in a sort of diabolical swoon."[26]

Over the next few years, the intimate familiarity between the writer's work and this group of painters continued to translate into obvious reciprocal borrowings. Zola's themes owe a great deal to his painter friends: the waterside cafés, the crowds on the boulevards, the obsession with the river Seine. Nana's comings and goings are a case in point: Manet owed the title and subject of his painting to Zola, who first introduced Nana in *The Drinking Den* as a depraved young girl determined to live by her looks. Then in 1877 Manet imagined her grown into a Parisian *cocotte*, a teasing, ironic, and—for now—triumphant figure. Zola picked up the story again and finished it three years later. In a letter to Degas, Zola openly admitted that his description of working women in *The Drinking Den* was inspired by Degas's paintings.[27] It would also be perfectly reasonable to suggest that twenty years after seeing Manet's *Line in Front of the Butcher Shop*, Zola remembered it in *The Debacle* (*La débâcle*) when he referred to "those grueling sieges, those poor women shivering in rain showers, with their feet in icy mud."[28] Contemporary critics had already spotted the rapprochement between these artists but did not necessarily congratulate them on it.

On January 23, 1868, Louis Ullbach, a journalist writing for *Le Figaro* under the name Ferragus, attacked Zola

EDOUARD MANET *Nana* 1877

violently in an article entitled "La littérature putride" (Putrid Literature): "My curiosity recently glided into a puddle of dirt and blood called *Thérèse Raquin*, whose author, Mr. Zola, passes for a talented young man. At least I know he aspires strenuously to make a name for himself. With his enthusiasm for crudeness, he has already published *Claude's Confession* (*La confession de Claude*), about the idyll of a student and a prostitute; he sees women as Mr. Manet paints them, mud-colored with rosy makeup…the monotony of the sordid is the very worst sort."[29] Zola took no offense: he knew this was the best form of recognition. And Ullbach went on to say that, consciously or not, the writer had been influenced by his painter friends, particularly for an outing to the country. "Zola's image is put together like a painter's: Thérèse is in the foreground, at the balustrade; and visible below her is the quayside with its open-air cafés, its archways, the stalls, the crowds, the Parisians out to have fun on a Sunday. There is one difference, though. This is not the glowing carefree crowd of Renoir's *Boating Party*."[30] In this first major novel, Zola already demonstrated his obsession with the downward spiral from desire to depravity and death. And the great historian of Impressionism, John Rewald, accurately points out that—despite her dark eyes and fine lips—Thérèse Raquin does not remind us so much of the proud, shameless Olympia as of Cézanne's strange painting "in which a naked woman, her hair hanging in the air, is cast to the ground, suffering the ferocity of the man strangling her."*[31] At about this time Cézanne displayed a

* The painting, *La femme étranglée*, hangs in the Musée d'Orsay.

similar taste for violent and erotic subjects drawn from the same brutal, colorful imagination as his friend Zola.

In 1866, after publishing *Stories for Ninon* (*Les contes à Ninon*) and *Claude's Confession* (dedicated respectively to his old friends, Cézanne and Baille), Zola was sufficiently confident to resign from Hachette and live from his writing. His first great success, *Thérèse Raquin*, vindicated the decision. But his literary preoccupations were still closely associated with the paintings he discovered. It is worth remembering here that the Goncourt brothers accused Zola more than once of plagiarizing their novel *Manette Salomon*, which revolved around a painter, but they themselves completely ignored Impressionism. Bazille, Pissarro, Sisley, and Berthe Morisot are not mentioned in their *Journal*. Monet and Renoir are referred to only in passing. "With Manet and painters who followed him," they wrote, "came the death of oil painting, that is to say painting with a pretty, amber-lit, crystallized transparency, typified by Rubens's *Woman in a Straw Hat*. Now we have opaque painting, matt painting, chalky painting, painting with all the characteristics of glue-size art. And everyone paints like that nowadays, from the greats down to the lowliest pupil of Impressionism."[32] This contemptuous view of contemporary painting was not one Zola came close to sharing. Quite the opposite, he deliberately strove to write with light, exactly as his friends painted.

5 The Writer as a Painter

"I have not only supported the Impressionists, I have translated them into literature,"[1] Zola declared, thereby recognizing his debt to painters. There is no denying the influence they had on his style, and on the way he saw and described things. Balzac liked to say that only a painter could render the truth of a place or of a person's appearance. Convinced of this maxim's validity, Zola aspired to appropriate a number of pictorial techniques.

And so he became the first landscapist writer. He would not be the last: the descriptions of the ocean, trees, and flowers in Maupassant or Huysmans are like paintings, and Proust would prove a master of this art. But Zola remains the first to have made light so predominantly important in his writing. In his view, whether a scene took place out of doors or inside, the way in which it was lit was crucial. Even a session of the Chamber of Deputies opens with a precise description of the light falling from a bay window, the gray light of a rainy May afternoon that suited "the pompous austerity of the room."[2] The use of natural light was the very definition of new painting. "Our young artists of today have taken another step toward truth by wanting their subjects to be bathed in real sunlight and not the false light of a studio."[3] Monet, the first of them,

manipulated light like a virtuoso in his impressions, and it is hard not to be reminded of his paintings when reading the description in *The Masterpiece* of the effect produced by the artworks hanging in the Salon des Refusés:* "What a lovely overall tone, what a blast of light is delivered, a fine, diffuse, silver-gray light brightened by all the dancing reflections in the open air."[4]

One of the most striking examples of how crucially important light was to Zola is the opening of *The Belly of Paris* (*Le ventre de Paris*), his novel about the Paris central market, Les Halles: the reader is led entirely by the sunrise. The novel begins in darkness, with vegetable growers making their way toward Paris in the dead of night, their carts laden with produce. Along the way the horse belonging to a tradeswoman, Madame François, almost trips over a shapeless black lump. Unable to see anything by the light of the small square lantern hanging on her cart, Madame François jumps down; she can just about make out a man lying there, and, with a surge of generosity, gets him to climb into her vehicle. The man, Florent, is an escapee from the penal colony in Cayenne, and is hoping to hide in the anonymity of Paris. They trundle slowly toward the great city as it gradually appears out of the darkness. To depict the effect, Zola used a technique borrowed from the Impressionists, creating something like a tracking shot in film. He said of one of Manet's paintings, "At first the eye picks out only large daubs of color. Soon objects emerge and take up their places, and after a few seconds

* An art exhibition first held in 1863 in Paris by command of Napoleon III for those artists whose works had been refused by the jury of the official Salon.

the entire image appears robust and solid."[5] He uses the same process in his novel when Florent arrives at first light and—feverish, starving, and reeling—does not immediately recognize the city:

> When he turned into the wide central street, he thought of some foreign city...arranged in its entirety inside a hangar on a rainy day, as a gigantic practical joke. The shadows... multiplied the forest of pillars...and heading off into the depths of darkness lay a whole world of vegetation, a whole world of blooms, a monstrous display of metal...when the sun was truly up at last the great expanse of the market emerged from the shadows, emerged from the dream...It solidified into a greenish gray, more enormous still with its prolific masts supporting the endless swags of its roofs.[6]

With the clear light of day, the story can begin, and it does so with a very extensive description of the markets. Florent is completely lost in the capital, which has been transformed by the Second Empire's building initiatives, and he lets Madame François entrust him to a local, a painter, Claude Lantier, who sees the market primarily as a series of virtual canvases comprising stalls of fruit, vegetables, and flowers exploding with color. At the sight of this sea of vegetables lit by the rising sun, Lantier gives free rein to his enthusiasm:

> a river of greenery created by bunches of spinach, bunches of sorrel, bouquets of artichokes, piles of green beans and peas, heaps of romaine lettuces, tied with straw and singing the whole range of green,...a sustained range that dwindled

all the way to the motley hues of heads of celery and bundles of leeks…The mouth of the rue Rambuteau was blocked by a barrage of orange pumpkins, in two rows, spreading wide, expanding their stomachs. And the bronzed varnish of a basket of onions, the blood red of a pile of tomatoes, the yellowish self-effacement of a batch of cucumbers, the dark purple of a clutch of eggplants would light up here and there, while rows of black radishes arranged in funereal layers left a last few shadowy gaps among the vibrant joys of morning.[7]

Close by, the bouquets offered by a young florist named Cadine seem to reflect the feral qualities of this child who survives in the marketplace. On her stall "reds dominated, intercut with violent shades, blues, yellows, violets, with barbaric charm."[8] Describing these flowers was a way of suggesting the little salesgirl's character.

Zola used a similar technique but with different effects depending on his subject. In *The Ladies' Paradise* (*Au bonheur des dames*), the novel about a ladies' clothing store, he plays on seductively subtle colors and soft fabrics: customers are charmed by "a display of silks, satins, and velvets, [that] in a supple vibrant array blossomed into the most delicate floral hues: at the top, the velvets in deep black, in curdled milk white; below them the satins, their pinks, their blues, their bright folds fading to infinitely gentle pale tones."[9] And the painter in Zola is careful to specify the source of light streaming "from electric lamps whose opaquely white globes…shed a blindingly steady, whitish clarity spreading like the reverberation of a faded star killing the twilight. And in this new lighting, this colossal profusion of white seemed to burn too, to turn into light.

A white glow leaped off the linens and calicos...like the empty stripe that whitens the sky, the first glow, over in the east."[10] A problem specific to writers, who have far less freedom than painters in this respect, is the risk of repetition: how many times could the words "white" or "whitish" be used? Zola did not care. In fact, it is precisely this accumulation, this profusion of white and whitish and whitening that allows him to create a dazzlingly intense light: "there was now nothing beside this blinding feeling, the white of a light into which all the whites melted, a shower of stars snowing through that white clarity."[11]

It is not only the focus on color and lighting that make Zola a writer-painter but also the artistry of his composition. The department store's display of sunshades is an opportunity for a bravura performance:

All of them open, rounded as shields, covered the entrance hall from the bay window at the ceiling to the picture rail in varnished oak. Around the arches supporting the upper floors they formed festoons; down the length of the columns they fell in garlands, on the balustrades of the galleries...they ran in serried ranks; and everywhere, in their symmetrical arrangements, splashing the walls with red, green, and yellow, they looked like Venetian lanterns lit for some great celebration...while overhead, huge Japanese parasols featuring gold-colored cranes flying through purple skies, blazed and glowed like a fire.[12]

Here we have gone beyond realism to achieve an art form, with contributions from a painter's eye and a writer's virtuosity. The inclusion of Japanese curios, which were

such a novelty and figured prominently in the paintings of Manet, Monet, Degas, Mary Cassatt, and Van Gogh, completes the effect.

Zola continues to use his painterly technique when he moves out of doors. In nature, white is associated with snow, and by the light of a winter sun, a light "that flows limpid and cold as spring water," the sky veers toward a white devoid of any heat and becomes "a very pale, wan blue, scarcely a suggestion of blue in the whiteness of the sun."[13]

A taste for urban modernity unites Zola and his painter friends to the point that some passages in his novels read like descriptions of Impressionist paintings; Zola's work fully assimilated the atmosphere of gaiety and the glory of modern life so frequently illustrated by these young painters who were in love with Paris and its brand-new boulevards. "Everything blazed, the new foliage on the trees, the fountains in the pools springing up and wafting away like gold dust. They watched Paris go by as if through a divine light, the carriages with their wheels shimmering like stars, the great yellow omnibuses more golden than triumphant chariots..."[14] He joined Renoir, Monet, Pissarro, and Sisley in their radiant vision of the Paris streets.

But Zola was not interested merely in describing the city: he wanted to find a point of view, exactly as a painter would, before starting a landscape. Zola adopted this technique particularly for his Parisian panoramas, and he was the most methodical of writers. A large file of preparatory work under the title "Paris pour *L'œuvre*"(Paris for *The Masterpiece*) runs to over fifty pages. In the course of long walks in April and May 1885, he identified all the ref-

erence points provided by the capital's bridges and monuments, the position of the sun depending on the time of day, and variations caused by the weather. He also worked systematically for another Parisian novel, *A Page of Love* (*Une page d'amour*), in which the scenery assumes considerable importance. He obtained a panoramic photograph taken from the towers of Saint-Gervais facing west, and another from the Arc de Triomphe facing east. He was clearly interested in the layout of the major landmarks around the gap made by the Seine. What is even more interesting is that, when it suited his own ends, Zola abandoned the constraints imposed on a realist writer: he needed a reference point in the vast panorama of Paris in 1853–54 (when his novel was set), and showed no hesitation in featuring both the church of Saint-Augustin, which was built between 1860 and 1871, and "the huge bulk" of the Opéra, erected between 1862 and 1875. In response to critics of these anachronisms, he said he needed to balance the weight of his canvas to "break up the uniform plain of different neighborhoods." A true painter's response. "I admit my sin, you may have my head. When in April 1877 I climbed to the heights of Passy to make my notes... I was very put out to find not a single landmark to the north to help me anchor my descriptions. Only the new Opera House and Saint-Augustin church appeared above the jumbled sea of chimneys. I fought first to be faithful to the dates, but those looming shapes were too tempting, lit up against the sky, making my job easier with their tall silhouettes personifying a whole corner of Paris devoid of other edifices, and I capitulated..."[15] There is more: having been sensitized by Monet to the importance of light

and, therefore, the time of day and the weather, in this same novel Zola gives five big descriptions of the same view of Paris at different times of day and in different seasons. He was criticized for it but he defended himself:

> All they see in it is a wearyingly repetitive artist's conceit, a difficulty overcome to demonstrate a skilled hand. I may have been wrong, and I must have been wrong, since no one understood; but the truth is that I always had good intentions...It was a bad idea because it found no one to understand or defend it. Perhaps also the strictures within which I created the effect were too narrow and symmetrical. I needed an intimate drama, three or four individuals in a small bedroom, and then the vast city on the horizon, ever present, watching their terrifying torment with its eyes of stone.[16]

In fact, his painter friends, particularly Cézanne, admired and perfectly understood his intentions, as we can see from this letter Cézanne wrote to thank Zola for the book: "The way the places are painted infuses them with the passions affecting the characters, and this makes them more at one with the key players and less dispassionate overall. They seem, so to speak, animated, participating in the suffering of the living."[17]

This comment is very accurate. The subject of the novel is the disintegrating relationship between a young widow, Hélène, and her daughter, Jeanne, following the intrusion of a young man with whom Hélène falls in love. The first description of Paris comes at the end of the book's opening section, at a time when mother and daughter are extremely close and Paris is spread before them: "on

a glorious morning…yellow with sunlight [like] a field of ripe wheat…Paris gleamed as if under crystal…in dazzling motionless serenity."[18] The second view relates to the period when the mother's attention is no longer entirely focused on her daughter. She is dogged by thoughts of the man, and this unsettles the relationship between her and her child. When the two of them look out at the city in the evening, the light has changed: "The shadow from the dome of Les Invalides drowned the whole Saint-Germain neighborhood, while the Opera House, the tower of Saint-Jacques, the pillars and spires, drew a series of black stripes on the right bank…and the sky plumped its purple layers over the reddening city…Then a gray ash seemed to fall, and neighborhoods were left standing, flimsy and blackened like dead embers."[19]

Hélène's passion grows more violent, and when she looks at Paris by night she is aware of the great dark gaps, the ribbons of shadow stretching between lighted windows and the busy pattern of gas lamps. Eventually the moon comes up: "It looked like the red breath from a furnace. At first it was just a pallor in the darkness, a barely distinguishable glimmer. Then, gradually, as the evening wore on, it turned to blood; and hanging in the air, motionless over Paris, made up of all the flames and rumbling life exhaled by the city, it was like one of those clouds full of fire and thunder that crown volcanoes."[20] There is an intimation of tragedy.

Jeanne is increasingly jealous, and one evening when Hélène has joined her lover and left her child alone, Jeanne feels betrayed. She is staring fixedly at the window, waiting for her mother's return, when a storm breaks. The

city goes black, the wind howls, and "the ocean of roof-tops, now disturbed, seemed to swell in waves and...it was chaos. Enormous clouds, spreading like splashes of ink [and beneath the sound of the rain] a continuous rumbling grew louder, the voice of swollen streams, the thunder of water spilling into the sewers...and, as if destroyed and now dead after one last overriding convulsion, the vast city sprawled its expanses of upturned stones beneath the retreating sky."[21] The child, who stays by the window, catches a chill and dies; the mother never sees her lover again and settles for a marriage of convenience. The last view of Paris is from the cemetery where little Jeanne is buried. It is winter, the city is under snow, and "through this motionless sea of ice, the river Seine trundled muddied waters between banks that edged it with ermine."[22]

There are similar parallels between the description of a landscape and a character's psychological state in *Abbé Mouret's Transgression* (*La faute de l'Abbé Mouret*), written ten years earlier. This is the story of Serge Mouret, a young priest who has become a neutered creature thanks to the church's law of chastity. After suffering a bout of brain fever, he wakes to find himself surrounded by a luxuriant natural world, and at his side is the beautiful young Albine, who nurses him and allows him to rediscover his virility. But, back in the clutches of the priesthood, he is reduced to impotence once more.

His awakening sensuality is evoked first by the sky seen from his window. "It was not all blue, but some pink blue, some lilac blue, some yellow blue, a living flesh, a vast immaculate nakedness breathing so that it rose and fell like a woman's breast."[23] When he regains his strength he ven-

tures into the grounds, the "Paradou," around the house where Albine watches over his convalescence. His is so weakened and so innocent that he is unaware of Albine's charms. But nature will teach him.

On one of their walks, Serge and Albine go into a wood which feels enchanted with its "clusters of tall rambling roses rearing up from huge bush roses, where some shadowy corners offered alcoves for sweet contemplation, the smell of love, the warmth of a rapturous bouquet on a woman's breast...The roses were full of nests singing." The description of the roses becomes increasingly erotic: "The tea roses grew adorably moist, displaying hidden modesties, parts of the body that are not shown...the different roses had their own way of loving. Some consented only partly to open their buds...while others, their corsets unlaced, panting, wide open, looked crumpled, so delirious about their own bodies they might die of them."[24] Water springs are also eroticized, reaching out "arms whose whiteness spoke of purity [vital] as a child's playful nakedness; they fell in sheer waterfalls whose lazy curves seemed to arch back a woman's body with its fair skin. Lastly, beneath these heavy shadows the heat seemed to slumber voluptuously. The air slept, with not a breath of wind, in that moist alcove. An oriental love perfume, the perfume on the Shulamite's painted lips, was exhaled by those fragrant woods. [And at last] succumbing to the garden's entreaties, Albine gave herself. Serge possessed her."[25] The relationship between the natural world and the character's feelings is described here with astonishing and slightly excessive enthusiasm. This is Zola at his most heavy-handed. Still, there is no denying that his evocation

of this magic garden with its outrageous flowers demonstrates dazzling and very effective virtuosity. In this novel about nature, Zola proves both fanciful and accurate, but mostly—particularly in the very luminous, sun-filled sequences—he manages to suppress outlines and blur shapes exactly as some Impressionist paintings do.

Another example that displays Zola's techniques is the Île de la Cité in Paris, the subject of Claude's obsession in *The Masterpiece*: it is also depicted at different times of day in different weather and in different seasons. "In a late fall of snow, he saw it lined with ermine, above the mud-colored water, standing out against a pale slate sky. He saw it in the first sunny days, wiping off the winter...one day in a thin fog...quivering like a palace from a dream...at still other times, when the sun broke up into dust in the mist above the Seine, the island swam through the depths of that diffuse, shadowless light, lit evenly in every direction, charmingly delicate as a jewel fashioned of fine gold."[26] Zola is of course equally capable of painting a picture with a precision reminiscent of the Florentine *disegno*: in *The Belly of Paris*, Florent delights in the "beautiful sunsets that traced the fine lacework of Les Halles in black against the glowing reds of the sky...like a luminous frosted piece of openwork with every detail etched out, the thin fluting on the pillars, the elegant curves of the framework, and the geometric shapes of the roofs. He filled his eyes with this huge sketch color-washed with India ink."[27] Passages like this mean Zola cannot be considered a pure Impressionist, and interestingly, his fictitious painter, Claude, is not one either. Zola would say of him, "Naturally I have made him a naturalist,"[28] in other words a painter committed to

vigorous compositions, one who admired Ingres and was very conscious of beauty and the importance of the lines in his compositions.

Something else Zola borrowed from his artist friends, and especially from Degas, was his use of an unexpected angle which caught his attention and transformed the appearance of the monuments and streets he observed. In the opening sequence of *Money* (*L'argent*), the financier Saccard opens a window on the top floor of a house on the rue Feydeau and, spotting the Stock Exchange from so high up, exclaims that he is seeing it

> from such an unusual angle, in bird's eye view, with the four huge sloping zinc surfaces of its roof looking extraordinarily detailed, bristling with a forest of pipes. The lightning rods' spikes stood tall like gigantic lances threatening the sky. And the building itself was nothing more than a cube of stone, striped at regular intervals by its columns, an ugly, naked, dirty, gray cube with a ragged flag planted on it. But he was most struck by the steps and the peristyle, dotted with black ants, a whole anthill undergoing a revolution, fussing and moving about so much that, from this height, it was difficult to understand, and prompted pity.[29]

There is another impression of Paris, this time from the top of Montmartre, a Paris seen at nightfall, that could easily have been conceived by Monet: "It was in the fall; the city was languishing under a great gray sky, a soft and gentle gray, dotted here and there with dark greenery like large water lily leaves swimming on a lake."[30] Zola again chose a raised vantage point for the opening of *The Human*

Beast (*La bête humaine*). The first pages of the novel give a description of Saint-Lazare station from a fifth-floor window on a "mid-February day with gray skies, a warm damp gray shot through with sunlight...In the hazy coming and going of rail trucks and engines clogging the tracks, a big red signal light stained the pale daylight."[31] A stain that would have delighted Turner.

In *The Belly of Paris*, the buildings of Les Halles viewed at an angle look almost phantasmagorical: "they could have been mistaken for the facades of houses and palaces superimposed onto each other, a Babylon of metal, Indian in their delicacy, cut through with hanging terraces, aerial walkways, flying bridges launched into space."[32] And Notre-Dame cathedral, seen from the apse, is transformed into a fantastical creature, something "colossal, crouching between its buttresses, like resting paws, dominated by the twin heads of its towers, above its long, monster's spine."[33] In Mallarmé's words, the Impressionists had "an abstract, virgin eye."[34] Many Zola characters are given this same eye, this fresh viewpoint. The ability to see like this, setting aside what has been learned and forgetting the rules of perspective, is as important for a writer as for a painter. Klee's axiom could be applied to both: Art does not reproduce the visible, rather it makes visible.

Finally, it is also worth noting that Zola shared the artists' fascination with mirrors, instruments that have always been put to wonderful use by painters, and particularly by the Impressionists. Degas covered the walls of his ballet scenes with them, and used them extensively for his milli-

ner's shops. Manet doubled the size of his *Bar at the Folies-Bergère* thanks to a background made entirely of mirrors; Renoir put them in theater boxes, as did Mary Cassatt. Zola did the same thing—in a less elegant setting—when he used multiple mirrors and reflections in the pork butcher's shop in *The Belly of Paris*, and this profusion of mirrors meant that "doors seemed to open into other halls, ad infinitum, all filled with displays of meat";[35] or in *The Ladies' Paradise*, where "mirrors everywhere pushed back the shop floor, reflected the shelving along with snatches of the general public, faces tipped back, half shoulders and arms," but here he added a factor that Degas particularly liked: the splintering of images. Degas often placed a person partly outside the frame of his painting, or fragmented a figure by masking it with an object, usually a mirror.

Moreover, mirrors play an almost active role in many of Zola's novels. In *A Page of Love*, a mirror manages to make Hélène's own reflection and the reflection of the man she is drawn to seem unreal, and thereby gives her the freedom to abandon herself to him: "Henri had taken the fur coat, was holding it wide to help Hélène. When she had slipped both her arms into it, he turned up the collar, smiling as he dressed her before a huge mirror that covered one wall of the anteroom. They were alone and could see themselves in the looking glass. And then all of a sudden, without turning around, wrapped up in her fur, she dropped backward into his arms...He clasped her fiercely, kissed her neck. And she tipped her head back to return his kiss."[36] In *Nana*, the mirror's role is not to drive the narrative forward but to capture the courtesan's narcissism in one of the novel's most suggestive scenes. "One of Nana's pleasures

was to undress before her glass-fronted wardrobe, where she could see herself full length. She dropped everything down to her chemise; then, quite naked, she would forget herself and contemplate herself at great length...absorbed in her love of herself."[37] This narcissism is emphasized by the fact that her lover, Comte Muffat, is behind her and is also looking at her, but he does not appear in the mirror. He is the invisible spectator. As far as she is concerned, he does not matter, and when he throws her to the floor to take her, he never actually possesses her.

Renée, the heroine of *The Kill*, is not a courtesan, but morals are not her strong point. She is married to the financier Saccard but sleeps with her stepson, Maxime, although this affair affords her only fear and torment. Of course the young man will leave her to marry. She has run up debts and finds herself at the mercy of her pitiless husband. Renée has always liked looking at herself in her mirror, and checking her image in order to calm "the doubts felt by the most feted actresses, to see whether she really was as gorgeous as people said."[38] Her mirror has always been her friend until the day she finds the performance is over. She looks at herself out of habit and does not recognize herself in the "strange woman she saw before her. Madness beckoned." There follows an astonishing scene in which her reflection induces full-blown hallucinations that feed on childhood memories, mingling with images of her husband, of Maxime, and of her own physical disintegration, and the mirror eventually drives her to her death. "...she looked at herself again, studied herself closely. She was finished. She saw herself dead."[39] This is of course a far cry from Impressionist mirrors, but it is not

implausible to suggest Zola might have remembered *vanitas* images, which were very current in the seventeenth century and which he could have seen at the Louvre; or he may have thought of Memling's *Triptych of Earthly Vanity and Divine Salvation*, which he had admired at the Strasbourg Museum.

We have seen Balzac often admitting that a painter would be better able than he to describe a scene. When Zola finished his long *Rougon-Macquart* series with the novel featuring Docteur Pascal's great love for his niece Clotilde, he took up the notion and chose a pictorial comparison to describe the rural settings where the two lovers go for walks: the fields "were like old landscapes, classical landscapes like those in paintings from old schools, with hard colors and majestic, balanced lines."[40] As he neared the end of his career as a novelist, Zola seemed to concede how impossible it was to rival a paintbrush with only his pen. He stepped aside to let the painter go first. It is as if he was laying down the arms he had used his whole life. Paradoxically, the painters brought to life in his novels would not be triumphant.

6 Zola's Painters

Zola was a courageous writer who never shied away from controversy. He was always on the side of the protesters, so it is hardly surprising that his painters were not artists loved by the bourgeoisie and the Academy but were instead often poorly adapted to society, and that the best of them were rebellious and impetuous. In an article entitled "Confidences of a Curious Lady" ("Confidences d'une curieuse"), Zola described a group of artists as follows: "A strange procession of men with big beards and wide, felt hats. At first these men looked to me like conspirators; with their darkened brows, furious eyes, and ironic lips, they watched passersby with contained rage and an obvious longing to leap at their throats. Then I realized these men were painters."[1] The most striking thing is not their unusual dress sense but their anger against "the bourgeois," and this is also a characteristic of a number of artists in *The Masterpiece*, Zola's great novel devoted to art.

Already in *Thérèse Raquin*, Zola's first important novel, he created a painter character; a failed one to be sure, but still a painter. To the character of the murderous lover, Laurent, he gave, if not a career as a painter, at least the ambition to become one. But Laurent is too weak and lazy

to be a true artist. He very quickly abandons any hopes of success in this field and resigns himself to earning a living in an office of the Orléans Railway Company. There he befriends a colleague who turns out to be a childhood friend married to the beautiful Thérèse; Laurent inveigles his way into their household and soon into the wife's bed. The lovers decide to dispose of the husband by drowning him. With the crime committed, they marry, but they had not reckoned on their remorse. They are dogged by pallid images of the drowned man, and the obsession with his dead rival, "the terrifying upheaval," transforms Laurent. His mind derailed, he develops a "peculiarly lucid artistic perception"[2] and starts painting again. Much to the surprise of the fellow artists from his former studio, he creates works that are personal, lively, and therefore beautiful. But all his portraits, all his sketches, look the same, whether they are of a man, a woman, or even an animal. All their faces conjure up the man he murdered. And so he stops painting: "His fingers had a fatal, subconscious ability to keep reproducing portraits of [his victim]. He looked at his hand in horror. It felt as if this hand no longer belonged to him." Unable to resist this infernal obsession, the couple ends up committing suicide in front of the murdered man's aphasic old mother, while François the cat, the witness of their couplings, looks on. The whole story is narrated with considerable brutality, and, of course, neurosis plays a more important role in it than artistic creation. And yet the link between madness and the production of a work of art is a subject that had genuine significance for Zola and would reappear in his subsequent novels.

Five years later, Zola created a great painter character,

Claude Lantier, in *The Masterpiece*, the fourteenth volume in the *Rougon-Macquart* series, the story of a family under the Second Empire. Lantier had put in an appearance in a much earlier novel, *The Belly of Paris*, but there he played only a secondary part. Still, he was well realized, and Zola had carefully established him within the *Rougon-Macquart* framework. One of this family's characteristics is a type of madness that resurfaces in different generations, adopting more or less emphatic guises but always characterized by some form of unhealthy obsession. Claude is the son of Gervaise, the laundrywoman of *The Drinking Den*, and therefore Nana's brother, and he does not escape the family curse.

In *The Belly of Paris*,* he is described as generous, enthusiastic, and fascinated by the visual surprises of Paris, but his impatience and a corrosive tendency to criticize his own work are the first manifestations of his destructive perfectionism. What is significant for our purposes is that, from the moment we first meet him, Claude is a very personal artist, a modern painter, enthusiastic about working in the open air. He dresses à la Cézanne, with "a shapeless, reddened black felt hat and a huge jacket which was once soft brown,"[3] and Zola also gives him Cézanne's large head, bushy beard, and pale eyes. When he is not prowling around Les Halles, he can be found at the house of Madame François, the owner of the vegetable stand, painting the leaves of a plum tree, but his abiding passion is the

* The subject of the book is the struggle between the Fat and the Thin. The Fat are selfish, grasping bourgeois and the Thin are the rebels, the innovators, whether in art or politics.

streets of Paris and more specifically the extraordinary still life assembled and dismantled every day by the merchants and farmers who pour their fruits and vegetables into the city's central market. The whole of the first description of the neighborhood comes from this painter thrilled by the play of light, "by the slowly dawning day, in a very soft gray washing everything with watercolor hues";[4] a painter who sees paintings in the most prosaic and unexpected of places, so that "the little [woman] selling freshwater fish looked like a Murillo virgin, all blonde as she was amid her carps and eels,"[5] and the street urchin Marjolin "is gilded as a Rubens with reddish down clinging to his cheeks."[6]

But Claude is a tormented soul: "If I were one of the Fat, I would paint in peace, I would have a handsome studio and would sell my paintings for good money...instead of which I am destroying my constitution." On bad days, he slashes his canvases and regrets his vocation. He could have been happy as a carpenter. "Carpenters are very happy. They have a table to make, don't they? They make it, and then go to bed happy to have finished their table, perfectly satisfied...Whereas I hardly sleep at all at night. All these wretched studies I fail to complete dance around inside my head. I am never finished, never, ever."[7] He is also a man who sees the whole world bathed in art. It is just a question of knowing how to see, which Zola felt was even more important than actually creating. Claude therefore decides to make the window of his aunt's butcher shop into a real still life, and he describes what he claims to be his greatest work with almost comic enthusiasm: "You see I had all those vigorous shades, the red of stuffed tongues,

the yellow of ham knuckles, the blue of paper trimmings, the pink of carved joints, the green of heather fronds, and especially the black of black pudding, a magnificent black I have never managed to re-create on my palette. Of course the cauls, sausages, chitterlings, and breaded pork trotters provided me with the most delicate of grays. So I created a genuine work of art."[8] Unfortunately, his aunt is horrified by this display with its blazing colors, and takes it apart. "These brutes will never understand the language of a splash of red put next to a patch of gray,"[9] Claude concludes ruefully.

The novel, about a failed political conspiracy, does not revolve around this painter, who is interested only in his art, but Claude allowed Zola to introduce into the story aspects of the city and effects of the light that his painter friends had taught him to see. Claude walks about blinking to capture different views, and the reader may well feel Zola did the same. Paris goes on to become so important in Zola's subsequent novels that the city could be considered a character in its own right.

The much later novel, *The Masterpiece* (1885), on the other hand, concentrates entirely on the milieu of artists under the Second Empire. This topic had already been popular for some time. Balzac, as we have seen, devoted several short stories to the artists of his day, and the Goncourt brothers had published *Manette Salomon*, a novel-reportage about studio life, in 1867, to name only the most significant precedents. And this was a subject close to Zola's heart. Hadn't he known the art world for a long time and perhaps better than its literary counterpart? One may well wonder why he waited so long before writing his novel

about art. The explanation lies partly in the chronological strictures of his fictional family, the Rougon-Macquarts. Zola's painter had to take his proper place in the family tree, and therefore had to wait his turn, so to speak, to give the author time to tell the previous generation's story. Furthermore, the true subject of the novel is less an illustration of contemporary artists' lives and more the drama of the excruciating effort of creation. And this drama has to do with maturity, so the artist cannot be a very young man. Zola's friend, the writer Paul Alexis, who was sometimes referred to as his shadow, said of Zola's plans to write a novel about art that he needed only to remember what he had experienced himself and witnessed among their circle of friends. "His central character is all ready; he is the painter besotted with modern beauty whom we glimpsed in *The Belly*...I know he is planning to explore the appalling psychology of artistic impotence."[10]

Zola corroborated this view and explained himself very clearly in *L'ébauche*, his preparatory notebooks:

With Claude Lantier, I want to paint the artist's struggle with nature, the effort that goes into creating a work of art, an effort involving blood and tears, to give it flesh, to give it life; always a battle with what is true, and always defeated, always wrestling with the angel. In a word, I will describe my own private experience of creativity, the constant agonizing labor pains; but I will expand the subject with tragedy, with the fact that Claude is never satisfied, and is exasperated because he fails to deliver his own genius, and ends up killing himself in the face of his unrealized work. He will not be powerless, but a creator with too much ambition, trying to

put all of nature into a painting, and it will be the death of him. I will have him produce a few magnificent but incomplete, ignored pieces that people may laugh at. Then I will give him the dream of many pages filled with huge modern decoration, a fresco that encapsulates the whole era; and that is where he will snap.[11]

Of course the character would evolve and the psychological novel would be filled out, particularly with the introduction of two themes: a woman jealous of the artist's passion and the contrast between a writer's characters and a painter's. The writer, Pierre Sandoz, is both Claude Lantier's double and his opposite—his double in that he too suffers the torments of artistic creation, and his opposite because his unshakable will and his discipline mean he can resolve his self-doubts. The friendship between these two men, who are so alike but also so different, is at least as important a theme as that of the woman. It is worth noting that, unlike Balzac, who created a woman painter character, Zola completely ignores women artists, despite the prominence of Berthe Morisot and Eva Gonzales—both of whom were very close to Manet—and Mary Cassatt, who was given a great deal of support by Degas in her early days. The women in *The Masterpiece* are defined exclusively by their relationships with their male partners.

The Masterpiece is perhaps the most clearly autobiographical of Zola's novels; in his own words it is "the novel in which my memories and my heart overflowed."[12] Sandoz has so many of Zola's traits—his Southern origins, his friendships with painters, his disciplined work habits, the subjects of his books, a peaceful relationship with his

wife, and the absence of children—that it is easy to forget how much of himself Zola also put into Claude.

In a book about Zola published in 1882, with Zola's consent, Paul Alexis mentions the author's plans for this study of the art world and makes the point that "other artists will gravitate ... around the gifted central character ... a group of ambitious young men who have also come to conquer Paris: some will fail, others will more or less succeed; all of them cases of the sickness of art, variations of the great contemporary neurosis. Naturally, Zola will find he is forced to use his friends in this book, to collect their most typical characteristics. If I personally can identify myself in it, I pledge not to take him to court even if I am not flattered."[13]

Zola did not contradict him: how could he? In his preparatory notes, he very frequently used his friends' actual names when referring to fictional characters, but it would be disingenuous to think he would not transform his models during the writing process. Yes, memories of his youth fueled the pages about Claude, Pierre, and their pal Dubuche's teenage years; references to the Provence countryside, the constraints of school, and their passion for poetry ring true. Nevertheless, it would be absurd to reduce this novel to a roman à clef. Zola's ambition goes beyond painting a portrait of his old classmates. He wanted to show both the arduousness of creation and the hostility of most people's reactions to any artistic innovation.

One of the novel's attractions is the very evocative description of studios, whether those of sculptors where "the humidity of a laundry and a bland smell of wet clay [rises] from the floor"[14] or of painters. At the start of the

book, Claude has set up in a studio that no academic painter would want because the sun streams in "like liquid gold." Besides, the place is shockingly dirty, with its "big pine table laden with brushes, paints, dirty plates...chairs losing their stuffing, and rickety easels."[15] This mess reveals its owner's utter indifference to appearances and "his absolute contempt for anything that was not painting." Bongrand, one of the masters of the day, is equally passionate. He lives on the boulevard de Clichy in a huge, "naked, gray studio, decorated only with the master's studies."[16] The one difference between him and Claude is that Bongrand does not live at his place of work, so there are no lingering smells of everyday life, but he likes a Spartan feel and scoffs at "the opulence of hangings and knickknacks with which young painters were beginning to surround themselves." And Zola gives us an example of this in his description of the fashionable painter Fagerolles's studio, "a wonder, without a single painting, entirely covered in Oriental hangings, furnished with a vast divan, the parquet floor piled high with carpets, furs, and cushions." All that remains of his craft is "a small canvas on a black wooden easel, draped in red plush...a rosewood rack for storing pigments, and a box of pastels."[17]

Zola is also very aware of all the makeshift arrangements essential to artists who do not work with an easel. When Claude decides he wants to paint a vast canvas, he needs an extremely large studio. He finds what he is looking for when he stumbles across the drying room of a former dyeing factory, a space fifteen meters by ten. He doesn't want a luxurious setup but buys what is necessary for his project: a ladder on wheels with a platform at the

top and a movable base. Zola goes into detail about his complicated contraptions: there is no question of Claude using an easel because the picture he hopes to produce will be eight meters long by five high, so he needs to invent "a system of beams and ropes" to hold the canvas against the wall. It seems very likely that Zola had witnessed devices of this sort. Similarly, his meticulous description of paintbrushes must owe its origins to his posing sessions and long conversations with Cézanne. Claude "liked them to have a special type of handle, turning his nose up at marten and insisting on oven-dried bristles. And what really mattered was his palette knife, because he used it for the backgrounds, as Courbet did; he had a collection of them, long and flexible, short and sturdy, and, most importantly, a triangular one like those used by glaziers, one he had had made specially, a real Delacroix knife."[18] Zola expands on the manias, and on recipes for obtaining the exact desired density of paint. All these clear, precise details have the feel of an extremely conscientious reportage.

Equally authentic is the depiction of the novel's social and professional background. The group of young painters around Manet kept coming up against the same obstacle: it was impossible to exhibit their work because the Salon juries systematically rejected it. In 1861 one painter sent a "Rejects Petition" to Napoleon III. The emperor's spontaneous reactions were always liberal, and during a visit to the Palais de l'Industrie, the exhibition hall, in April 1863, a week before the Salon opened, he ordered that there should be a Salon des Refusés (Rejects' Salon) so that the public could see works turned down by the jury. The first of these Salons featured Manet's *The Luncheon on the Grass*

EDOUARD MANET *The Luncheon on the Grass (Le Déjeuner sur l'herbe)* 1862–63

(*Le Déjeuner sur l'herbe*), which caused a memorable scandal. All the fuss surrounding the 1863 Salon des Refusés comes to life under Zola's pen: he introduced into the book topics he and Cézanne had discussed after their first visit to the exhibition, and lent his own articles about the Salon to his character Jory, "a poet who had fallen into journalism." We must not forget that the first Impressionists—painters who worked out of doors, liked to deconstruct light, and were refused by the official Salon—were also booed at the Salon des Refusés. The taunts and insults heaped on these painters were also meted out to Zola, whose realism was deemed outrageously shocking. Just like his fictional painter, he had to take consolation "for being disparaged and turned down" by relying "on the equity of centuries to come." And he was using Sandoz as his mouthpiece when he had him say: "Would I have the courage to carry on with my work, would I stand up to the booing were it not for the consoling illusion that I will be loved one day!" To make matters worse, his malicious colleague, Edmond de Goncourt, always scathing about Zola's abilities, declared, "It is a perilous undertaking for a man who is a complete stranger to art, to write an entire book about it."[19] But Goncourt also denied that Manet had any talent: "What a joke, joke, joke, this Manet exhibition is! A mishmash of stunts to make the blood boil. Whether or not you like Courbet, he certainly has a painter's temperament, whereas Manet...is an illustrator."[20]

Zola's descriptions of the art market are not always fully realistic. There are two dealers in *The Masterpiece,* Malgras and Naudet. Malgras is an old-style dealer and could be a Balzac character. (Balzac's dealer, Elie Magus, has greater

stature and ambition, but he too keeps a low profile.) Malgras, "a fat man wrapped in a very dirty, green frock coat which made him look like an untidy coachman...was, under that thick layer of grime, a highly perceptive fellow who had taste and a nose for good painting...he instinctively homed in on creative artists who were still disputed,...he could see they had a great future well before anyone else...Coupled with this, he was a fierce negotiator [but] settled for an honest profit of twenty or thirty percent."[21]

When Malgras retires, he has only a very modest degree of comfort, but it is enough for him. There is nothing discreet, though, about Zola's other dealer, Naudet, "with a gentleman's trappings, his fancy morning coat, the glittering gem on his cravat pin, pomaded, polished, varnished..., living the high life, a broker who was radically unimpressed by good painting...he could tell which artist was worth launching, not the one who promised the debatable genius of a great painter."[22] And that is how he changed the rules of the game: he did not aim to sell to connoisseurs with any taste, just rich gamblers "who bought paintings as they would stocks and shares, out of vanity or in the hope their share price would go up." Naudet artificially raises prices and tumbles into disaster in the end; Zola's depiction of his speculating foreshadowed the dangerous machinations that would turn the art world upside down. Zola was probably thinking of Georges Petit, Durand-Ruel's great rival. All the same, the portrayal seems a little unfair to dealers of his day: Durand-Ruel took considerable financial risks to exhibit the Impressionists, and another dealer, Vollard, supported and encouraged

Cézanne long before he organized a major exhibition of his work.

Zola felt it more important to give his painters psychological nuance than to adhere to an absolute, objective reality. He shows us Claude distraught after a visit from Malgras, even though the dealer buys one of his sketches; and we see Bongrand vehemently refusing to sell to Naudet, saying that it would be paralyzing for him to "have a dealer on his back." That the relationship between an artist and a dealer may be strained, we can readily accept; it seems unlikely, though, that a painter would refuse to sell. But Zola was bound to the truth of his characters, and, like Proust, he could have argued that he frequently did only what they dictated. This is because Zola's imagination took over when he created his characters, although readers struggle to accept that this was the case, preferring to identify Claude with Cézanne lock, stock, and barrel. The question of whom Claude's character was based on gave rise to some hasty and harsh judgments, particularly as Cézanne's own reaction was misinterpreted until the very recent discovery of a number of documents, as we shall see below.

It is true that Claude resembles Cézanne in his facial features, his childhood in Aix, and his lasting friendships first formed as a schoolboy, as well as with respect to personality: his shyness and awkwardness and his affectation of contempt for women. He also has Cézanne's impulsiveness and his unexpected and brutal reactions. Like Cézanne, Claude meets with hostility from the jury and, also like Cézanne, having failed to be unanimously voted in by the judges, he would be a "charity case" imposed on the jury by a friendly fellow painter.

Claude has the same artistic intransigence as Cézanne, who would acknowledge the talents of only Delacroix and Courbet among his elders. Zola makes the point that he sees Claude as coming in the wake of Ingres, Delacroix, and Courbet. He wishes there were more of the natural world, more open air, more light—a very clear style of painting but carried out on vast canvases. Another thing Claude owes to Cézanne, who was—at least in Zola's view—"an aborted painter,"[23] is his ability to make admirable pieces and exquisite sketches. He had a wonderful gift "hampered by sudden unexplained impotence" and by his violent responses to failure. Like Claude, Cézanne slashed paintings he did not like, and Zola managed to stop him doing this on more than one occasion. But Zola felt that this violence—which was a consequence of the "effort of blood and tears" inexorably linked to artistic creation—was common to all true artists, be they painters or writers. In fact, Manet also slashed paintings that disappointed him. In Zola's mind creative work was inextricably linked to continuous doubt and a furious urge to produce, and these feelings appear just as much in Sandoz as they do in Claude and Bongrand. At one point in the book, Sandoz has an outburst during a conversation with Claude; he cries, "Argh! Yes, I work, I drive my books right to the last page...But if you only knew! If I told you about the despair, about the torment that goes with it...and I never read through what I wrote the day before for fear I will think it so appalling that I won't have the strength to keep going."[24] But most of the time Sandoz says very little about his output, and Zola deliberately makes his writer a slightly abstract character. He

is calm and steady, devoted to his mother and married to a peaceful and supportive wife, while Claude's love affair with Christine provides a dramatic backdrop, a subject we will revisit.

Still, there are considerable differences between the supposed model and the fictional character. Claude Lantier is not, like Paul Cézanne, the son of a provincial banker but the child of two alcoholic laborers, Gervaise and Auguste Lantier. An unhoped-for stroke of luck puts Gervaise back in touch with an aging oddball, a bourgeois from her birthplace, Plassans, who has known the family a long time. He shows an appreciation for young Claude's drawing skills, takes him under his protection, and gets him away from his family by sending him to school. When the old man dies, he bequeaths Claude an annual income of one thousand francs to give him a degree of independence. By contrast, Cézanne was financially dependent on his father, a situation made all the more trying because Cézanne senior refused to recognize that his son had any talent or future. Their relationship was so bad that Cézanne never told his father of his long affair with Hortense Fiquet or the birth of their son. It was only when his father died that Cézanne's financial circumstances became easier. Another important difference is that Claude comes across as the leader of a school, more like Manet than Cézanne, and in descriptions of his fictional paintings, we actually see more details from the work of Manet and Monet than from his supposed model. Lastly, his final painting, which will drive him to suicide, is the demented image of a naked woman "made of metals, marbles, and gems, spreading the mystic rose of her sex between the

precious columns of her thighs...the strange nudity of a monstrance in which gemstones seemed to gleam for some religious adoration"[25] standing in a Parisian cityscape; this has nothing in common with Cézanne's style but goes some way to evoking Gustave Moreau, a painter who apparently irritated Zola by displaying "the flights of fancy an artist can be reduced to in pursuit of originality and out of loathing for realism."[26]

When the story begins, Claude lives surrounded by fellow artists, a friendly, stimulating, encouraging environment, but, because of his inflexible nature, one that fails to provide him with all the reassurance that a more balanced man like Sandoz derives from it. Claude repeatedly comes up against the same obstacle: "It was always the same with him, he would exhaust himself in one great surge, a magnificent rush; then he would be unable to produce the rest, he did not know how to finish."[27] All the same, "this kindly camaraderie" galvanizes him, and the painter and the writer support each other in times of despondency. Despite the torments of creativity that they both experience, they are soothed by the "warmth of shared hopes."

Claude and Sandoz are not isolated; they form part of a little group of artists (comprising the sculptor Mahoudeau, the painter Fagerolles, another painter, Gagnière, whose real passion is music, and the journalist Jory) who meet regularly at cafés or at Sandoz's open house every Thursday. All their conversations revolve around art. They are all "brimming with devotion, for now there was nothing separating them, all in the same boat."[28] They are too young to stay shut up indoors all day, and when they cannot escape for a few days in the country, they stride

like conquerors through the city's long streets like "a war party. These young fellows with their fine twenty-year-old's stature, took possession of the streets. Whenever they were together, they were preceded by fanfares."[29]

Zola did not restrict Claude's world to the company of painters. He seems to be surrounded by a whole group of people who accept him as leader. And yet Zola cast a prophetic note even over Claude's vigorous early days when he was so full of promise. During a dinner that brings all these young men together, the great painter of the previous generation, Bongrand, comes through the door.

Bongrand, the grandson of a peasant and son of a very artistic mother, is at the pinnacle of a fine career but has managed to stick to his bohemian tastes and opinions. Zola describes his art as the work of someone who is accurate in his observations but does not confront nature full-on "in the harsh light of day."[30] To illustrate the work of this "moderate and logical romantic,"[31] Zola attributes to him two paintings whose titles evoke Courbet, *A Marriage at Ornans* and *A Village Burial*. His paintings hang in museums, he has been elected as a member of the Institute, and is decorated, but his success does not lead him to abandon his young and more revolutionary friends. And the young adore and admire him. Nevertheless, "despite the hundred paintings that made his name," he suffers: "With each new work, he was a novice, it was enough to make him knock his head against the wall."[32] Bongrand is just as tortured as the beginners, but his anxieties are paired with the fear of seeing his gift wane. He achieved success when he was very young and ever since has been afraid he will not match his first masterpieces. Zola knew from experience that this fear

gnawed at many established figures and that Flaubert, to name but one example, was haunted by the success of his first novel, *Madame Bovary*. Zola himself was quite justifiably worried he would never match the print runs of *The Drinking Den* and *Nana*. Zola was so distressed by this constant fear, common to many great creators, that he illustrated it with a very minor character who was also a painter: Courajod. This acclaimed landscapist has withdrawn from the world and lives in a small house with his hens, ducks, and dogs, "gone to ground like a mole," barricaded against "attempts at admiration from the street,"[33] having lost his creative energy and all illusions about his own importance.

One of the most powerful scenes in *The Masterpiece* describes the first great exhibition at the Salon des Refusés, where Claude is exhibiting a painting whose subject very clearly alludes to Manet's *Luncheon on the Grass*, and provokes a brutal, idiotic response from the general public. Despite the contempt Claude feels for them and the faith he has in his own talent, "he suffered this as a disastrous puncturing of his illusions, a sharp pain to his pride,"[34] but he is resilient and "felt a breath of courage, a blast of good health and childhood coming from all this cheerfully courageous painting."[35] And most importantly, his friends get together to discuss his passion and his very new brand of art, as well as the incomprehension it elicits. Claude does not seem discouraged: "The public needs educating," he declares, "go ahead and laugh, Paris, you great fool, laugh till you fall to your knees."[36] But his excitement collapses when he is left alone, and it is on this same evening that Christine, the young woman he loves, gives herself to him. Then a whole other aspect of his life begins.

Zola brings together these two characters in rather unusual circumstances. Christine, a provincial, convent-educated orphan, has arrived in Paris with nothing to her name, to work as a reader for a blind old lady. Her train is so late that no one has stayed to wait for her at the station. To add to this, a violent storm breaks out. The poor girl gets lost in the streets. Soaking and terrified, she takes cover under a porch, where Claude, preparing to head home, runs straight into her. He takes pity on her and slightly grudgingly offers her shelter in his room. With some hesitation she follows him. He gives her his bed and spends the night in an armchair. The following morning, captivated by her loveliness, he draws her as she lies sleeping; when she wakes she agrees to hold the pose but is shocked by the images hanging on the walls: "terrifying sketches making the walls blaze...brutal painting... violent colors,"[37] painting that "pained her like a carter's cursing heard on the doorstep to an inn."[38]

From the very beginning, "she felt hatred toward [this painting], the instinctive hatred of an enemy." Their idyll develops slowly, tenderly, but Christine's fundamental incomprehension of Claude's work remains: "Was it possible for an intelligent man to paint so irrationally, so hideously, so falsely? Because she not only found his canvases monstrously ugly, she also felt they went beyond an acceptable reality. When all was said and done, he must be mad."[39] She never tells Claude this but it is clear that her narrow-minded attitude toward his art explains the fact that the couple never achieve complete union. There is no need to identify inspiration for this in any of Zola's friends' relationships: differences in artistic or political opinions

never hindered tender feelings. Zola must have been well aware that despite his intense friendship with Cézanne, the two men could neither fathom each other's creative process nor entirely grasp the results the other obtained. This did not hamper their affection, but all through their lives their fondness would be based more on their childhood memories than a comprehensive appreciation of each other's work. In the case of the fictional Claude, it is his intellectual and artistic isolation, rather than emotional isolation, that leads to tragedy.

Claude and Christine do, however, have a brief period of happiness. The young couple decide to leave Paris and retreat to the country. After months of idle contentment, Claude loses the sense of urgency an artist needs to work. He dawdles, works only for his own amusement. Christine is not forceful enough to drive him, and he is never sure she understands the nature of his ambition and talent. Eventually wearied by their stagnant situation, which is made only worse by the birth of their child, Claude and Christine decide to return to Paris.

There he meets up with his friends, who reignite his enthusiasm for painting, but this impetus evolves into a dangerous obsession, and neither Christine's love nor her self-sacrifice can surmount what clearly becomes a form of madness, because Claude cannot paint without destroying his own work:

> How he suffered never to give himself entirely, with a masterpiece whose genius he failed to bring out! There were always masterful moments, he was pleased with this or that or the other. Why then the sudden gaps? Why the shameful

areas that went unnoticed while he worked but later killed the painting with their inescapable imperfection? And he felt incapable of correcting them, the point came when a wall went up, an insurmountable obstacle, one he was not allowed to breach. If he went over the piece twenty times, he made it worse twenty times, the whole thing became a mess and descended into disaster. He grew angry, could no longer see what he was doing, or do what he wanted, ended up in complete indecisive paralysis.[40]

He now frightens his former friends: "The slow breakdown between Claude and his old gang of friends had worsened. They had all taken to making shorter, less frequent visits, uncomfortable at the sight of his disturbing painting, increasingly shaken by the derailing of what had once been admiration; and now they had all fled, not one of them came back."[41] Only Sandoz stays faithful to him, but he is of no help. Claude is certainly mad, but in Zola's savagely dark view, surely every true artist is condemned if not to madness, then at least to despair

Added to this is the tragedy of Christine, the woman who is jealous of art and paradoxically of her own image (this subject was touched on by Balzac in *The Unknown Masterpiece*, when Nicolas Poussin's mistress complains that he no longer sees *her* when he is drawing her). Christine's jealousy is aggravated by Claude's theory "which he expounded to her a hundred times, [according to which] genius should be chaste, an artist must sleep only with his work."[42] Intentional abstinence should eventually force the artist to give "all his virility to the painting."[43] Zola takes this theory to extremes: Christine is driven to

despair by Claude's demented obsession with the woman at the center of the painting he is going to such lengths to complete, and she shrieks at him: "Just try, then, just try telling me she hasn't gotten inside you one limb at a time, inside your head, your heart, under your skin, every inch of you. She has you like a vice, she's eating you up. She's your wife really, isn't she?"[44] Christine ends up forcing him to make love and spend the night with her, but he commits suicide at dawn. This then is how Zola gave a dramatic twist to the subject of the artist's wife. Balzac's Gillette has trouble accepting that her lover looks at her so dispassionately when he is painting her, but she settles for leaving him. Goncourt shows marriage to be incompatible with artistic creativity, but the wife who also acts as a model in *Manette Salomon* is an extremely venal Jew, and she serves more to justify the author's anti-Semitism than to illustrate his theories about relationships between men and women. By contrast, in Zola's novel, Sandoz's wife is the very epitome of the perfect, indispensable companion, and the strains in Claude and Christine's relationship derive from Claude's psychological problems and the inherent difficulties of creativity, not from his conjugal circumstances.

It is also worth emphasizing the fact that in Claude's case it is not the real woman who is "breaking his heart and consuming his mind,"[45] but the painting. Here we have the whole theme of conflict between art and reality, a conflict which the artists feel should end with art triumphing. Christine fights to establish her supremacy but by the end of the novel she admits defeat "and could feel all the sovereignty of art weighing on her."[46] Claude himself is aware of this when he says, "We are even more insane

than the idiots who kill themselves for a woman. When the world shatters in space like a dry walnut, our works won't add a single atom to its dust."[47] This tragic lucidity leads to death and heralds the novel's bitter ending. Standing by Claude's grave, Bongrand admits how desperate he feels, because "he can see himself going downhill and wallowing in despair." His anguish is different from Frenhofer's, who, as we have seen, ends up destroying himself and all his work but remains convinced of his own genius, believing it is only other people's blindness that stops them appreciating it. "Better to go," Bongrand thinks, "than to struggle on like us creating these infirm children who always have something missing, legs or a head, and who never come to life."[48] And Sandoz goes further by concluding, "Claude was logical and brave. He admitted his impotence and killed himself."[49]

But Zola also suggests another explanation for his painters' failures, an explanation he first offered after the 1868 Salon. After a fierce criticism of the portraits and landscapes, "the nice little pictures, the big serious contraptions and the naked torsos preserved in vinegar, in keeping with the School's sacrosanct recipe,"[50] he makes a considerable effort to explain the inferiority of contemporary art. First of all, the general public is distressingly stupid. Edouard Manet's first paintings cause a riot. If only the public "would consent to be intelligent and not boo new arrivals, we might see other paintings hanging on the walls of exhibition halls, living, human works that are profoundly true and interesting." Next he attacks Horace Vernet,* "a bourgeois down to the marrow,"[51] who panders to the French fondness for "clean, clear-cut images that are easy

to understand." Then he comes to his fundamental theory: "The hysteria that our modern times are experiencing. Artists are no longer big, powerful men, sane of mind and strong of limb like the Veroneses and the Titians. The cerebral machine has gone off the rails. Nerves have gained the upper hand, and weak, wearied hands now try to create only the mind's hallucinations."[52] We recognize Laurent from *Thérèse Raquin* in these words, as well as an aspect of Claude and possibly of Delacroix, who, according to Zola, "was afflicted by an acute neurosis; he painted as others would write, describing all the searing fevers of nature."[53] Delacroix is, however, not a very convincing example, if only because he produced a magnificent body of work over the course of a long career.

In his *Rougon-Macquart* series, Zola defended the belief that heredity and circumstances explain personality. Some of his characters escape the consequences of their forebear Aunt Dide's madness, others do not. Claude, as we have seen, breaks away from the awful family he was born into, and in him the neurosis is expressed as genius, but this genius eventually succumbs, crushed by inexorable atavism. And the fractures, rivalries, and fears inherent in the world of art—his chosen circumstances—contribute to his headlong flight toward disaster. On top of his onerous inheritance, Claude is a victim of the feverish atmosphere of an artist's life, and therefore of the way he has elected to live.

* Horace Vernet (1789–1863) was a classical military painter despised by Baudelaire, who wrote of him in his critique of the 1845 and 1846 Salons, "I loathe art improvised to a drumroll, these canvases daubed at the gallop, this painting manufactured on a pistol shot."

Of all Claude's friends, only Sandoz and Bongrand follow his hearse all the way to the cemetery. Bongrand confesses his distress yet again: "I'm a desperate creature myself. I'm dying of misery and I can feel everything falling apart." And their conversation, along with the novel, ends with the nightmare of their era: "this age has a bad feel to it, this closing century dragged down by demolition, gutted buildings, land plowed over a hundred times...Our nerves are being derailed, a wholesale neurosis is coming into play, art is losing its way..."[54]

The great sadness in *The Masterpiece* is that there is nothing left of Claude's work. He was a great painter, and yet not one canvas, one study, one sketch survives. Everything he did not destroy himself was stolen.

The novel caused a considerable stir, not with the general public—*The Masterpiece* did not have the success of Zola's most popular works—but in literary and artistic circles, and the way Claude was closely indentified with Cézanne had a good deal to do with this.

7 Repercussions: Huysmans and Maupassant

It is no surprise that Edmond de Goncourt loathed *The Masterpiece*, which he deemed "old-fashioned and improbable." He was convinced that art was uniquely his topic, his private hunting preserve; as we have already seen, he would not concede Zola's competence in this field, and repeatedly accused him of having no original ideas. But Goncourt's jealousy, which was exacerbated by Zola's sizable print runs, robs his criticisms of any authority. Zola did not even deign to respond to his accusations, but he did deny that he had been inspired by Balzac's *Unknown Masterpiece*. "It is a very short novella," he wrote in response to an article which appeared in *Le Voltaire* under the title "Un nouveau plagiat" (Another Plagiarism), "and I can honestly say I have only the vaguest recollection of its subject. There may be some points in common, some similarities; in any event, they are infinitely more developed in *The Masterpiece*."[1] However, Zola did agree that Ludovic Halévy, best remembered as the librettist with Henri Meilhac for *Carmen* and several of Offenbach's operettas, was right to criticize him for being a little hazy with dates. *The Masterpiece* is not anchored in the history of its time, and the fall of the Second Empire, the siege of Paris, and the

Commune do not feature even at the margins of Claude and Christine's story.

It is the way painters responded to *The Masterpiece* that is truly interesting. In general, they did not much like it and they let this be known. Monet appointed himself as their spokesman and revealed their discomfort in a letter to Zola: "I am left feeling disturbed, anxious, I have to say. You have been careful to ensure that none of your characters resembles any one of us, but in spite of this, I am afraid that our enemies in the press and the general public will mention Manet or at least name us as a group to make us look like losers."[2] Pissarro proved less easily offended and more measured: he told Monet he did not believe the book would do them any harm, saying, "Coming from the author of *The Drinking Den* and *Germinal,* it's just not a great novel, that's all."[3] But what did Cézanne think of it? For more than a century it was believed that the book's publication caused a complete rift between him and Zola.

Cézanne's letter acknowledging receipt of the copy Zola had sent him was brief, but then Cézanne was not given to pouring his heart out, and nothing about the letter allows us to infer that he had read the book yet, except perhaps for the early chapters, which cover Claude's childhood and teenage years in Aix. The tone of the letter is not aggressive, and he thanks Zola with these words: "My dear Émile, I have just received *The Masterpiece* which you were kind enough to send to me. I would like to thank the author of the *Rougon-Macquart* for this fine account of our memories, and I should like to shake his hand as I remember those years gone by. Ever yours under the effects of past times."[4] And there the correspondence stops: noth-

ing more, no exchange, not a single letter. It was deduced that the two men had fallen out definitively, and that the novel may have caused the breach: Cézanne could have identified himself in Claude, even though the latter's large landscapes of the Seine bore no relationship to Cézanne's own preoccupations, and he was too intelligent and knew Zola too well to confuse a fictional career with a real one. Their estrangement could also have been aggravated by the chilly relationship between their wives—Mme Zola systematically refused to receive Hortense Fiquet until Cézanne married her after a nearly twenty-year affair—and, more significantly, by the radically different positions the two men took during the Dreyfus affair.

But this whole construct came tumbling down in 2013 with the discovery of a letter dated November 28, 1887 (two years after the supposed quarrel), in which Cézanne thanks Zola for sending him a copy of *Earth* (*La terre*) and promises to visit him as soon as he is back, proof that the quarrel never happened. The two artists saw less of each other because Cézanne hardly ever left the South of France and Zola later (1898) threw himself into the battleground of the Dreyfus affair. It is impossible to identify a split that can be put down to *The Masterpiece*, but it is clear that the Dreyfus affair destroyed the harmony within the tight-knit group. Of the former painter friends, only Pissarro and Monet were Dreyfusards. Cézanne, Degas, and Renoir were fiercely nationalist. The familiarity and the exchanges that had brought them so close evaporated, and there were no further discussions about *The Masterpiece*.

By contrast, the book had a considerable effect on other writers. *The Masterpiece* was so violent and so cruel in its

depiction of a failing artist that, even though Zola's contemporaries continued to create painter characters, they seemed unwilling to compete with him in this field. We should also note that while J. K. Huysmans, Guy de Maupassant, and Anatole France continued to take an interest in painting, they did not attempt to bring to life a group of artists with Zola's verve and vigor, particularly as none of them shared his intimate knowledge of the world of painters. Most often, they reverted to the "Balzacian" tradition of according substantial symbolic importance to a painting that would sometimes trigger a new turn in the plot. They did not concern themselves with the creative process itself. It is as if Zola's bohemian artists had been tamed and were now acceptable company, better equipped to discuss art than create it. The painters who appear in the works of Anatole France could just as easily have been lawyers, doctors, or mathematicians. The artist in *The Red Lily* (*Le lys rouge*) is less preoccupied with aesthetic concerns than with the torments of jealousy. And Évariste Gamelin, the implacable revolutionary judge in *The Gods Are Thirsty* (*Les dieux ont soif*), is devoid of artistic sensibility despite being a painter. There still remains a passionate interest in painting, particularly in the work of two writers who knew Zola well, J. K. Huysmans and Guy de Maupassant. Both were members of the Groupe de Médan, close friends of Zola's, whom he enjoyed bringing together at his house in Médan, near Paris.

Huysmans was descended, through his father, from a line of Dutch painters, and he actually modified the name on

his birth certificate (Georges-Charles) to adopt a name that better reflected his Dutch origins (Joris-Karl). Just after his first book was published in 1876 he started working as an art columnist for various newspapers. This gave him the opportunity to discover the works of several young artists, most of them Impressionists, to whom he referred as *indépendants*, in order to differentiate them from official painters, and he was outraged that their work was systematically rejected by Salon juries. "They are introducing a whole new method, a unique, truthful flavor of art that distills the essence of their era in the same way the Dutch naturalists expressed the taste of theirs; new times call for new procedures. It's just common sense."[5] His tone is brisk, incisive. Hardly surprising then that Zola was drawn to this ardent young man who confessed his boundless admiration for the elder statesmen of art but also battled to secure recognition for Caillebotte, Pissarro, Gauguin, and Jean-Louis Forain.

Huysmans later collated his many columns into two volumes: *L'art moderne* (1883) and *Certains* (1889). After reading them, Claude Monet declared that no one had ever written so well and so perceptively of modern artists. And Stéphane Mallarmé saw Huysmans as "the only man to talk about art who can make us read about Salons gone by from start to finish and make them feel fresher than those of today."[6]

When he started out, Huysmans was a naturalist both in painting and in literature. In one of his early books, dated 1879, *The Vatard Sisters* (*Les sœurs Vatard*), he paints a picture, a harsh picture, of the women's working conditions in a book-binding workshop, and introduces an incon-

gruous character, a painter called Cyprien Tibaille who behaves like a bohemian, though he lives comfortably off a private income. Cyprien is, however, of no interest as an artist: he is lazy, slack, and depraved. "All he understood of art was modern,"[7] so he knew nothing of the foundations of his craft; we never see him at work and, as is only fair, he enjoys no success. He is first noticed by the two eponymous young sisters because he has "pared nails and white hands," but they assume he is more of an art entrepreneur, because his thumb is sometimes dappled with pink and green. They doubt he can be "a painter who paints pictures…as the gentleman does not have long hair or wear velvet coats."[8] The sisters' image of a painter is comical, and the character too uninteresting for Huysmans to grant him much importance in the novel.

But Huysmans would break away from the realist school and pursue an innovative trajectory which would show another aspect of the connections between literature and painting. He confided in Zola about his plans: "I have started work, immersed in a peculiar sort of novel-fantasy, a lively folly which I believe will be rather original but will have people calling for my immediate internment in Charenton…I positively needed to have a fresh start with a wild fantasy, something crazy but still real."[9] He is introducing his book *Against the Grain* (*À rebours*). This marks a complete break from Zola in aesthetic terms, but their friendship endured. Huysmans explained his position many years later in the preface to a subsequent edition: "[In 1884] naturalism was wearing itself out, endlessly grinding the millstone in the same old circle…Zola managed well enough painting his relatively precise canvases;

he very successfully suggested the illusion of movement and life...but Zola was Zola, in other words a rather massive artist but one blessed with strong lungs and stout fists...The less sturdy among us who concentrate on a more subtle and truthful art cannot help wondering whether naturalism will lead to a dead end and whether we will soon hit that wall."[10]

Against the Grain is indeed an unclassifiable book, extravagant and fantastical. It explores the phobias of a dandy who loathes the time into which he was born. He is afflicted by what was referred to as the neurosis of decadence. Weary of the pleasures offered by society, the book's antihero, Jean des Esseintes, withdraws to a cottage in Fontenay-les-Roses* and surrounds himself with his favorite books and paintings, and the rarest of plants. The only journeys he undertakes now are imaginary ones; and he adopts the most absurd regimens involving nourishing enemas. He ends up abandoning this completely artificial existence and returning to Paris. Nothing happens in the way of action. Huysmans simply depicts a mind going inexorably astray, but he uses dazzling, adroit language with impressive evocative power.

Zola did not show a great deal of enthusiasm, "regretting the lack of progress and logic in the story," which has Des Esseintes no more or less mad at the end than he was at the beginning. "I think," he adds, "the book would have had more shocking impact if you had based it on a more logical footing, however insane it was going to be," but he admired the book's outrageousness and

* A famous French insane asylum.

"the beautiful passages of art criticism on the painters Des Esseintes loves."[11] When Zola and Huysmans went for a walk together at Médan, Zola enjoined him to "come back to the beaten path and buckle down to a study of manners," but, despite such advice, Huysmans never returned to naturalism. "The two of us often argue amicably," he wrote, "about issues on which we completely disagree, but we are old friends from before the days of *The Drinking Den* and I think he has great talent...and, anyway, naturalism, romanticism, etc....what of it? The truth is some people have talent and others do not."[12]

What is more significant for our purposes is the role paintings play in Des Esseintes's obsessions. This is a man whose imagination runs wild to the point of mania. We should not try to identify the fictional character's tastes with the author's; the painters that Huysmans most admired, such as Degas and Whistler, are not even mentioned in the book. Des Esseintes seeks out the bizarre, hence the importance given to Moreau and the Goya of the *Caprichos*. Huysmans translates this monomania into an astonishing exploration of style. The most beautiful passage in *Against the Grain* is the description of Gustave Moreau's *Salomé*. Des Esseintes rejects "the paintings people hang on the walls of their homes, depicting men hard at work all over Paris, or wandering through the streets in search of money."[13] The only works he is willing to bring into his own home have a "subtle, exquisite painting style, bathed in an ancient dream, in an antique sort of corruption."[14] And to be more specific, what he actually chooses to have before his eyes are two paintings by Gustave Moreau, "whose talent sent him into sweet transports

of delight."[15] Both pictures are of Salomé, one showing her dancing before Herod and the other standing before a vision of John the Baptist's head. There is no description of a painting to rival the power and beauty of Huysmans's. In his words, the first of these Moreau works depicts Salomé just as she begins her

> lubricious dance: diamonds attached to her person glitter against the moist gleam of her skin; her bracelets, girdles, and rings flash fiercely; her triumphal robe is stitched with pearls, leafed with silver and woven with gold, and forms an ardent pairing with the jeweled goldwork of her breastplate, whose every link is a precious stone, its fiery snakelets criss-crossing, teeming over her dusky flesh, her tea-rose skin, like gorgeous insects with resplendent elytra, shot through with carmine, flecked with sunrise yellow, emblazoned with steel blue and banded with peacock green.[16]

And Huysmans sustains this impressive style—distinctive for its research, precision, and choice of rare words—for pages on end. He continues in a somewhat different vein to describe Salomé after she has danced, confronting the vision of the saint's head: "Here, she really was venal; she was true to her temperament, a cruel and ardent woman; she was alive, more refined and more feral, more loathsome and more exquisite...with the charms of some great lascivious bloom, grown in profane seedbeds, cultivated in godless hothouses." How far we have come from *Nana* and Zola's realism. What Huysmans sees and admires in Moreau is "a visionary who could cut himself off from the world sufficiently to see, right in the heart

GUSTAVE MOREAU *Salomé Dancing Before Herod* 1876

of Paris, imposing incidents from past ages, moments of cruel misery and magical accomplishment."[17]

In Huysmans's view, there was an intimate connection between writing and painting, which is why he said of the pictures that bowled over Des Esseintes:

> the one analogy he could conceive between these paintings and all those created to date existed only truly in literature. Looking at these Moreaus, he actually felt an intellectual response almost equal to the experience he had reading certain strange and charming Baudelaire poems, certain descriptions from the admirable *Salammbô*, certain superb passages from *The Temptation of Saint Anthony*, and even, to make the analogy more striking, more meticulous, more accurate, he felt it would have taken a *Temptation* written not so much in Flaubert's impeccable and grandiose language but chiseled in the captivating, refined style of the Goncourts with its master jeweler's precision.[18]

In a review for the daily *Gil Blas*, Maupassant deemed *Against the Grain* astounding and, interestingly, uproariously funny. But he personally adopted a slightly different position if only because, as a confirmed disciple of Flaubert, he was suspicious of the Goncourts' master-jeweler writing. "There is no need for the outlandish, complicated, extensive, and foreign vocabulary foisted on us nowadays under the guise of artistic writing trying to pin down every little nuance of thought...We should strive to be excellent stylists rather than collectors of arcane terms."[19]

Maupassant was not Zola's most submissive admirer and did not intend to succumb to "the inanities of the

naturalist school," but he was part of the older writer's circle of literary friends. He wrote a truly glowing review of *The Belly of Paris*: "This book smells of the sea like fishermen coming back to harbor, and of garden-grown vegetables with their earthy tastes and mild, rustic smells."[20] He had the same intense response when he read *The Transgression of Abbé Mouret*, which allowed him to "breathe in the smell of the earth, of trees, of fermentation and seedlings, [and] to dive headlong into such an excess of reproduction it eventually goes to the head."[21] The two men became still closer when Zola bought his house in Médan; Maupassant visited often, and in *A Parisian Bourgeois's Sunday* (*Les dimanches d'un bourgeois de Paris*) he described it as a "large, square new house, very tall and, like the mountain in the fable, it seemed to have given birth to a tiny little white house huddled next to it."[22] It was Maupassant the boating enthusiast who took it upon himself to buy a *chasse-canard* (duck hunter), a five-meter rowing boat, for Zola, and he personally brought it down the Seine to Médan. He told Zola he had named the boat *Nana*. Nana, why Nana? he was asked. Because, Maupassant replied, everyone will get into her.

Maupassant is indeed a realist writer, but he is very different from Zola, if only because he had neither his stamina nor his pugnacity. Maupassant worked in a different register and explained this in *The Life of a Landscapist* (*La vie d'un paysagiste*), in which he has his painter character say: "I see all that terrible struggle that Zola describes in his admirable *Masterpiece*, all of that endless wrestling between the man and his thoughts, all of that splendid, elusive battle, I see it all and, being puny and powerless

but just as tortured as Claude, I serve it up in imperceptible tones, with indefinable pairings that perhaps only my eye observes and notices; and I can spend agonizing days looking at the shadow of a milestone on a white track, knowing for sure I cannot paint it."[23]

This is not to say that Maupassant was an obdurate realist; what mattered most to him was the atmosphere, "the finish of the vision."[24] Like Corot and Monet, whom he watched at work out of doors at Étretat, the thing that had the most profound effect on him was light. So the young woman in *A Life* (*Une vie*) is speaking for the author when she swoons at the sunrise "piercing the scarlet mists, stippling its fire over the trees, the plains, the ocean, the whole horizon,"[25] and when she is on a trip at sea and says, "there were only three truly beautiful things in creation: light, space, and water."[26] It is hardly surprising that Maupassant was more drawn to the landscapist Harpignies, whom Anatole France nicknamed the Michelangelo of trees and peaceful countryside, to Millet, a founder of the Barbizon School, to Renoir, Corot, and Monet, than to artists of his own generation, the Postimpressionists such as Van Gogh, Gauguin, Signac, and Seurat. Besides, he had an affinity for the places so often depicted by the former, and his novellas—which frequently feature boats on the water, pauses at little bars along the Seine, and excursions to bathing establishments surrounded by greenery—are like elaborations of Renoir's *Luncheon of the Boating Party* (*Le Déjeuner des canotiers*) or his *La Grenouillère* or Monet's *Bathers at la Grenouillère* (*Bain à la Grenouillère*). The river Seine was one of the Impressionists' favorite subjects, and in *Mouche*, Maupassant said it was "my great, my only, my compelling

passion for ten years, ... I've loved it so much; I believe this is because it seems to have given me a sense of life. Oh, the walks along its flowered banks, my friends the frogs dreaming on a lily pad with their bellies kept cool, and the elegant, fragile water lilies in among tall, slender grasses, and then all of a sudden from behind a willow tree it would be like turning the page of a Japanese picture album when a kingfisher darted away from me like a blue flame! How I loved all that, with the instinctual love of my eyes which spread a profound, natural joy all through my body."[27]

Another example of this perfect concordance between the writer's view and the artists' was Étretat, with its extraordinary cliff arch painted by Monet, Courbet, and Boudin, and described by Maupassant as "a strange-shaped rock, curved and pierced through, [looking] rather like an enormous elephant delving its trunk into the waves."[28] And surely Maupassant's appreciation of the beauty in misty landscape derives from his familiarity with a number of paintings he cherished. Monet's *Étretat* is also evoked in this passage from *Une vie*: "There was a very low, golden, transparent fog that hid nothing, but softened everything in the distance";[29] and we are reminded of Monet again, in his *Hôtel des Roches-Noires at Trouville*, by these words from *Pierre and Jean*: "From a distance [Roches-Noires beach] looked like a long garden full of dazzling flowers ... [with] parasols in every color, hats in every shape, frocks in every variety ... [which] really did look like huge clusters of flowers in an oversized meadow";[30] and perhaps it is to Monet yet again that we owe this description from *La Maison Tellier*: "a whole field so overrun with poppies it seemed to have been sprinkled with blood."[31]

CLAUDE MONET *Étretat, la Manneporte, reflets sur l'eau* 1885

The net result of this undeniable absorption of works of art was that Maupassant developed great modesty as a man of words. Of course Balzac readily wrote that only a Raphael or a Rembrandt could do justice to such and such a face, but Maupassant gives a more elaborate explanation of how painting is superior to writing. With the evasive harmonies brought out by Monet or Manet, "the human eye has adapted and now recognizes colors that would even be impossible to explain with words...Look at Chinese pinks and reds, the whole range of red lilacs, pink lilacs, orangey lilacs, and all those greens that are so different, so gorgeous, so fresh, so impossible to count and impossible to name, all those colors our eyes can now identify but our mouths cannot yet define."[32] Like his peers, Maupassant tried his hand at art criticism in the form of reviews of various Salons. His articles are incisive, ironic, and often comical, but his fundamental reservations about the validity of criticism are what make them original and explain why they were not as well received as those of Zola, for example, or Baudelaire.

When Maupassant explores the question of who is equipped to judge painters, he dismisses critics, whom he deems "relatively incompetent," as well as the general public, who are "radically" so, to the extent that "if the public were told what is mysterious and complicated about a beautiful work of art, they would be more astonished than a monkey looking at the workings of a watch."[33] In Maupassant's opinion, the problem with critics is that they have no "knowledge of the complicated, difficult execution that only years of studying can achieve"; a problem exacerbated by the fact that painting and literature alike appear to be accessible to everyone. "Any man who can

write a letter with accurate spelling readily judges writers without ever suspecting their torments, their aims, their strategies, or their secret martyrdom to raise words to the mysterious existence of art. And a man strolling through the Palais de l'Industrie [where the Salons were held] feels free to judge painters for the simple reason that he has eyes to see. Is it enough to see a locomotive in action to know everything an engineer knows? Well, critics think they know well enough because they have seen a lot of trains go past, trains or paintings, if you will."[34]

And Maupassant revisits the question of man's evolving ways of seeing, saying that to appreciate pictorial art we need "eyes so sensitive very few people have them, even among painters…an astute, practiced eye…can distinguish these nuances, can savor them with boundless joy, can grasp their harmonies that are invisible to the crowds…for the crowds know only a few colors, the mother colors."[35] Which of these amateur enthusiasts could hope to understand Rembrandt's blacks, those luminous blacks in which there is "more color, more sumptuousness, more variety, more unexpectedness, and more captivating charm than in Rubens's sensational canvases?"[36] Nevertheless, Maupassant tired quickly of writing about Salons, perhaps simply because he felt overwhelmed by the hundreds of recommendations that flooded his writing desk, and he ended his series of columns with a very fine piece in which he featured himself as a landscapist "who now lives only through his eyes." In those few pages written in 1886, he sketched out the portraits of three painters. First, Monet, whom he had in fact met at Étretat: he pictured him setting off to paint, followed by a small gaggle of children who carried

his pictures, five or six canvases representing the same subject in different lights. Remembering when he watched Monet work, Maupassant shows his true artistry by finding the words and images to describe him: "I have seen him pick out...a glittering shaft of light on that white cliff and capture it as a stream of yellow tones which strangely managed to convey the surprising, fleeting effect of that blinding but elusive illumination. Another time, when a shower pelted onto the sea, I saw him catch it with his bare hands and throw it at the canvas. And he really did paint rain like that, just rain veiling the waves, the rocks, and the sky, so you could barely make them out in the deluge."[37]

Corot was another painter whom Maupassant had opportunities to watch. Maupassant was barely fourteen when he saw Corot painting in the open air, and he would never forget it. Twenty-two years later he brought the scene back to life: "On a farm, a small farm, I caught sight of an old man wearing a blue smock and painting under an apple tree...He was painting on a small square canvas, working slowly, peacefully, hardly even moving. He had quite long white hair, looked gentle, and had the suggestion of smile on his face...This old painter's name was Corot."[38]

Finally, Maupassant described Courbet in a house he knew well, where his cousin, the painter Eugène Lepoittevin, lived. A fat, "greasy, dirty-looking [man] was using a kitchen knife to stick slabs of white paint onto a large bare canvas. The sea came so close it seemed to beat at the house, which was surrounded by spray and noise...Courbet...talked heavily but brightly, was jokey but brutal. He had a sluggish but precise mind full of rural common

sense lurking beneath his crass jokes."[39] The painting he was working on became *The Wave* (*La vague*), and it made some waves of its own.

Three years later Maupassant wrote a novel, *Strong as Death* (*Fort comme la mort*), and chose to make his central character a painter. By doing this, he was adding to the long tradition of books in which an artist is essential to the plot, but he did something different: the most striking of these painter characters are—like Frenhofer, Claude Lantier, Pellerin (the painter in Flaubert's *Sentimental Education*), or Coriolis in *Manette Salomon*—beaten, sometimes failed men, or tormented souls bordering on insanity. Confronted with this slightly worn subject, particularly following the publication of Zola's *The Masterpiece,* Maupassant chose to make his character a successful painter who specializes in portraits and is pampered by high society.

The novel is rigorously contemporary. It was published in 1889, at a time when the major battles surrounding the Impressionists, described in such lively terms by Zola, were over. The stage now belonged to the Postimpressionists, Seurat, Gauguin, Van Gogh, and Cézanne. The fact that Maupassant's painter Olivier Bertin is a conservative Impressionist is more than realistic—it corresponds exactly to the times. The Impressionists were no longer shocking and were becoming sought after.

Although he did not have Zola's combative nature or his intuition about innovators, Maupassant had a genuine liking for art. This was heightened by his friendship with his cousin Lepoittevin, an acclaimed landscapist, by the time he spent with contemporary painters, and by his familiarity with Zola. Monet recognized that Maupassant's

intuition was sound and that when he liked something, "he didn't choose the worst things."[40] He especially liked plein air images and therefore landscapes. If he opted to depict an indoor painter, a classic portrait painter, it is because the subject he wanted to explore was the role of the artist in elegant society.

Bertin, a bachelor, is adopted by the family of the comte de Guilleroy. As is only fitting for a Parisian novel, he soon becomes the countess's lover, and this affair goes on for ten years so serenely and conveniently that the husband and the lover become the very best of friends. Bertin does not move in the most rarefied of aristocratic circles—a painter would probably not be made to feel entirely at his ease there—but in a world where a rich merchant's daughter can marry a man with a minor title and a career in politics, an environment where painting is not discussed intelligently because too much time is spent admiring its elegant intricacies, "the feelings it expressed...and never art, art alone, art stripped of ideas, trends, and social prejudices."[41] Characters here subscribe to the review *Arts Modernes*, which "they have to take because of its price, a subscription being four hundred francs a year."[42] The mistress of the house loves and plays Schubert, and displays Baudelaire's *The Flowers of Evil* (*Les fleurs du mal*) and Stendhal's *The Red and the Black* (*Le rouge et le noir*) on her desk. Bertin is not fooled by this veneer of culture: he is too lucid to be an integral part of this world. In Maupassant's view, an artist—even a rich, sought-after, conventional one, covered in glory and not only well versed in the ways of the world but happy to accept them without protest—is still an exceptional creature, set apart.

Bertin is first and foremost a spectator and therefore a critic—of others and of himself. He is aware he achieved success too young. "Had society's sudden infatuation with his elegant, distinguished, and decent paintings influenced his personality by stopping him becoming whoever he would otherwise have been? Since that early triumph, an eagerness to continue pleasing others gnawed at him without his realizing it, secretly altering his course, dulling his convictions."[43] If he allowed himself to get carried away with such thoughts, he would be distressed by feelings of contempt for his coterie of admirers. He is perfectly capable of judging others harshly. In rare moments of irritation he is able to set aside his good nature, which usually obscures the clarity of his thinking, and "demonstrate that intelligence among society folk, even the most educated, had no value, nothing to feed off and no scope...[These people] are reduced to taking ardent pleasure in nothing; besides the beauty of the world or the beauty of art, which they discuss without ever discovering it for themselves...they are incapable of latching onto something to the point of loving it alone, or acting entirely without self-interest to the point of being illuminated by the joy of understanding."[44] But most of the time he is loath to disrupt such a pleasant life and the comforts of its luxurious pleasures.

He is therefore not permanently driven by rage, like Zola's misunderstood artists, and his visit to the Salon is the exact opposite experience to Claude's in *The Masterpiece*. Refusing to rival Zola, who took up the cause of rejected innovative artists, Maupassant describes the exhibition as seen by established painters, not that he harbored many

illusions about the value of an institution that saw "the Palais de l'Industrie filled up every year with these bazaar-grade paintings that are awarded medals out of indulgence in order to give them an easy progress through galleries for art enthusiasts…and where appalling cacophonies of different tones [produced] an unspeakable jumble of colors exasperated to find themselves side by side."[45] Perhaps only thanks to the medals and prizes he once won, Bertin's work is always exhibited. His painting has made him rich: a gold medal from the Salon brought in four thousand francs,* and such a well-known painter could command a thousand francs for a portrait. As a result, he experiences neither the anxieties of an unknown artist nor the complex feeling of superiority which would allow him to derive comfort from being refused by the jury, a response that characterizes the young wolves portrayed by Zola.

Like Balzac and Zola, Maupassant put considerable emphasis on the impressive crowds of people thronging through the exhibition halls. He has a "swarming, buzzing soup of people"[46] lingering in front of paintings, and highlights the documentary aspect of his novel by having Bertin name outright the painters on view: "A fine Salon. The Bonnat is remarkable, two excellent Carolus Durans, a remarkable Puvis de Chavannes, a very surprising, very new Roll, an exquisite Gervex, and plenty more besides, works by Béraud, Casin, Duez…"[47] It is worth noting that Gervex and Béraud were friends of Maupassant.

Unlike *The Masterpiece*, the subject of the novel is not

* One thousand francs represented approximately twice the annual income of a laborer.

the drama of the creative process or of an artist faced with indifference from the general public and sometimes his peers; here the plot revolves around the painting itself. Bertin falls in love with Any de Guilleroy as he paints her portrait. From their first meeting he is struck by "the arresting contrast between her face, so delicate and luminous under her golden hair, and the austere black of [her] clothes."[48] He agrees to paint her portrait and, during the course of the long sittings, the inevitable happens. Their affair remains discreet, whereas the portrait is the most beautiful ornament in the Guilleroys' living room, to which it seems to give life. It is so stunning, such a good likeness, that everyone, and Bertin most of all, always sees Any as she is depicted in the painting. "It was in fact almost the done thing, a sort of urbane custom, like making the sign of the cross on entering a church, to compliment the model for the painter's work every time one stopped to look at it."[49]

Years go by, and the time comes for Any's daughter Annette to be introduced to society. She looks so like her mother she could be her younger sister, or rather she looks like the portrait. And Bertin is suddenly aware how much Any has aged; what is worse, she herself realizes this and can see, even before Bertin himself does, that he is attracted to her daughter. Despite her love for her child, Any then longs to remove Annette by marrying her off as soon as possible. But her efforts are wasted: Bertin becomes increasingly obsessed with Annette, and this goes hand in hand with a tormenting awareness that he himself is growing older. Alexandre Zviguilsky believes that he has identified the inspiration for the novel in confidences that Turgenev made to Maupassant.[50] The Muscovite, as

Turgenev was known in Paris, fell in love with the daughter of his mistress, Pauline Viardot. This could indeed have sparked Maupassant's interest in the subject, but the book also deals with his longtime obsession with the themes of senescence and doubles.

Louis Forestier, the great French specialist on Maupassant, very astutely pointed out how smart it was of Maupassant to choose a painter—and an Impressionist at that—to illustrate the drama of change. By definition, a good painter is capable of capturing something that is fleeting, and making motion perceptible. Bertin is too much of a painter not to notice in minute detail the signs of aging in Any and in himself, but then the time comes when the process accelerates. Maupassant pictures Bertin at a performance of *Faust*, where the theme of youth predominates, and the bitter realization that a longing for renewal is futile fills him with sadness and disgust. "He felt old, finished, lost...relegated, retired from life, like a superannuated civil servant whose career is over; what intolerable torture."[51]

Finally, "having descended through all the degrees of powerless, jealous, secret love,"[52] he is, to cap it all, wounded by an article claiming his art is outdated. Maupassant has pinpointed Bertin's flaw: it is not only his impossible love that makes him unhappy, but also, perhaps even more so, the appalling feeling of "impotence as he dreams of new things, of fresh discoveries."[53] Instead of fully exploring his art, he has allowed himself to be stifled by a superficial, deceitful, bourgeois society. In despair, he goes out for a walk late at night and falls under the wheels of an omnibus. An accident or suicide? I tend toward

suicide. Bertin does not die straightaway, though; he is taken home and the Guilleroys rush to his bedside as soon as they hear the news. Any manages to have some time alone with Bertin by persuading her husband to leave with the doctor to fetch a nurse. At death's door, Bertin thinks of his mistress's reputation and asks her to burn her letters, which he has kept all this time in a desk drawer. She throws them into the fire, and the novel closes with a magnificent image: as they burn, the letters produce

> a bright ring of paler flames that filled the room with light...[Any] cast one final glance over this destruction and the pile of already half-burned paper as it contorted and blackened, and saw a trickle of something red. It was like drops of blood. They seemed to come from the very heart of the letters, of each letter, like a wound, and they spilled slowly toward the flame, leaving a trail of carmine.
>
> The countess was shaken to the core, terrorized by this supernatural sight, and backed away as if she had witnessed an assassination, and then she understood, she suddenly realized that she had simply seen the wax seals melting.[54]

This vision of blood and flames gives us an idea of the power of Maupassant's painterly imagination.

We have seen how much Zola's landscapes owe to the paintings of his era; like him, Maupassant had scrutinized so many works of art that he too was permeated by them. The effects of light explored by Impressionism were now an integral part of how their contemporaries perceived the

world. What was more personal and original was the way Maupassant used swift strokes like those he admired in the works of Forain and Toulouse-Lautrec. In *Mont-Oriol*, a doctor arriving "at a brisk pace which made the tails of his old frock coat flutter like a pair of wings"[55] is an example of a description carried out in the style of a painter with a quick eye. Maupassant almost certainly did not see Carpaccio's Venetian paintings, but the monks fleeing before Saint Jerome's lion also have white cassocks with fluttering black sleeves. We could be forgiven for thinking we are looking at a Toulouse-Lautrec in the opening pages of *The Mask* (*Le masque*), which describe the dancers at a ball at Elysée-Montmartre: "The two women, whose thighs seemed to be attached to their bodies on rubber springs, made astonishing movements with their legs. They threw them in the air so vigorously that the limbs seemed to fly up into the clouds, then they suddenly spread them wide as if their bodies were spliced up to their bellies; sliding one forward and the other backward, they touched the ground with their middles in a repulsive but amusing splay. Their partners leaped, jigged, minced on their feet, waving their arms in the air like featherless wing stumps, and beneath their masks you could see them breathing heavily."[56]

Maupassant sometimes borrowed a telegraphic style from caricaturists. In *Bel-Ami*, a woman is described in just two lines: "A tall, thin woman, sixty, false curls, English teeth, Restoration mentality, same era clothing."[57] Again in *Bel-Ami*, he uses the same economy to describe a woman of suspect morals: "A fat brunette, her skin whitened with paste, dark eyes elongated and emphasized with pencil, framed beneath huge drawn-on eyebrows...with painted

lips, red as a wound."[58] And later in the same novel, "Saint-Potin, a small pale man, puffy-faced, very fat and bald with a gleaming white pate, wrote nose to paper, due to excessive myopia."[59] Lastly, in *The Maison Tellier*, one of the women is described in just one line: "Rosa the Redhead, a little bundle of flesh, all stomach on tiny legs."[60]

Maupassant was too in tune with his own era not to gauge how much his characters' choice of art would inform readers about their personalities. In *Strong as Death*, it is her choice of books, magazines, and pieces of music that complete the portrait of Any de Guilleroy; in *Bel-Ami*, it is the banker Walter's art collection—and especially the way he puts it together—that gives us vital clues to understanding his character. First of all, it reveals his cynicism and his liking for speculation: "'I'm buying young at the moment, very young, and I set them aside in my private apartments, waiting until the artists are famous.' Then he adds very quietly, 'Now's the time to buy paintings. Artists are dying of hunger. They don't have a penny, not a penny.'"[61] And to display how cultured he is, he hangs in his salon a large canvas of a beach in Normandy by Guillemet, a landscape by Harpignies, and a rather shocking view of Algeria by Guillaumet with a dead camel in the foreground, then Gervex's *Une visite d'hôpital*, Bastien-Lepage's *Moissonneuse*, Bouguereau's *Veuve*, and Jean-Paul Laurens's *Exécution*, depicting a priest in the Vendée region being gunned down outside his church. Last of all comes a small painting by Jean Béraud entitled *The Top and the Bottom* (*Le haut et le bas*), showing a pretty Parisian woman climbing the stairs in a tram. The men on the lower deck are staring at her legs, while those on the upper deck smile at

the young face heading toward them. It is not the choice of painters—all of whom were friends of Maupassant, and whose work he admired—that is ironic or surprising, but the somewhat eclectic combination. Walter still has a way to go before making his mark on high society, but he will get there quickly.

A few months later, a successful speculation on iron and coal mines, some land in Algeria, and a Moroccan loan make him "one of the masters of the world, one of those omnipotent financiers stronger than kings, who make people bow before them, make mouths stammer and come out with everything base and cowardly and envious that lies deep in the human heart. He was no longer Walter the Jew, director of a dubious bank, owner of a questionable newspaper, and a deputy suspected of shady dealings. He was Monsieur Walter, the wealthy Israelite."[62] Walter then buys a splendid residence on the rue du Faubourg Saint-Honoré but feels it is not sufficiently dazzling: "So he had another idea, truly the idea of a conqueror who means to take Paris, an idea à la Bonaparte."[63] At the time, the whole of Paris was going to see a large painting by the Hungarian artist Karl Marcowitch,* depicting Christ walking on the water. Walter buys the painting for five hundred thousand francs, thereby forcing elegant Parisian society

* Interestingly, although Maupassant cites the actual names of all the French painters in this novel, he changes the name of the Hungarian painter. "Marcowitch" is Mihály Munkácsy, whom Maupassant knew well and whose *Christ before Pontius Pilate* was extraordinarily well received. The artist completed the work too late for it to be exhibited at the Salon, but his dealer, Charles Sedelmeyer, showed it at his gallery. More than three thousand people rushed to admire the painting.

to talk about him. This painting will be the instrument of his revenge for all the snubs he suffered before making his fortune. To mark the purchase, he holds a large reception and all of a sudden the closed world of duchesses and the Jockey Club—consumed with curiosity and deeming that accepting an invitation represents no commitment to reciprocate—descends on his apartments: these society figures "visited his home to see the face of a man who had earned fifty million in six weeks; they also visited to see and count who else was there; finally they came because he had had the good taste and aplomb to invite them to admire a Christian painting in his home, when he was a son of Israel."[64] Once again, Walter's calculations pay off: his salons will never be empty again, and the painting has fulfilled its role as bait.

It is clear that Zola and Maupassant alike projected their own anxieties as artists into the lives of their fictional painters. In Zola's case, the constant threat of failure, the feeling that talent can never be taken for granted, and that there must be no letup in the pace of work all contributed to the dark side of Claude; and Maupassant, who was crippled by the appalling symptoms of syphilis, which would destroy his mind before killing him, was terrified that his inspiration would run dry, a fear that must have sparked the despair of the aging Bertin. We shall see that Proust had an altogether different approach when he created the great painter of *In Search of Lost Time*.

.

8 Elstir: Proust's Master

The last great fictional painter of the nineteenth century is Proust's Elstir. I say of the nineteenth century because, although *In Search of Lost Time* is a between-two-centuries novel, to use Antoine Compagnon's expression, Proust chose to make Elstir a character whose age and preoccupations are indisputably connected to the nineteenth. The author himself straddled the two centuries and was therefore of a generation that no longer shared the concerns of his elders, Zola and Maupassant, who so passionately defended the painting of their time. Proust himself was never actually tempted to take sides in the various controversies that shook the art world, and if painting has something of a privileged place in his novel, it is for a quite different reason. Proust's knowledge of classical art was admirable, and he appreciated the Impressionists, but he was not very familiar with later painting. He had never seen a Cézanne. "Where are they to be seen?"[1] he asked his friend and portraitist, the painter Jacques-Émile Blanche; and he had no better grasp of Matisse or Bonnard, nor did he seem interested by Picasso or Braque. Like all the novelists I have mentioned, Proust frequently visited the Louvre, and had done so since his early teens. He went there so often with his classmates that it has been

said that the museum was an "annex" of his school, the Lycée Condorcet.[2] The museum was a place where these young men could meet in complete freedom: the "cultural alibi" was beyond reproach, and a love of art could justify daily get-togethers. According to his friends, Marcel was the most passionate of them all, and they complained that he could spend over half an hour in front of a single painting. Mme Proust was also a frequent visitor, and left a comical account of a visit in the middle of August when the Louvre was abandoned to copyists, "a pathetic flotsam of old women in glasses…perched on the tops of their ladders to get a closer look at their models,…and a group of Englishmen, ladies and gentlemen all with their binoculars slung across one shoulder following behind a strenuously enthusiastic guide."[3] Like these English tourists, Proust concentrated on museums during his rare trips abroad, for example to Amsterdam, where a huge Rembrandt exhibition was organized to coincide with Queen Wilhelmina's coronation in 1898. Four years later, he made what was for him a long journey: he spent two weeks in Belgium and the Netherlands, traveling first to Bruges, then Delft, Haarlem, and The Hague, and returning via Amsterdam. Between these two visits he went to Venice and Padua. Proust had acquired a bookish knowledge of Italian Renaissance painting thanks to Ruskin, so this was less a question of discovering the works of Titian, Tintoretto, Carpaccio, and Giotto than the realization of a dream. In fact, on his arrival in Venice he wrote to tell Mme Straus, the widow of Georges Bizet and the mother of his close friend, Jacques Bizet, "my dream has quite incredibly but very simply become my address."

His knowledge of contemporary works derived from exhibitions in Parisian galleries and from his friends' collections. He assiduously attended the gatherings held by Mme Straus, whose house was adorned with numerous paintings by Corot, Monet, and Boudin; he met Monet at the home of the artist Madeleine Lemaire; and during his visits to Jacques-Émile Blanche, for whom he posed, he had opportunities to study in detail the Corots that Blanche collected. Furthermore, he actually saw Manet's *Asparagus*, which puts in an appearance in the novel, when he visited Charles Ephrussi, a great collector, owner of the *Gazette des Beaux-Arts*, and a Jewish banker in some ways reminiscent of Proust's character Charles Swann. But illness and constant preoccupation with his book slowed all this activity. Proust went out very little in the last ten years of his life, and stopped visiting the Louvre or going to openings. His last visit to the galleries at the Jeu de Paume to see a Vermeer exhibition was an exceptional event, and a dramatic one because there he suffered a debilitating dizzy spell.

Proust did not write a novel about an artist; his secondary character Elstir is important only for his paintings, his concept of art, and, above all, for initiating the Narrator into the world of art. Proust, it is widely recognized, was not a realist novelist like Balzac or Zola. He did not set out to evoke the life of a painter, his apprenticeship, his friendships or struggles; we know nothing of how Elstir's career developed and Proust gives few concrete details of his work as a painter. But Proust certainly allows the reader to see

Elstir's experience over time, first by showing his successive styles and then by letting it be understood that, after difficult beginnings and a dazzling prime, he went into decline. By contrast, Proust does not expand on the evolution of his other two artists, the composer Vinteuil and the writer Bergotte. Vinteuil's first composition, which opens with "an incommensurable keyboard," seems no less sublime than his posthumous septet, and similarly, although Bergotte dies regretting that his style never achieved the sumptuous richness of Vermeer's palette, there is nothing to indicate that his art evolved over his lifetime.

We see Elstir first as a clownish artist, then as a respected master, without ever learning anything about the years between. The only sign of his success is the way he is referred to as a mature man. In the first part of the novel, he has no name other than the whimsical nickname of Biche.* Most of the time he is referred to simply as "the painter." Later the reader learns that he is called Elstir, an anagram of "Whistler" omitting the first two letters, or a combination of the first syllable of "Helleu" and "Steer," the English painter who studied and exhibited in Paris. In the 1890s Robert de Montesquiou introduced Proust to both Whistler and Helleu. Proust did not have much further contact with Whistler, but to the end of his days he held Helleu in sufficiently high regard to be sure that the latter would draw him on his deathbed. The English ring to the name Elstir is justified, as we shall see, by the artist's long-standing appreciation of English painting.

* Often used as a term of affection, usually for women, *biche* actually means a female deer. —*Trans.*

JAMES WHISTLER *Arrangement in Black and Gold:*
Comte Robert de Montesquiou-Fezensac 1891–92

Throughout the novel, Proust plants discreet allusions to Elstir's love of all things English and the interest the English take in him.

The character first takes shape in *Swann's Way*, in which he features as a friend of the Verdurins, a couple whose ambition is to create an artistic salon. In the early days, however, they succeed only in gathering a fairly paltry collection of people: a professor of medicine, Dr. Cottard, whose culture leaves much to be desired; a professor of literature at the Sorbonne named Brichot; a pianist; an anonymous painter; and a pretty woman of questionable virtue, Odette de Crécy, who brings Charles Swann with her as a guest one evening. His elegance, discernment, and knowledge of the arts are in stark contrast to the rest of the group.

It is around 1870 and "the painter" appears to be an Impressionist, judging by the Cottards' astonished response to his paintings, in which he seems to have thrown color onto the canvas at random. Mme Cottard is amazed that he thinks it normal to make women blue and yellow, and to depict her husband with mauve hair. Swann, on the other hand, appreciates his taste—which is a good sign—and recognizes that he is a man of intelligence when not playing the fool. He also regrets that the painter does not give serious answers to his questions about the virtuosity of a fashionable artist instead of ranting about the materials he uses: "There is no way of knowing whether it is done with glue or rubies or soap or bronze or sunlight or poop."[4] In this part of the novel, the painter speaks and behaves like a mischievous fine arts student; far from taking himself seriously, he indulges in the most outland-

ish pranks. Does he not, one fine evening, come up with the idea of having a bathtub delivered to the Verdurins' living room while they are having dinner and emerging from it naked and cursing just as the guests leave the table? Another time he dresses as a butler and mutters obscenities into the ladies' ears as he serves them. It is hard to imagine a brilliant future for this clown. In fact, we hear no more about him for some twenty years (or rather five or six hundred pages). And yet Swann, trusting his original intuition, continues to take an interest in Elstir and encourages the duchesse de Guermantes to buy his paintings, but the reader learns this only much later.

In *Within a Budding Grove*, the second volume of the novel, the Narrator—who was not yet born in the days of Swann's "amours"—is a young man, and when he mentions a major artist, Elstir, who lives in Balbec, the small Normandy town where he is spending his vacation, the reader pays little attention, no more able than the Narrator himself to believe this can be the Monsieur Biche of the Verdurins' soirées. All the same, at the restaurant he frequents with his friend Robert de Saint-Loup, the Narrator notices an "unfamiliar, solitary diner who arrives late." Intrigued by the handsome man with the graying beard and "thoughtful eyes gazing with some application into the void,"[5] he inquires of the manager, who tells him it is the famous Elstir. The manager had been struck by how much one of his customers, an Englishwoman, had admired the painter, and by the number of letters he received from abroad. Now remembering that he has heard Swann mention the name, the young man persuades Saint-Loup to send him a note expressing their respects.

When he has finished his meal, Elstir comes over to say a few words; he does not respond to the name Swann but seems to grasp that the Narrator, rather than Saint-Loup, genuinely appreciates the arts, and invites him to visit him in his studio.

Unlike all his predecessors—Balzac, Goncourt, Zola, and Maupassant—Proust never shows his painter plagued by an artist's uncertainties and anxieties. In fact, we never see him at work, although he is finishing a painting just as the Narrator arrives at his studio. Proust does not linger to describe the tools of the painter's trade in this room, which strikes him as "dark, transparent, and compact in its density, but also damp and gleaming along the cracks where the light formed a setting for it like a lump of rock crystal with one facet already cut and polished, and that occasionally flashes like a mirror and grows iridescent."[6] Proust takes absolutely no interest in the material side of producing a painting. In his essay on Rembrandt, he writes: "Museums are homes that house only thoughts...paintings are precious...the canvas, the colors that have dried onto it, and the gilded wood that frames it are not."[7] Which means that he sees an artist's studio not as some everyday work space, "but like the laboratory for a sort of new creation of the world."[8] Proust takes his contempt for technical terms so far that he often prefers to use words such as "froth," "fog," "snow," or "foam" to evoke a color rather than name it directly. He is quick to see Elstir as a god who creates a world, and actually often refers to him as a creator. But Elstir is also a mentor.

What impresses us first about Elstir is his kindness, goodwill, and generosity toward the young; not only does

he spontaneously invite the Narrator to his home, but it turns out that he is also on easy, friendly terms with the group of sporty young girls whom the young man finds intriguing and attractive. We later learn that "Elstir likes to give, to give of himself. He would have given everything he owned—his ideas, his works, and all the rest that he valued much less—to someone who understood him. But for lack of tolerable company, he lives in isolation and behaves with an unsociability that society folk call a pretense and bad upbringing, the public authorities an unsound mind, his neighbors madness, and his family selfishness and pride."[9] But when the Narrator pays his visit, Elstir treats him with affectionate familiarity. He carries on working and leaves his guest to turn around the canvases propped against the wall and rummage through his sketches.

Elstir not only enjoys giving, he also enjoys explaining, imparting knowledge like a teacher; and not necessarily on intellectual matters. Albertine, one of the young Balbec girls, has a very distinctive taste in clothes, and this is owed to Elstir's influence. Identifying her as an orphan who has been left entirely to her own devices, he has decided to mold her sense of style. When the Narrator admits that he was disappointed by the church in Balbec, this provokes a whole lesson on medieval sculpture which delights the young visitor. During this first meeting, Elstir proves so aware of the young man's state of mind that he transforms himself into a doctor, virtually a psychoanalyst: Elstir takes the Narrator's side when he confides that those close to him are concerned because he is so inclined to daydream. "When a mind tends to dream, it must not be stopped from this, or rationed... It is important to know all our

dreams if we don't want them to make us suffer."[10] When the Narrator finally realizes that Elstir is Monsieur Biche from the Verdurins' salon, he is amazed that "this genius, this sage, this loner, this philosopher who made such wonderful conversation and who mastered everything, was the ridiculous, perverse painter once adopted by the Verdurins…[Refusing to deny his past,] like a true master, [Elstir] chose not the words that could have avenged his pride, but those that could instruct…" And the artist added that no one should ever deny an episode of his life, however unpleasant the memories might be, because that is the only way to discover wisdom: "You have to discover it yourself after a journey no one else can make for you."[11]

It may seem surprising that Proust chose the painter for this role as a teacher. But on reflection, the decision makes sense, since he thought that "for writers and painters alike, style is not a question of technique but of vision."[12] He also chose to make Elstir an eminently moral character whose life—characterized by his taste for solitude, his fidelity to his wife, and his indifference to financial gain, highlighted by the fact he does not court collectors—is perfectly consistent with his artistic passion. Bergotte is a great writer, profoundly admired by the Narrator, for whom he reveals the hidden beauties concealed in Racine's texts and in performances by the famous actress Berma, but he does not improve on further acquaintance. He makes boring conversation, he is malicious, he takes a perverse interest in little girls, and, more pathetic still, dies convinced he failed in his work. Vinteuil, the musical genius, is so dull—"an old fool," to use Swann's verdict—that no one even wants to talk to him. This could not be further from Elstir. Besides,

Elstir's role in the Narrator's life goes far beyond allowing him to discover beauty hidden in life's lowliest manifestations: it is thanks to Elstir that the Narrator finally meets Albertine; thanks to Elstir also, or rather the pretext of seeing his work, that the young man gains access to the Guermantes' salon and discovers the splendors and miseries of society life.

The most important thing, though, is that Elstir teaches the Narrator to see: "Having been taught by Elstir how to remember with precision details I would previously have deliberately brushed aside, my eyes gazed at length on things they could not see in the first year."[13] He suddenly finds himself trying "to discover beauty in places [he] had never imagined it could be, in the most everyday things...the remains of a glass of wine, dark but glittering with light...the metamorphosis of plums going from green to blue and blue to gold in the already half-empty fruit bowl."[14] Our young intellectual of a Narrator turns his nose up at horse racing, and Elstir tells him he is wrong to: "What a transformation everything undergoes in the luminous vastness of a racecourse, where you can be surprised by so many shadows and flashes of light that you see nowhere but there. How pretty the women can be!"[15]

This transformation of things is highlighted by the fact that the Narrator does not recognize the landscapes in Elstir's canvases, because Elstir can paint "only by first transplanting [what he sees] into this inner garden,"[16] and the Narrator pursues this idea, explaining that a rose painted by Elstir is a new variety because, were it not for him, no one would ever have seen it. The same is true of the landscape of the Creuniers cliffs. In one of Elstir's

paintings, the cliffs look like huge pink arches, reminiscent of a cathedral. But, painted on a sweltering day, they seem to have been reduced to dust, volatilized in the heat. The vision is so personal that the young man is unable to recognize the cliffs, and he exclaims how sorry he is not to have seen that part of the coastline, when he has actually been there a hundred times. He now starts to understand that a true artist makes his creation burst out from the deepest, most secret part of himself, which would remain incommunicable without art. And, therefore, "thanks to art, instead of seeing just one world, we see it multiplied, and there are as many worlds available to us as there are original artists."[17] Most significantly, the Narrator understands that Elstir looks not with the eyes of intelligence and familiarity but with eyes that register only the impression things make. We have to forget what we know, Elstir tells him, and paint only what we see. "Elstir's work consisted of not showing things as he knew them to be, but staying true to the optical illusions that make up our first view."[18]

Here Proust is borrowing one of the tenets of the great English landscape artist, Turner, which he learned from reading Ruskin. Ruskin reports that Turner once drew some ships silhouetted against a bright sky and showed his sketch to a naval officer, who pointed out indignantly that the portholes were missing. But look, explained the painter, you can't see them in this light. True, replied the officer, but you know they're there. Of course, Turner agreed, but my job is to draw what I see and not what I know is there. In Elstir's case, or to be more precise, in the case of a seascape of the harbor at Carquethuit that the Narrator studies in detail, the painter has done away with the bound-

ary between the sea and the land, and Proust prepares the viewer's eye for this by using urban terms for everything to do with the sea and maritime ones for the land. So the boats were "moored along the jetty, but in such tightly packed rows that men could chat from one ship to the next without anyone noticing the distance between them or the intervening water, so this flotilla looked less like something that belonged to the sea than, for example, the churches of Criquebec, which stood in the distance surrounded on every side by water...seeming to emerge from the waves, whipped up out of alabaster or sea spray."[19] It is this confusion, this contamination of the elements, that constitutes the foundation of Elstir's work: he removes any distinction between the elements, and "it was this comparison, tacitly but tirelessly repeated within the same picture, that introduced its powerful, multiform unity."

This feature of Elstir's work, rejecting precise delineations, was not unfamiliar to Proust, for whom various dichotomies, notably that of masculine and feminine, were often indistinct. Here the character and the novelist share these preoccupations, whereas Balzac and Zola projected their concerns as creators onto their fictional artists. On his very first visit to the painter, the Narrator is struck by the absence of a precise demarcation between the sexes in a watercolor he finds among the paintings cluttering the studio. The picture shows a youthful figure wearing half men's and half women's clothing, "not pretty but an interesting type, sporting a headdress not unlike a bowler hat trimmed with cherry red silk ribbon; one of the mittened hands was holding a lighted cigarette while the other held a sort of large garden hat at knee level."[20]

The model appears to be a woman but the Narrator cannot quite decide, struck by the coexistence of two hats, one a man's (the bowler), the other a woman's (the garden hat); by the hair which is short like a man's but fluffed up like a woman's; by the male trait of holding a cigarette and the female trait of having a hat for protection from the sun; and by the contradiction between the masculine velvet jacket and a shirt front with frivolous pleats decorated with small bells like lilies of the valley. Was this a rather tomboyish girl or a perverted, effeminate young man? The painter "had focused on these signs of ambiguity as if on elements of a particular aesthetic that warranted highlighting."[21] He had not so much pitted the two tendencies against each other as underscored a shifting orientation, an oscillation: "The gender seemed to be about to make itself known...eclipsed itself...reestablished itself...then slipped away again, still elusive."[22] The painting—whose very title, *Miss Sacripant*, is significant because to French ears it confusingly combines the feminine *Miss* with the masculine *sacripant* (rascal)—sits well with the to and fro of sexual preferences in so many of the novel's characters.

Throughout the novel, the Narrator is obsessed with conflicts of likeness and identity: features inherited from Gilberte's parents, Swann and Odette, battle for supremacy in her face; Albertine bicycling, strapped into her supple yet oddly hard rubber tunic on rainy days, and sowing terror through the streets of Balbec, is seen as a warrior woman depicted by Mantegna, when at other times she evokes Titian's beautiful mistress, Laura; and the young Saint-Loup, who makes his first appearance in the novel in light, fluid clothes, and exudes a very feminine sort of

elegance which is immediately contradicted by his military valor, his skilled horsemanship, and his brisk, impatient gait. Lastly, Charlus's apparent virility is called into question because his voice becomes high and full of laughter when he drops his guard and surrenders to an altogether feminine sensibility. The power of this ambivalence, which is a feature of so many characters around the Narrator, was first revealed to him by Elstir.

Elstir's enduring interest in a sort of confusion between the sky and water or the earth and water could be seen as a sustained metaphor for sexual ambiguity, underscored, as Emily Eells points out, by the adjective "amphibian," used to describe the population of Carquethuit.[23] After Albertine's death, the most striking and painful thing for the Narrator, who is tormented by Albertine's love of women, is the memory of two of Elstir's paintings "in which naked women appear in a densely wooded landscape. In one of them, a girl is lifting her foot, as Albertine must have done, offering it to the washerwoman. In the other, she is pushing another girl into the water and her victim is playfully resisting, with her thigh raised and her foot scarcely touching the blue water. I now remembered that this raised thigh made the same swan-neck curve with the crook of her knee as Albertine's tapering thigh had when she was beside me on the bed, and I had often wanted to tell her she reminded me of these paintings. But I did not, so as not to kindle in her mind images of women's naked bodies."[24]

This is not the only lesson that the Narrator learns from his close friendship with the painter. Elstir reveals so fully

the beauty of objects and of the natural world around him that the young man feels no need to hang paintings in his home. He deliberately leaves his walls unadorned because he feels that every window frames a painting, and every day the painting is different:

> One time it was an exhibition of Japanese engravings: next to the narrow outline of a red sun as round as the moon, a yellow cloud looked like a lake against which gladiatorial swords were silhouetted...Sometimes the ocean almost completely filled my window, raised higher by a strip of sky marked only along its top edge by a line of the same blue as the sea...And sometimes against a uniformly gray sky and sea, a hint of pink introduced itself with exquisite refinement, while the wings of a small butterfly that had fallen asleep at the base of the window seemed to add Whistler's favorite signature to the bottom of this "harmony in gray and pink" so in keeping with the taste of that master from Chelsea.[25]

At the Grand Hotel in Balbec, the Narrator has the choice between the seascape that changes every day and appears before him framed by his bedroom window, or the view of the countryside visible from the landing outside his room. He sees the latter only very occasionally, as the landing window has opaque glass and is usually kept closed because the floor service waiter cannot tolerate drafts, but the Narrator likes it all the better because it elicits different pictorial responses in him. When he looks at the house a little way away from the hotel, he feels "that the angle and the evening light, while respecting its size, gave it a precious carved quality and nestled it in velvet, as if for one of

those miniature architectures, a small temple or tiny chapel worked in gold and enamels, artifacts that act as reliquaries and are only very rarely exposed to the veneration of the faithful." Looking out of the window in Paris affords the same surprising pleasure. "The houses were so very close to the windows across the courtyard that each casement became a frame through which a cook daydreamed as she gazed at the floor, or a young girl allowed her hair to be brushed by an old woman whose face, though barely discernible in the shadows, looked like a witch's; so, because the sound was lost in the distance between the buildings and because these silent gestures were revealed in a rectangle kept under glass thanks to the closed window, every house became an exhibition of a hundred pictures for its neighbors."[26]

There are many other examples of scenes seen briefly through a window or glimpsed in a mirror. There is Albertine seen through the honeysuckle-clad window of Elstir's studio, "on her black hair a cap pulled down toward her chubby cheeks, her eyes gay and a little insistent,"[27] before she immediately moves away; there are the two misbehaving lesbians seen in a mirror at the Grand Hotel;[28] and last there is the vision of the Narrator's own face in his final years of sickness and constant work, the face of a man "who, having not looked at himself for a long time and who always conjured a face he could not see based on the ideal image he has of himself in thought, backed away when, in the middle of an arid, deserted face, the mirror showed him the oblique pink protuberance of a nose as gigantic as an Egyptian pyramid."[29] Views become more complicated when there is more than one window, as for example on a

train, and the Narrator, dazzled by the sky and modulations of the light, spends his time "running from one window to the next to bring together, [bind] together the intermittent fragments, seen from opposite sides of the train, of [his] gorgeous shifting scarlet morning, so as to have an overall view of it and a continuous picture."[30]

So it is not a painter's work or his life that interests Proust, and neither is he trying to make his character a thinly disguised portrait of a living person. Interestingly, the only detail that could associate Elstir with a real painter is a linguistic mannerism. Elstir tends to use the word *type* (fellow) in an almost anachronistic way when, for example, he says of a medieval sculptor, "you can be sure that the fellow who sculpted this facade was just as skilled and had ideas just as profound as the people of today you most admire."[31] We recognize a habit of Vuillard's in this usage, thanks to a letter from Proust to Reynaldo Hahn: "[Vuillard] says intently, 'a fellow like Giotto, wouldn't you say, or perhaps a fellow like Titian, they knew just as much as Monet, did they not, a fellow like Raphael,' etc...."[32] What Proust wants to demonstrate, then, is not an artist's life but how a great artist can half open the door to a new world for anyone who knows how to look, and perhaps this explains the choice of a painter rather than a writer or a musician for this demonstration. Reading implies a deliberate effort, while looking around us is inevitable. Reading is not for everyone, but whether we like it or not, we live surrounded by paintings. Although we do not see Elstir again after the Narrator's second stay

in Balbec, his work and his influence endure throughout the novel.

Proust's readers are often tempted to identify models for characters in the novel—a pointless exercise where Elstir is concerned. While Jean-Pierre Angrémy was director of the French Academy in Rome, he came up with the idea of giving Elstir a show. Using all the clues scattered by Proust throughout the text, he hoped to mount the first retrospective of Elstir's work. Sadly, the project came to naught. Perhaps it was simply impossible to put on because Elstir is inspired by so many artists, from Raphael to Monet via Chardin, Turner, Gustave Moreau, Whistler, Manet, Degas, Renoir, and Helleu; and his style is dizzyingly diverse, not least because of his erudition. This aspect of the character, which produces a degree of contradiction in Elstir's thought, is very like that of Émile Mâle, the great historian of the Middle Ages whom Proust consulted frequently. Indeed, for a scholar, only an ancient monument warrants attention, whereas to an Impressionist painter, "ancient monuments and modern buildings are on an equal footing."[33] Elstir is often torn between these two concepts, and this antagonism assumes its full significance during his digressions on the subject of restoration work.

There are times when Proust intentionally names a work of art, allowing the reader to substitute the name of a real painter for Elstir; at others only an allusion hints at the model Proust had in mind. When, for example, the duc de Guermantes rebels against Swann's ambition to make him buy Elstir's *Botte d'asperges*, it is not hard to guess that in this instance Elstir is Manet, particularly as the duchess comments that Zola wrote a monograph on him, a very

clear reference to Zola's famous article about Manet.[34] In the same scene, Elstir becomes Renoir when the conversation shifts onto some other paintings, and the duke pokes fun at the incongruous top hat worn by a gentleman on the terrace of an open-air café, amid a group of working-class boys in boating jerseys, and relaxed-looking young women. It is impossible not to recognize Renoir's *Luncheon of the Boating Party* (*Déjeuner des canotiers*), even though Proust does not identify the painting by name. Neither does Proust mention the name Degas, but does he need to when Elstir shows the Narrator "a sketch made at a nearby racecourse"[35] and expands on the jockey "in his blazing jockey cap, completely at one with the prancing horse he is reining in...and the brilliant splash he makes"?

Helleu, like Elstir, adored the sea and showed a predilection in his paintings for young women dressed in white, and he too clearly appears when Elstir tells the Narrator and Albertine how he sees something exquisite in its simplicity: "What is graceful are those light, single-color white outfits in calico, linen, raw silk, or twill which, when seen in sunlight against the blue of the sea, turn as brilliant a white as a white sail."[36] It is hard for us to gauge Helleu's success at the time, but it went beyond the borders of France. He was so popular in the United States that he was asked to decorate the ceiling of New York's Grand Central Terminal with a starry vault featuring a zodiac with golden signs and a silvery Milky Way. Strangely, when Helleu copied his starry skies from a medieval manuscript it came out the wrong way around. The mistake, which Helleu justified with the argument that he had shown the view God

PIERRE-AUGUSTE RENOIR *Luncheon of the Boating Party*
(*Déjeuner des canotiers*) 1880–81

had of the heavens, was never corrected! Proust amused himself by slipping in many more allusions in order to give his Elstir further depth: he owes the gods, muses, and centaurs of his first period to Gustave Moreau; thanks to Chardin, he passes on to the Narrator a liking for still life, illustrated by the description quoted earlier of a table at the end of a meal.

But the painters to whom Elstir owes the most are Monet and Turner. We detect the supreme importance given to Monet, one of Proust's favorite painters, in key passages dealing with Elstir's art. It is clearly Monet who inspired Proust when he described the landscapes of cliffs as well as the seascapes, in which the Narrator admires "the places where the sea is so calm that the reflections feel almost more solid and real than the hulls of boats vaporized by the effects of the sun,"[37] or the paintings inspired by Monet's Venetian canvases, in which the reflections of various buildings seem to invent a new reality: "Elstir was so interested in the interplay of shadows, now made commonplace by photography, that he had once taken pleasure in painting actual mirages, where a castle topped with a tower appeared as a perfectly circular castle lengthening into a tower at the top and an equal and opposite tower at the bottom, either because the extraordinarily clear air of a fine day lent the shadow reflected in the water the rigidity and brilliance of stone, or because the morning mists made actual stone as nebulous as a shadow."[38]

At the end of the novel the Narrator says of Monet that he gave Swann and M. Verdurin lessons in the truth. He could have added that Monet gave him, the Narrator himself, such memorable lessons in this vein that he seems to

CLAUDE MONET *Bridge Over a Pool of Water Lilies* 1899

be describing Monet's famous paintings when he relates his joy at seeing "veritable gardens of water lilies flowering in the small pools that make up the Vivonne…a little farther on, clustered together in what amounted to a floating flowerbed, they could be mistaken for garden pansies that had alighted, their frosted bluish wings like butterflies, on the transparent obliquity of this aqueous flower garden."[39]

When we consider Ruskin's profound influence on him, it is hardly surprising that Proust borrowed from English and American painters in his portrait of Elstir. Proust spent nine years immersed in reading, translating, and studying Ruskin, the highly acclaimed British art critic who believed that artists should interpret nature, and writers should describe only what they saw—a theory Proust would lend to Elstir. Ruskin is barely mentioned in *In Search of Lost Time*, but it is clear that Elstir's taste for Turner and the Pre-Raphaelites comes from reading Ruskin. It is Turner, though, who would give Elstir his most striking characteristics. In fact Turner is the only painter whose name is appended to Elstir's, and the very fact of juxtaposing the name of a real person with that of a fictional character reinforces the close association. "It afforded the same pleasure [as] a landscape by Turner or Elstir,"[40] the Narrator comments. Ruskin wrote of Turner:[41] "Never was he able to accept the idea of a definite distinction between sea and sky, or sea and land."[42] The Narrator describes Elstir's painting *Le port de Carquethuit* almost in the same terms: "In the foreground on the beach, the painter had managed to train his eyes not to recognize a fixed boundary, an absolute demarcation between the land and the ocean. Men pushing boats into the sea ran through the waves as

well as on the sand."[43] The confusion only increases when he speaks of the "ship out to sea, half hidden by protruding structures in the dockyard, [which] seemed to be drifting through the middle of the town [so that] the whole painting gave the feel of those ports where the sea plies into the land, where the land is itself seafaring and its population amphibian."[44]

Finally, Whistler is of undeniable importance all the way through the novel. Proust admired him unreservedly (Ruskin, on the other hand, loathed him and wrote a particularly virulent and unjustified review of his work, which prompted Whistler to sue him for libel.) We shall see later the role Whistler played in the development of the baron de Charlus character, but he is also very present in Elstir's seascapes, particularly those in which the sky and the sea mingle in an almost monochrome silvery blue.

As mentioned above, Elstir appears only in two episodes of the novel, but Proust gives tremendous significance to some of his paintings, either to reveal his characters' personalities or to move the plot forward.

9　The Painting as a Novelist's Tool

Proust never describes a character's appearance in its entirety. He might evoke it with only one detail, one gesture, or a silhouette until a painting comes along to complete the image. The painting is more often than not real, either hanging on the walls of the Louvre or remembered from a visit to Italy or the Netherlands; occasionally, though, it is Elstir's paintbrush that comes to the author's rescue.

The character most significantly and most obviously linked to models in paintings is Odette, the courtesan whom the elegant Swann marries after a long affair. In her case, at least one work of art is essential, because, paradoxically, Swann does not fall in love with the woman herself but with the Botticelli of which she reminds him. The first image associated with Odette, then, as she appears to Swann in the early days of their love, is the figure of Zephora, daughter of Jethro, who features in a fresco in the Sistine Chapel dedicated to the life of Moses. The real Odette is a little worn out and languid, her skin peppered with a tiny red rash, and her eyes often tired and sullen, in a word, unremarkable, but in Swann's eyes she becomes part of an imaginary world where she is "suffused with nobility." It feels as if Proust had a reproduction of the image in front

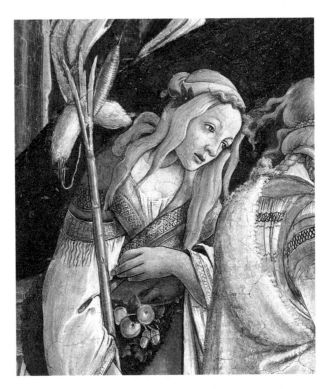

SANDRO BOTTICELLI *The Trials of Moses* 1481–82

of him as he described Odette with her richly embroidered robe clutched over her breasts like a coat and bending one knee almost as if dancing, and from this point on she is transformed in Swann's eyes. She becomes an object of admiration, with "the big eyes, the delicate face with its suggestion of imperfect skin, the glorious waves of hair down the sides of the tired cheeks" of the girl in the painting.[1] And it is the transformation of an actual woman into a painting that sparks the man's desire. The real Odette did not attract Swann: she bored him, "aroused no desire in him, even caused him a sort of physical revulsion,"[2] but as soon as he sees her as Zephora she becomes "a priceless masterpiece, cast just that one time in some different, especially charming material, creating the rarest of pieces that he contemplated sometimes with the humility, spirituality, and selflessness of an artist, sometimes with the pride, egotism, and sensuality of a collector."[3] And instead of putting a photograph of Odette on his desk, he chooses a reproduction of Zephora: "When he had looked at this Botticelli for a long time, he thought of his own personal Botticelli, whom he found still more beautiful."[4] But rather than finding happiness with Odette, Swann is torn apart by jealousy, tormented by this woman who turns out to be cold and grasping. Another painting is then substituted for the fresco in Rome: now when he thinks of his mistress the image that comes to mind is the naked, bejeweled Salomé pointing at the head of Saint John the Baptist in Gustave Moreau's *The Apparition*, "a shimmering amalgam of diabolical, unfamiliar elements, set ... among venomous flowers intertwined with precious gems."[5]

Swann's passion fizzles out, and in one of the most

famous dramatic flourishes of the novel, he marries Odette when he no longer loves her. The enduring aesthete in Swann wants his wife to be exceptionally elegant: she will never again be his Zephora, but he still sees a Botticelli in her, and likes the fact that her hands remind him of "the Virgin's fluid, slightly tormented gesture as she dips her quill into the inkpot handed to her by the angel"[6] in the *Madonna del Magnificat* at the Uffizi Gallery in Florence. Odette resists this and refuses to wear a gorgeous blue-and-pink oriental scarf he buys because it is exactly like the one the Virgin is wearing in the painting. In the end Odette gives in and allows Swann to order for her "an outfit scattered with daisies, cornflowers, forget-me-nots, and campanulas, as seen in *Primavera*."[7]

Another work is essential to Odette's makeup, but this one is fictional rather than historical. It is Elstir's portrait *Miss Sacripant*, and it reveals to the Narrator aspects of Odette's character he had never suspected, as well as her age, because the painting is dated. The Narrator, as we have seen, is intrigued by the subject because of the model's sexual ambiguity. He has an inkling that it is a depiction of Mme Swann before her marriage, and the portrait opens his eyes to Odette's past, a subject about which he—and therefore the reader—knows very little. Her evasive personality, her propensity to vice, and her amorality are suddenly obvious to him. He also suspects an affair with Elstir, when they were both young, because he is surprised by how swiftly the painter hides the watercolor when his wife comes into the studio. Everything falls into place in the Narrator's mind just from seeing this sketch. It is this image, then, that extends our knowledge of two characters: an Odette with a

dubious past and an Elstir who is now a good and faithful husband, balking at the thought of arousing retroactive suspicions in his wife, his beautiful Gabrielle.

When dealing with a character as crucial and complex as the baron de Charlus (and, what is more, a character who is not seen almost exclusively through the eyes of another character, as Odette is seen by Swann), Proust uses pictorial references more indirectly, whether describing him physically, highlighting a moral or intellectual quality or even suggesting a perversion. Charlus evolves over the course of *In Search of Lost Time*: at the beginning of the novel he is a vigorous and very elegant young man, an ideal model for Whistler: "the willful and artful simplicity of his tailcoat, which, with the merest details that only a tailor could spot, [made him] look like a *Harmony in Black and White* by Whistler."[8] This reference to Whistler is interesting in several ways. First, people of Proust's milieu would immediately have grasped the similarities between Charlus and Robert de Montesquiou, a magnificent, provocative homosexual of whom Whistler had painted an admirable portrait. Second, Whistler was not a popular painter at the time, and Charlus cruelly points out to the Narrator that he, in his colossal ignorance, probably does not know him. So Whistler is used here as a code word implying homosexuality, elegance, and a sort of exclusiveness.

One of Charlus's defining characteristics is his outrageous pride. He deploys it in a sequence during which he pretends to forgive the Narrator for an imaginary offense by referring to a famous painting: "Just as in Velázquez's *The Surrender of Breda* ... the conqueror steps toward the humblest of men and, as all noble men should, given that I was

everything and you were nothing, I was the one to take the first steps toward you."[9] The victor at the battle of Breda, the subject of Velázquez's painting, was in fact the great strategist Ambrogio Spinola, a descendant of one of the oldest and most powerful families in Genoa, and he treated his adversary, General Justin of Nassau, the illegitimate son of William the Silent, with perfect chivalrous courtesy. A more unexpected pictorial allusion comes later, when Proust introduces the image of the cardinal nicknamed the Great Inquisitor and painted by El Greco, to describe not the elegant Charlus in fine company, but a shiftier Charlus on the prowl along the *grands boulevards* of Paris or in the waiting room at Saint-Lazare station, a Charlus with blackened eyelashes and powdered cheeks. What Proust wants to suggest is that in this guise, Charlus is paradoxically both frightening—just like the powerful Inquisitor in his resplendent robes, with his icy stare and clenched hand—and looks "like a forbidden priest."*[10] In doing this, Proust brings on the stage the ghost of one of Charlus's literary models, Balzac's Vautrin, a terrifying homosexual who at one point is disguised as a Spanish priest.

Lastly, Proust calls on Carpaccio to provide a background for Charlus's final appearance before his eventual downfall. This takes place in a war-torn Paris, not the grim, dark Paris of blackouts but a fantastical Paris, "an imaginary exotic city" where so many different people converge: Allied soldiers in their national uniforms, "Africans in wide red skirtlike pants, white beturbaned

* During the French Revolution, priests who refused to pledge allegiance to the new constitution had to hide to avoid persecution. They were known as the refractory or forbidden priests.

Hindus, [a Paris transformed] into an Orient that was both meticulously precise in terms of costumes and the color of faces, and arbitrarily whimsical as far as the setting was concerned, in the same way that Carpaccio could turn the town where he lived into a Jerusalem or a Constantinople by filling it with a crowd no less gloriously multicolored than this one."[11] Into this scene comes the tall, bulky Charlus in his greatcoat, tailing two Zouave infantrymen, surrounded by unusual-looking, beautiful, and virile young men, and he looks so different from his former self, the great and elegant nobleman, that he seems to be wearing a mask, to have lost possession of himself. Whistler, the portraitist who excelled at representing the refinement of the aristocracy, gives way to Carpaccio, whom Proust sees here as a magician, a master of metamorphosis. It is as if the painting had a psychological function here, announcing or commenting on the character's behavior, and in so doing altered the subject of the painting to serve the novel. "Confronted with a painting, Proust behaves like a predator," points out the historian Sophie Bertho.[12] He takes from the painting whatever he finds useful.

A good many other characters are outlined with the help of pictorial allusions; these are often ironic, and are almost sacrilegious when Proust uses religious images. It isn't the painting itself that matters to him but the fact that it serves his purpose. Let us take the famous example of Aunt Léonie's kitchen girl, nicknamed "Giotto's *Charity*" by Swann, who is struck by the appearance of "the poor girl, so fattened up by pregnancy even on her face, even

in her cheeks, which hung straight and square, [that] she genuinely did look like those bulky, mannish virgins...in whom the virtues are personified at the Arena."[13] Giotto is also used to add complexity to Albertine's character and to accentuate her mystery. The Narrator catches sight of her "flicking up a strange object on a length of thread, which made her look like Giotto's *Idolatry*, it is in fact called a *diabolo*."[14] We should not forget that this allegory represents both idolatry and infidelity, and that in Giotto's fresco the subject is a young man holding an idol with a woman's face on the end of a piece of string. This image of a young woman dressed as a young man and adoring a female idol introduces the theme of lesbianism, which is to become an obsession for the Narrator, and will partly determine the nature of his relationship with Albertine. Proust uses a painting by Carpaccio when he returns to the ambiguous nature of Albertine's sexuality at the end of the novel: Albertine's death has done nothing to appease the Narrator's jealous curiosity about his friend's tastes, and now in Venice, working his way through the galleries at the Academy, he sees *The Cure of a Lunatic by the Patriarch of Grado* and feels "a slight bite" at his heart because one of the characters depicted in it, a member of La Calza's brotherhood, seems to be wearing the Fortuny coat he gave Albertine. "It was from this Carpaccio painting that that genius son of Venice had taken it, he had taken it from the shoulders of that member [in the joyous brotherhood] to throw it over the shoulders of so many Parisian women."[15] All the Narrator's fantasies come together in this painting. Embroidered on the hood of one of the young men's coats are the words *Con Tempo*; and these elegant

young men all have an undeniably feminine appearance. Sophie Bertho points out that Proust had very probably closely studied an engraving taken from a preparatory sketch for the painting which shows the young companion from behind, draped in the folds of a long coat, his hair falling to his shoulders, his ankles fine and his legs long and slender. And—an unexpected twist—this engraving hangs in the Albertina Collection in Vienna.[16] The bite that the Narrator feels at his heart reminds us of his conviction that during her lesbian romps, Albertine would bite her partner. Finally, how can we not attach importance to the French title of the painting as Proust would have known it, *Le patriarche du Grado exorcisant un possédé* (The Patriarch of Grado Exorcises a Possessed Man)? For Proust attributes to the painting an exorcising power: having recognized Albertine in the young man, the Narrator will at last be able to forget her. "Resuscitated in Venice for the space of a slight bite, Albertine returned all the more fully to oblivion."[17]

Other examples show Proust appropriating a work of art in order to retain only a few details that were of use to him. One character, M. de Palancy, has an insignificant walk-on role in the princesse de Guermantes's opera box, but he is unforgettable thanks to his nose, filched from an old man painted by Ghirlandaio, and "his fat, carplike face with its round eyes [whose monocle looked like] an accidental and perhaps purely symbolic fragment of the glass walls of his aquarium."[18] These features remind Swann of Giotto's "*Injustice*, beside whom a leafy bough evokes the forests in which his lair is hidden." Another very fleeting character, Doctor du Boulbon, earns his "lifelike

authenticity"[19] thanks to "the broken nose, penetrating gaze, and puffy eyelids"[20] he shares with a Tintoretto model. Proust took remarkable liberties in his use of masterpieces: one final example of a Giotto appears during the Narrator's visit to Padua, when he studies the fresco in which the artist depicted angels flying in the sky. The Narrator sees "winged creatures...rising up, describing arcs, executing loop-the-loops with the greatest of ease...and looking more like a variety of bird or young pupils of Garros practicing their gliding than Renaissance angels."[21]

Whole rafts of characters are associated with a painting or painter in this way to help the reader picture them. The Narrator's exasperating friend Bloch is elevated somewhat in the reader's opinion when Swann says he remembers him because "he looks so like Bellini's portrait of the Sultan Mehmet II. Oh! It's striking, he has the same pointy eyebrows, the same hooked nose, the same strong cheekbones. When he grows a little beard, it will be the same person."[22] The duchesse de Guermantes, who is the subject of such prolonged and passionate observation throughout the novel, makes a very prosaic entrance in the first volume. The Narrator is still a child and pictures her in "the colors of a tapestry or stained-glass window," and to his great surprise he is shown a lady, like so many others, with "a big nose, piercing blue eyes...and a small spot at the corner of her nose."[23] In this particular instance, Proust is not describing a character but emphasizing the difference between the dream and reality; what is interesting for our purposes, though, is that to achieve this Proust still refers to a work of art, in this case a stained-glass window.

In the same way that he did not always cite his literary sources, Proust did not always mention the painters to whom he alluded. The actress Rachel appears in the duchesse de Guermantes's salon with a large lily in her hand and a costume, the writer specifies, copied from *Ancilla Domini*. Here, Proust does not give the name of the painter, Dante Gabriel Rossetti; it is up to the reader to know it. When describing Napoleon III's cousin, Princess Mathilde, whom Swann meets along with his wife and the Narrator while they are out walking, Proust settles for identifying her with just a mention of the name Winterhalter, portraitist for Napoleon III's entire court. Sometimes he chooses a very secondary figure in a work of art to outline one of his characters. Swann, for example, is compared to one of the Magi in Bernardino Luini's *Adoration* for his blond hair and hooked nose. And before Swann even appears on the stage, his artistic tastes are indicated by the fact that his Corot is mentioned in *Le Figaro*. Proust can also be surprising in his precision: the horrible Madame Blatin, who pesters the Narrator's mother, is Fra Bartolomeo's *Savonarola*; and the beautiful Morel, with whom Charlus is madly in love, is a Bronzino. The mother in the novel, an aging figure in mourning, is reduced to the image of the old woman with sad eyes and black veils in Carpaccio's *Funeral of Saint Ursula*. Here of course there are no surprises but an excellent shortcut, just like the one used for M. de Beausergent, whose features, stiffened by arteriosclerosis, "have the intense, almost grimacing definition of prolonged immobility that they would have had in a study by Mantegna or Michelangelo."[24]

On the other hand, there is a more unexpected comparison of the duc de Guermantes, who is so often brutal, vulgar, and cutting, with Rembrandt's burgomaster Jan Six, who exuded "gentle gravitas." This is because Proust wants to evoke the duke's despairing resignation when he hears that his friend Swann is a Dreyfusard. The duke's anti-Semitism is also very discreetly intimated through the Elstir painting mentioned above, modeled on Renoir's *Luncheon of the Boating Party*. The duke seems to know the man in the top hat (a clear allusion to Charles Ephrussi, a very elegant Parisian Jew and one of Renoir's first champions) featured in the painting, but cannot recall his name and says, "I know he's not a nobody nor is he a disaster in his field, but I've had a falling out with people's names. I have it on the tip of my tongue, Mr.... Mr.... well, what does it matter, I've forgotten. Swann can tell you who it is."[25] There is heavy innuendo in this passage. Charles Ephrussi was known by all of Parisian high society, but the Dreyfus affair saw him denied access to every aristocratic salon. Nothing surprising then in Basin de Guermantes's having struck him from his universe and turning to the Jew Swann to be reminded of his name. In Proust's work, a painting opens the door to far more than the world of fine art.

Even the character of Françoise, Aunt Léonie's cook in Combray, is conveyed through an image. The first time the Narrator sees her he is still a child, and she appears to him "beneath the folds of a dazzling bonnet, as stiff and fragile as if it were made of spun sugar,...framed in the small doorway to the corridor like the statue of a saint in her alcove."[26] This first impression is important because

Françoise, a medieval peasant who has survived into the nineteenth century, represents the virtues of ancient France, virtues inexorably linked to piety and respect for the church. A few hundred pages farther on, a few years later, Françoise has left Combray for Paris after Aunt Léonie's death, and combines the duties of cook and chambermaid. It is in the latter role that she accompanies the Narrator and his grandmother to Balbec on the Normandy coast. Her unfailing good taste allows her to make such pretty improvements to the secondhand clothes she is given that, according to the Narrator, only Chardin or Whistler would have been able to position a velvet bow or a knotted ribbon with the same artistry. But Proust does not relinquish the medieval image, and goes on to compare the old servant in her inside-out coat of cherry-red serge with its fur collar "to someone in those pictures by Anne de Bretagne, painted by an old master in books of hours."

Given the diversity and precision of pictorial allusions in *In Search of Lost Time*, it is surprising that the three women—the duchess, Gilberte, and Albertine—who most occupy the Narrator's imagination and heart do not provoke more significant references. The duchess, as mentioned above, appears as if in a "tapestry or stained-glass window," then she is linked to a Tiepolo for the red of one of her stupendous evening gowns; Gilberte is not associated with a painter; and if Albertine's braids evoke Titian's portrait of Laura Dianti, if her *diabolo* reminds us of Giotto's *Idolatry*, and if, from a certain angle, "one aspect of her face…as hooked as in some of Leonardo's caricatures, [seemed] to reveal spitefulness, a grasping nature,

and the trickery of a spy,"[27] she is never transformed into a work of art. This is because, unlike Swann, the Narrator is incapable of admiring a woman "in an artistic way." He even adds that when Albertine rests her fingers on the keys of the pianola like a Saint Cecilia, and he first sees her as a "gloriously patinated" angel musician, she immediately starts to bore him.

The most singular feature of this constant analogy between art and life is that the object of comparison is not always a person. Seen from the railway line, Combray nestling within the remains of ramparts looks like "a small town in a primitive painting" contained within a perfectly circular line. The Trocadéro, a peculiar construction built for the 1878 Universal Exhibition in Paris (and torn down and replaced by the Palais de Chaillot in 1937), was half Moorish and half Byzantine in style, "with giraffe-neck towers," and is reminiscent of the background in Mantegna's *Saint Sebastian*. Even psychological characteristics are specified with the help of paintings: the duc de Guermantes's mental universe, frozen in a pre-Revolution past, is compared to old bewigged portraits dating back to the days of Louis XIV. And when the Narrator reflects on the fact that the Combray that is still alive in his imagination no longer exists, he explains his thoughts by referring to Bellini's great painting featuring the portal of Saint Mark's Basilica as it was in 1496 but is now no longer.

Last of all, we must make room for Vermeer and "the most beautiful painting in the world," *The View of Delft*. Proust refers to Vermeer twice: the first time, as is usual for him, he

uses the painter to dig deeper into his character's personality; the second time, the painting has a more dramatic role.

Present-day readers are often unaware that Vermeer was very little known and even less admired when Proust was a young man. Thoré-Burger, a journalist who first trained as a lawyer, salvaged the neglected painter from oblivion by publishing an article on him in the *Gazette des Beaux-Arts* in 1866. But that was not enough to secure glory for Vermeer. In 1881 a Dutch official bought his *Girl with a Pearl Earring* at a public auction for the derisory sum of two gulden and thirty cents. Proust saw his first Vermeers during a trip to the Netherlands in 1902. He was instantly won over and later told his friend, the art historian Jean-Louis Vaudoyer: "Ever since seeing *The View of Delft* at the museum of The Hague, I have known I have seen the most beautiful painting in the world."[28] And he went on to introduce Vermeer into *In Search of Lost Time*.

Early in the novel, Vermeer is evoked enigmatically with the appearance of a brightly lit section of wall in the shadows when the Narrator remembers Combray in the middle of the night, prefiguring the section of yellow wall in *The View of Delft* which will become so important much later in the work. Vermeer is mentioned specifically for the first time when there is talk of a study that Swann wants to devote to the painter. Given that the episode takes place around 1870, when the painter was neglected, this is Proust's way of emphasizing Swann's genuine and original taste. Meanwhile, when Odette is made aware of this project, she asks Swann naively about the artist because she has never heard of him; her ignorance is less shocking than her stupidity, which is demonstrated by the fact

that she loses interest when Swann admits he does not know whether the artist ever suffered at a woman's hands or was ever inspired by a woman. Swann, we are told, abandons the project, and it seems the Narrator also abandons Vermeer. The painter returns only thousands of pages later, and it is not Swann who reintroduces him but the novel's great writer, Bergotte, just as he is dying.

We know that, despite the terrible difficulties he encountered undertaking any daytime activity, Proust decided not to spend a day in bed so that he could visit the exhibition of Dutch paintings at the galleries of the Jeu de Paume with Jean-Louis Vaudoyer. This visit gave him the basis for Bergotte's death scene. Disregarding the advice of his doctor, who has prescribed rest, Bergotte is determined to go to the museum because a critic has "said that in Vermeer's *The View of Delft*...a painting he adored and thought he knew well, a small section of yellow wall (that he did not recall) was so well painted that, if you looked at it alone, it was like a precious work of Chinese art, so beautiful it was sufficient unto itself."[29] Once in the gallery, Bergotte realizes that his recollection of the painting is indeed rather imprecise, and "like a child locking onto a yellow butterfly he hopes to catch, he pinned his gaze on the precious little section of wall."[30] The impression is so strong that, with a sudden powerful sense of the unity of the arts, Bergotte unexpectedly finds himself considering the proximity between a painter's art and a writer's, and in a moment of intense regret concludes: "This was how I should have written...my last books are too spare, I should have applied several layers of color, made my sentences precious in themselves,

like this little section of wall."[31] This strikes me as the best description of Proust's style, long sentences in which every word adds a nuance, a varnish, a detail to achieve a pure marvel.

The importance of classical paintings is obvious in the way Proust's characters see things and therefore in the way they think, but it is difficult not to wonder about the role of cubism in Proust's work. I have said earlier that Proust did not seem especially inquisitive about contemporary art. He rarely left his apartment in the last ten years of his life—years of sickness and intensive work—and no longer visited galleries. Through the young poet Jean Cocteau, he had antennae into the world of the avant-garde, and it was Cocteau who took him to see Picasso in his studio. According to his housekeeper, Céleste Albaret, Proust was not exactly thrilled. Back at home, he told her that Picasso "is a Spanish painter who has turned to what they call cubism. I have to admit that I didn't really understand it."[32] An interesting statement, given the number of cubist elements in his own style in the sense that he often simultaneously adopts different points of view to describe individuals, things, or events.

Certainly, there are no mentions in the novel of cubist paintings or painters. Elstir is an Impressionist, and it would not have been possible for Proust to represent Elstir's works had he not spent a great deal of time looking at Manets, Monets, and Renoirs. But if we accept the definition of cubism as an abandoning of a single viewpoint, then there are parallels between the cubist painters and the way Proust looks at and describes characters and

landscapes. The first reader to detect this trait was his publisher, Jacques Rivière: "[O]ne thing that struck me for the first time is your relationship with the cubist movement, and more fundamentally your profound immersion in contemporary aesthetic reality. Never have the same statements been presented from so many different angles, to the point, no doubt, that they seem to lose all meaning, and would lose all meaning if the movement and ceaseless continuation of your narration didn't ensure their restoration."[33] Fernand Gregh was saying the same thing of his friend Marcel in more familiar terms when he commented: "At twenty, Marcel looked on life the same way a fly does, with a multifaceted eye. He saw polygonally. He saw all twenty sides of a question, and added a twenty-first which was prodigiously inventive and ingenious."[34]

We have an illustration of this aptitude when the young girls appear at Balbec: "I knew nothing of them except that one had a pair of hard, stubborn, laughing eyes; another cheeks whose pink had a coppery note somehow reminiscent of geraniums... and when I saw a white oval, a pair of dark brown eyes, a pair of green eyes appear, I did not know whether it was the same girls who had been so charming earlier... And this failing in my sight, the demarcations I would soon establish between them, disseminated a harmonious wavering through their group, the continuous translation of a fluid, collective, shifting beauty."[35] Or in this comment about the indefinable Albertine, which immediately conjures a Picasso painting:

* Siamese twins Radica (Proust mistakenly wrote "Rosita") and Doodica were successfully separated through an operation in 1902.

"How much more strange it is for a woman to be joined, as Rosita and Doodica* are, to another woman whose different type of beauty produces another personality, and to see one you have to view her in profile, and the other full in the face."[36] The very common dislocation in cubist tendencies is also present in this description of a modern outfit of Odette's: "it was difficult to make out the continuity [of Odette's body] because the bodice bulged so far forward, as if over an imaginary stomach, ending abruptly in a point, while the billowing of the double skirts started to swell out underneath it, so that the woman seemed to be made of two different pieces badly hafted together."[37]

Of course landscapes provided many more opportunities to describe an amalgam from different points of view. The Narrator says that in Paris he knows "a window through which you can see, beyond a first, a second, and even a third layer of rooftops accumulated over several streets, a violet-colored dome…which is none other than the cupola of Saint-Augustin, and it makes this view of Paris feel like some of Piranesi's street scenes in Rome."[38] The bell tower at Combray looks completely different depending on the time of day and the place from which it is seen: "When you saw it at five o'clock…an isolated pinnacle suddenly rearing up over the line of roof ridges…or, venturing further…you saw it at an angle, showing its edges and new surfaces in profile, like a solid figure caught at an unfamiliar phase of its rotation; or from the banks of the Vivonne, when the apse was muscularly hunched together and heightened by the perspective and seemed to spring up with the physical effort that the bell tower was making to launch its arrow right into the sky."[39] The most

convincing example is the steeples of Martinville, which appear during an outing in a horse-drawn cart, and afford the young Narrator a mysterious pleasure. At a bend in the track he spots "Martinville's two steeples lit up by the setting sun, and the movement of our cart and the twists in the track made them look as if they were changing places, and then the steeple in Vieuxvicq which, although on a plateau in the distance and separated from them by a hill and a valley, seemed to be their close neighbor."[40] In the scene when he first kisses Albertine, the Narrator adds a fourth dimension—time—to his view of the face coming toward him: "by vastly accelerating the speed of changes in perspective and changes in coloring with which another person presents us in our various encounters, I wanted to contain them all in the space of several seconds to make an experimental re-creation of the phenomenon that diversifies a person's individuality, and separate out all the possibilities it comprises, as if drawing them from a sheath, so that in the brief journey my lips made toward her cheek, I saw ten Albertines."[41]

Not having studied any cubist works at length, Proust was not influenced by them, and neither were the cubists influenced by his style: they passed each other by. Whereas there are justified analogies to be found between the Impressionists and writers who were their contemporaries, the same cannot be found in the case of Proust and the cubist movement. But there is no escaping the striking coincidence in their vision, operating through the fragmentation and recomposition of images. The definition Guillaume Apollinaire gave for cubism as consisting in "painting new compositions with formal elements bor-

rowed not only from the view as it really is but also as it is conceived"[42] applies just as much to Proust's description of a face seen both front-on and in profile, or of accumulations of roofs that take no account of the distance between buildings.

In 1925, when Virginia Woolf was immersed in reading Proust, she wrote, "Were all modern paintings to be destroyed, a critic of the 25th century would be able to deduce from the works of Proust alone the existence of Matisse, Cézanne, Derain and Picasso. He would be able to say with these books before him that painters with the highest originality and power must be covering canvas after canvas, squeezing tubes after tubes in the room next door."[43] Painting and literature had been inextricably linked for over a century. Virginia Woolf's enthusiasm may have been a little excessive, but she saw things as they were and her observation about Proust could have been made apropos of each of the writers I have discussed.

Conclusion

For many centuries it was writers who to a large extent fueled the imagination of painters, with the obvious exception of portraitists. All the religious art of the Middle Ages—and especially manuscript illuminations, which constitute the most admirable manifestation of a close union between text and illustration—is based on profound knowledge of the Bible. From the Renaissance onward there was a proliferation of paintings based on literary subjects. Painters not only continued to interpret the great events of the Old and New Testaments, they also drew on the wealth of themes from classical mythology. The abundant and accurate representation of figures, scenes, and symbols from the ancient world demonstrate that artists were well versed in Greek and Latin literature. Even landscapes that do not serve exclusively as a background, particularly those of Claude Lorrain, are populated with mythological characters. Painting, therefore, usually told a story, and did so until the beginning of the nineteenth century. To take just one example, David did not scorn literary or historical themes, and, for all their innovations, neither did his immediate successors, Géricault or Delacroix.

Everything changed with the next generation, when painters took to spurning great subjects. They thought

it pointless to justify their work with a legend, an event, or an anecdote. At the same time, drawn by the power of images, writers sought to establish literary equivalents of pictorial achievements by taking into consideration effects of light and color. The Romantics and to a greater degree the realists wanted to look at the outside world the way a painter does. Flaubert prefigured Zola's sense of wonder at the unique mechanism of the eye when he told Louise Collet, in a letter dated 1852, "I shall see things as if I were shortsighted." Painters were no longer narrating history, and writers took inspiration from the painters' vision. Besides, writers often favored a particular style of painting. For example, Manet suited Zola and Monet Proust.

I chose to end this book with Proust because it seems to me that his novel marks the point at which an equilibrium was established in the dialogue between painting and literature. The mutual admiration of artists and writers was just as fruitful for both parties: the writers enriched their texts by referring to works of art and altered their style by employing painters' techniques for dealing with light and composition; meanwhile the painters' success would have been slower in coming and more laborious without the enthusiastic support of their writer friends.

The writers' works of criticism reassured an often unadventurous public: aware that he needed to publicize his young artists, a shrewd dealer like Paul Durand-Ruel not only took great care with his exhibition catalogues but also called on renowned poets and novelists to provide introductions: Stéphane Mallarmé, Octave Mirbeau, and Émile Zola wrote them for, respectively, Berthe Morisot, Pis-

sarro and Monet, and Marcellin Desboutin, a very talented engraver who posed as the man in Degas's *L'absinthe*.

The tradition of authors writing about painting, initiated by Diderot and developed in the 1800s, continued into the twentieth century. From the 1920s onward, writers showed a growing interest in new aesthetics such as cubism and surrealism. Guillaume Apollinaire and Pierre Reverdy expressed their great admiration for cubism, and André Breton celebrated surrealism. It would, however, be difficult to detect a continuing direct influence of painters and novelists on each other. Gone were the common subjects, gone the constant allusions to contemporary works of art and the numerous appearances of painters and sculptors as characters in fiction. The intimate mingling of the arts so obvious in the previous period had disappeared. Zola had declared candidly to Degas that Gervaise, his washerwoman, was inspired by the artist's laundresses, and in a letter to Degas he said: "In my books, I have quite simply described, in more than one place, some of your paintings,"[1] thus illustrating how the two forms of art were entwined. The last word, in a sense closing an era, belongs to Proust, who has his great writer Bergotte look at Vermeer's *View of Delft* when he knows he is dying, and say, "That is how I should have written."

Writing some fifty years later, we have Hemingway, who, during his stay in Paris, constantly visited the Musée du Luxembourg to look at the Cézannes. Like Bergotte, he was obsessed not with the subject but with the painter's method, notably his treatment of details and his omissions. "I was learning something from the painting of Cézanne," he recalled, "that made writing simple true sentences far

from enough to make the stories have the dimensions that I was trying to put in them. I was learning very much from him but I was not articulate enough to explain it to anyone. Besides it was a secret."[2] The old partnership between writers and painters, their intimate union, the exchange of topics, the endless arguments among the different artists, the common language they used, which had been so striking in the period I have studied, had evolved into something completely different, and were now at times almost subterranean.

Acknowledgments

I first want to thank from the bottom of my heart Susan Grace Galassi and Colin Bailey, who invited me in 2012 to speak at the Frick Collection on French literary society at the time of Renoir. Four years later, that lecture turned into this book.

For many years, I have been fortunate in having Judith Gurewich as my friend, my publisher, and my editor. Patient and enthusiastic, sharp and provocative, she has forced me to revise and rethink endlessly. Her advice has always been invaluable. I am deeply grateful to her.

Many thanks to my scrupulous translator, Adriana Hunter, and to the indefatigable and supportive Other Press team, including Amanda Glassman; Marjorie DeWitt, the ultimate problem solver; Esther Kim; Iisha Stevens; and Yvonne Cárdenas, who keeps us all in line and on schedule.

This book is dedicated to my husband, Louis Begley, who has kept me happy and focused while this book was taking form.

Notes

Introduction

1. Quoted in William J. Berg, *The Visual Novel: Zola and the Art of His Times* (Pennsylvania State University Press, 1992), 4.

2. Jean Chatelain, *Dominique Vivant Denon et le Louvre de Napoléon* (Librairie Académique Perrin, 1973), 165. All translations are Adriana Hunter's.

3. Elisabeth Vigée Le Brun, *Souvenirs* (Éditions des Femmes, 1986), 2:64.

4. Geneviève Haroche-Bouzinac, *Louise-Elisabeth Vigée Le Brun: Histoire d'un regard* (Flammarion, 2011), 405.

5. Stéphane Guégan, *Théophile Gautier* (Gallimard, 2011), 87.

6. Ibid., 31.

7. Ibid., 35.

8. Ibid., 46.

9. Quoted by James J. Sheehan, *Museums in the German Art World* (Oxford University Press, 2000), 51.

10. Roberto Calasso, *La Folie Baudelaire*, trans. Alastair McEwen (Farrar, Straus and Giroux, 2008), 5.

11. Ibid.

12. Honoré de Balzac, *Gaudissart II* (Bibliothèque de la Pléiade, Gallimard, 1950), 853.

13. Émile Zola, "Après une promenade au Salon," in *Écrits sur l'art* (Gallimard, 1991), 441.

Chapter 1 — Balzac's Paintbrush

1. Balzac, preface to *Eugénie Grandet* (Bibliothèque de la Pléiade, Gallimard, 1959), 11:200.

2. Olivier Bonard, *La peinture dans la création balzacienne: Invention et vision picturales de "La maison du chat-qui-pelote" au "Père Goriot"* (Librairie Droz, Geneva), 147.

3. Balzac, preface to *Une fille d'Eve* (Bibliothèque de la Pléiade, Gallimard, 1959), 11:371.

4. Charles Baudelaire, "Théophile Gautier," in *Œuvres complètes* (Bibliothèque de la Pléiade, Gallimard, 1976), 2:120.

5. Bernard Vouilloux, *Le tournant "artiste" de la littérature française: Écrire avec la peinture au XIXe siècle* (Hermann, 2011), 120.

6. Eugène Delacroix, *Journal 1822–1863* (Plon, 1981), 738.

7. James Wood, *How Fiction Works* (Farrar, Straus and Giroux, 2008), 62.

8. Baudelaire, "Théophile Gautier," 2:579.

9. Balzac, *Le chef d'œuvre inconnu* (Bibliothèque de la Pléiade, Gallimard, 1965), 9:391.

10. Balzac, *La peau de chagrin* (Bibliothèque de la Pléiade, Gallimard, 1965), 9:176.

11. Balzac, foreword to *La comédie humaine* (Bibliothèque de la Pléiade, Gallimard, 1962), 1:13.

12. Balzac, *La maison du chat-qui-pelote* (Bibliothèque de la Pléiade, Gallimard, 1962), 1:21.

13. Balzac, *Un début dans la vie* (Bibliothèque de la Pléiade, Gallimard, 1962), 1:656.

14. Balzac, *Autre étude de femme* (Bibliothèque de la Pléiade, Gallimard, 1958), 3:227.

15. Balzac, *Modeste Mignon* (Bibliothèque de la Pléiade, Gallimard, 1962), 1:370.

16. Balzac, *Le curé du village* (Bibliothèque de la Pléiade, Gallimard, 1961), 8:575.

17. Balzac, *La Cousine Bette* (Bibliothèque de la Pléiade, Gallimard, 1960), 6:437.

18. Balzac, *Les secrets de la princesse de Cadignan* (Bibliothèque de la Pléiade, Gallimard, 1960), 6:29.

19. Ibid., 28.

20. Detail noticed by Françoise Pitt-Rivers in *Balzac et l'art* (Le Chêne, 1993).

21. Balzac, *Les paysans* (Bibliothèque de la Pléiade, Gallimard, 1961), 8:67.

22. Balzac, *Le Cousin Pons* (Bibliothèque de la Pléiade, Gallimard, 1960), 6:637.

23. Vouilloux, *Le tournant "artiste,"* 139.

24. Balzac, *Le bal de Sceaux* (Bibliothèque de la Pléiade, Gallimard, 1962), 1:97.

25. Balzac, *La recherche de l'absolu* (Bibliothèque de la Pléiade, Gallimard, 1965), 9:485.

26. Balzac, *Honorine* (Bibliothèque de la Pléiade, Gallimard, 1960), 2:284.

27. Balzac, *Illusions perdues* (Bibliothèque de la Pléiade, Gallimard, 1963), 4:632.

28. Balzac, *Eugénie Grandet* (Bibliothèque de la Pléiade, Gallimard, 1958), 3:500.

29. I owe this example to Patrick Berthier, "Balzac

portraitiste: Position picturale du problème," in *Écrire la Peinture entre XVIIIème et XIXème siècles*, ed. Pascale Auraix-Jonchière (Presses Universitaires Blaise Pascal, 2003).

30. Balzac, *Béatrix* (Bibliothèque de la Pléiade, Gallimard, 1960), 2:396.

31. Balzac, *La peau de chagrin,* 28.

32. Balzac, *La fille aux yeux d'or* (Bibliothèque de la Pléiade, Gallimard, 1962), 5:256–57.

33. Ibid., 263.

34. Ibid., 260.

35. Ibid., 268.

36. Ibid., 280.

37. Ibid., 290.

38. Ibid., 272.

39. Ibid., 299.

40. Ibid., 316.

41. Ibid., 299.

42. Ibid., 273.

43. Ibid., 302.

44. Ibid., 302–3.

45. Ibid., 311.

46. Ibid., 303.

47. Ibid., 321.

48. Ibid.

49. Bonard, *La peinture,* 48.

Chapter 2 — The Painter and Society

1. Balzac, *Une fille d'Eve* (Bibliothèque de la Pléiade, Gallimard, 1960), 2:92.

2. Balzac, *La vendetta* (Bibliothèque de la Pléiade, Gallimard, 1962), 1:864.

3. Ibid., 865.

4. Bernard Vouilloux, *Le tournant "artiste" de la littérature française: Écrire avec la peinture au XIXe siècle* (Hermann, 2011), 146.

5. Balzac, *La vendetta,* 865.

6. Ibid., 875.

7. Olivier Bonard, *La peinture dans la création balzacienne: Invention et vision picturales de "La maison du chat-qui-pelote" au "Père Goriot"* (Librairie Droz, Geneva), 24.

8. Balzac, *La maison du chat-qui-pelote* (Bibliothèque de la Pléiade, Gallimard, 1962), 1:20.

9. Ibid., 22.

10. Ibid., 31.

11. Ibid., 32–33.

12. Ibid., 34.

13. Ibid., 47.

14. Balzac, *La bourse* (Bibliothèque de la Pléiade, Gallimard, 1962), 1:329.

Chapter 3 — Ambitions, Success, and Defeat

1. Balzac, *La muse du département* (Bibliothèque de la Pléiade, Gallimard, 1963), 4:177.

2. Balzac, *Pierre Grassou* (Bibliothèque de la Pléiade, Gallimard, 1960), 6:114.

3. Ibid., 123–24.

4. Balzac, *Le Colonel Chabert* (Bibliothèque de la Pléiade, Gallimard, 1960), 2:1097.

5. Balzac, *Pierre Grassou*, 130.

6. Ibid., 131.

7. Ibid., 132.

8. Ibid., 127.

9. Balzac, *La fille aux yeux d'or* (Bibliothèque de la Pléiade, Gallimard, 1962), 5:265.

10. Balzac, *La rabouilleuse* (Bibliothèque de la Pléiade, Gallimard, 1958), 3:904.

11. Ibid., 1100.

12. Balzac, *Illusions perdues* (Bibliothèque de la Pléiade, Gallimard, 1963), 4:652.

13. Balzac, preface to *La peau de chagrin* (Bibliothèque de la Pléiade, Gallimard, 1965), 9:174.

14. Balzac, *Pierre Grassou*, 121.

15. Balzac, *Le chef d'œuvre inconnu* (Bibliothèque de la Pléiade, Gallimard, 1965), 9:397.

16. Ibid., 390.

17. Ibid., 395.

18. Ibid., 393.

19. Ibid., 409.

20. Ibid., 412.

21. Olivier Bonard, *La peinture dans la création balzacienne: Invention et vision picturales de "La maison du chat-qui-pelote" au "Père Goriot"* (Librairie Droz, Geneva), 78.

22. John Rewald, *Cézanne: Sa vie, son œuvre, son amitié pour Zola* (Albin Michel. 1939), 200.

Chapter 4 — Zola, the Painter's Friend

1. Zola, "Documents littéraires," in *Écrits sur l'art* (Gallimard, 1991), 11.

2. Zola, *L'œuvre*, in *Les Rougon-Macquart* (Bibliothèque de la Pléiade, Gallimard, 1966), 4:39.

3. Zola, "Mon Salon," in *Écrits sur l'art*, 90.

4. Zola to Baille, October 2, 1860, in Zola, *Lettres de jeunesse* (Arvensa, 2014), 117.

5. F. W. J. Hemmings, *Emile Zola* (Clarendon Press, Oxford, 1953).

6. Balzac, *Le Père Goriot* (Bibliothèque de la Pléiade, Gallimard, 1952), 2:856.

7. Zola, *La curée*, in *Les Rougon-Macquart*, 1:387.

8. Zola to Baille, in Zola, *Correspondance* (Presses Universitaires de Montréal et CNRS, 1978), 1:112.

9. Paul Alexis, *Émile Zola: Notes d'un ami* (Charpentier, 1882), 41–42.

10. Zola to Cézanne, in Zola, *Lettres de jeunesse*, 96.

11. F. Baille, *Les petits maîtres d'Aix à la belle époque*, ed. Paul Roubaud (Aix-en-Provence, 1981), 86.

12. At www.Cahiers-Naturalistes.com.

13. Zola, *Nouvelle campagne* (Charpentier, 1896), 1048.

14. Quoted by John Rewald, *Cézanne: Sa vie, son œuvre, son amitié pour Zola* (Albin Michel, 1939), 141.

15. Zola, *L'œuvre*, 45.

16. Raymond Jean, *Cézanne et Zola se rencontrent* (Actes Sud, 1994) 73.

17. Rewald, *Cézanne*, 127.

18. Zola to Baille, June 10, 1861, in *Lettres de jeunesse*, 60.

19. Zola, *Correspondance: Les lettres et les arts* (Charpentier, 1908), 16.

20. Quoted in Gaëtan Picon and J. L. Logan, "Zola's Painters," *Yale French Studies*, no. 42 (1969): 127.

21. Rewald, *Cézanne*, 137.

22. *L'Événement*, April 27, 1866, cited by Henri Mitterand, *Zola* (Fayard, 1999–2002), 1:500.

23. Mitterand, *Zola*, 1:597.

24. *L'Événement*, May 7, 1866, cited by Mitterand, *Zola*, 1:505.

25. Zola, *Thérèse Raquin*, Bibliothèque électronique du Québec, 57. See also Robert Lethbridge, "Zola, Manet et *Thérèse Raquin*," *French Studies* 34, no. 3 (1980): 278–99.

26. Zola, *Thérèse Raquin*, 86.

27. Degas to Zola, quoted in Wikipedia, article on Degas.

28. Zola, *La débacle*, in *Les Rougon-Macquart*, 5:865–66.

29. *Le Figaro*, January 23, 1868.

30. Mitterand, *Zola*, 1:579.

31. Rewald, *Cézanne*, 161.

32. Edmond et Jules de Goncourt, *Journal: Mémoires de la vie littéraire* (Robert Laffont, 1956), 3:271.

Chapter 5 — The Writer as a Painter

1. William J. Berg, *The Visual Novel: Zola and the Art of His Times* (Pennsylvania State University, 1992), 9, quote taken from an interview in "Émile Zola, témoin de la vérité," *Europe* 30, nos. 83–84 (November–December 1952): 32–33.

2. Zola, *Son Excellence, Eugène Rougon*, in *Les Rougon-Macquart* (Bibliothèque de la Pléiade, Gallimard, 1966), 2:13.

3. Zola, "Le naturalisme au Salon," in *Écrits sur l'art* (Gallimard, 1991), 420.

4. Zola, *L'œuvre*, in *Les Rougon-Macquart*, 4:230.

5. Zola, *Écrits sur l'art*, 119.

6. Zola, *Le ventre de Paris*, in *Les Rougon-Macquart*, 1:621.

7. Ibid., 627.

8. Ibid., 769.

9. Zola, *Au bonheur des dames* (Fasquelle, 1966), 8.

10. Ibid., 497.

11. Ibid., 498.

12. Ibid., 284.

13. Zola, *Une page d'amour* (Bibliothèque de la Pléiade, Gallimard, 161.), 2:1091.

14. Zola, *L'œuvre*, 135.

15. Letter from Zola dated 1884, accompanying an illustrated edition of *Une page d'amour*, quoted in Berg, *Visual Novel*, 155–56.

16. Zola, *Correspondance: Les lettres et les arts* (Charpentier, 1908), 5:183.

17. Henri Mitterand, *Zola* (Fayard, 1999–2002), 2:410.

18. Zola, *Une page d'amour*, 850.

19. Ibid., 912.

20. Ibid., 974.

21. Ibid., 1032–33.

22. Ibid., 1091.

23. Zola, *La faute de l'Abbé Mouret* (Bibliothèque de la Pléiade, Gallimard, 1960), 2:1524.

24. Ibid., 1340–41.

25. Ibid., 1385.

26. Zola, *L'œuvre*, 231.

27. Zola, *Le ventre de Paris*, 730.

28. Quoted in Berg, *Visual Novel*, 183.

29. Zola, *L'argent*, in *Les Rougon-Macquart*, 5:31.

30. Zola, *La curée*, in *Les Rougon-Macquart*, 4:388.

31. Zola, *La bête humaine*, in *Les Rougon-Macquart*, 4:997.

32. Zola, *Le ventre de Paris*, 781.

33. Zola, *L'œuvre*, 101.

34. Berg, *Visual Novel*, 37

35. Zola, *Le ventre de Paris*, 653.

36. Zola, *Une page d'amour*, 986.

37. Zola, *Nana*, in *Les Rougon-Macquart*, 2:1269.

38. Zola, *La curée*, 333.

39. Ibid., 576.

40. Zola, *Le Docteur Pascal*, in *Les Rougon-Macquart*, 5:1081.

Chapter 6 — Zola's Painters

1. Zola, *Les Rougon-Macquart* (Bibliothèque de la Pléiade, Gallimard, 1966), 4:1346.

2. Zola, *Thérèse Raquin*, Bibliothèque électronique du Québec, 309.

3. Zola, *Le ventre de Paris*, in *Les Rougon-Macquart*, 1:617.

4. Ibid., 626.

5. Ibid., 619.

6. Ibid., 625.

7. Ibid., 680.

8. Ibid., 800.

9. Ibid., 801.

10. Paul Alexis, *Émile Zola: Notes d'un ami* (Charpentier 1882), 121–22.

11. Zola, *Les Rougon-Macquart*, 4:1353.

12. John Rewald, *Cézanne: Sa vie, son œuvre, son amitié pour Zola* (Albin Michel, 1939), 298.

13. Ibid., 300.

14. Zola, *L'œuvre*, in *Les Rougon-Macquart*, 4:66.

15. Ibid., 99.

16. Ibid., 180.

17. Ibid.

18. Ibid., 247.

19. Edmond et Jules de Goncourt, *Journal: Mémoires de la vie littéraire* (Robert Laffont, 1956), 2:1153.

20. Ibid., 2:1043.

21. Zola, *L'œuvre*, 54.

22. Ibid., 185.

23. Zola, *Écrits sur l'art* (Gallimard, 1991), 468.

24. Zola, *L'œuvre*, 191.

25. Ibid., 343.

26. Patrick Brady, *"L'œuvre" d'Émile Zola* (Droz, 1967), 255.

27. Zola, *L'œuvre*, 234.

28. Ibid., 85.

29. Ibid., 72.

30. Ibid., 87.

31. Ibid.

32. Ibid., 89.

33. Ibid., 260.

34. Ibid., 130.

35. Ibid.

36. Ibid., 135.

37. Ibid., 27.

38. Ibid., 23.

39. Ibid., 109.

40. Ibid., 207.

41. Ibid., 202.

42. Ibid., 347.

43. Ibid., 341.

44. Ibid., 344.

45. Ibid., 360.

46. Ibid., 244.

47. Ibid., 321.

48. Ibid., 363.

49. Ibid.

50. Zola, "Mon Salon," in *Écrits sur l'art*, 193.

51. Ibid., 194.

52. Ibid.

53. Ibid.

54. Ibid., 359.

Chapter 7 — Repercussions: Huysmans and Maupassant

1. In Henri Mitterand, *Zola* (Fayard, 1999–2002), 2:818.

2. Ibid., 814.

3. Ibid.

4. Paul Cézanne, *Correspondance* (Grasset, 1978), 300.

5. J. K. Huysmans, "*L'art moderne*," in *Écrits sur l'art* (Flammarion, 2008), 51.

6. Ibid., 19.

7. Huysmans, *Les sœurs Vatard* (Paris: Charpentier, 1880), 155.

8. Ibid., 112.

9. Huysmans to Zola, around November 15, 1882, quoted in Mitterand, *Zola*, 2:697.

10. Huysmans, preface to *À rebours* (Crès, 1922).

11. Zola to Huysmans, May 20, 1884, in Zola, *Correspondance* (Presses Universitaires de Montréal et CNRS, 1978), 5:107–8.

12. Zola to Jules Destrée, November 22, 1884, in Zola, *Correspondance*, 5:110, and in Mitterand, *Zola*, 2:740.

13. Huysmans, *À rebours*, 67.

14. Ibid., 67.

15. Ibid.

16. Ibid., 75.

17. Ibid.

18. Folio 32 bis of the original manuscript, quoted by Jacques Lethève in "I: Goûts et dégoûts de des Esseintes: Les hesitations de Huysmans d'après le manuscript d'*À rebours*," in *Cahier de l'Herne consacré à Huysmans* (Éditions de l'Herne, 1985).

19. Guy de Maupassant, preface to *Pierre et Jean*, in *Romans* (Bibliothèque de la Pléiade, Gallimard, 1987), 714.

20. Mitterand, *Zola*, 2:117.

21. Ibid., 232.

22. Maupassant, *Les dimanches d'un bourgeois de Paris*, Bibliothèque électronique de Québec, 60.

23. Maupassant, *Romans*, 1560.

24. Louis Forestier, preface to Maupassant, *Romans*.

25. Maupassant, *Une vie*, in *Romans*, 14.

26. Ibid., 26.

27. Maupassant, *"Mouche" et autres nouvelles* (LGF, 1995), 1.

28. Maupassant, *Une vie*, in *Romans*, 26.

29. Ibid.

30. Maupassant, *Pierre et Jean*, in *Romans*, 775.

31. Maupassant, *La Maison Tellier*, in *Contes et nouvelles* (Bibliothèque de la Pléiade, Gallimard, 1974), 1:267.

32. Maupassant, *Au Salon: Chroniques sur la peinture* (Balland, 1993), 83.

33. Ibid., 78.

34. Ibid., 76–77.

35. Ibid., 78.

36. Ibid., 80.

37. Ibid., 135.

38. Ibid., 136.

39. Ibid., 137

40. Monet letter quoted in "Ces horribles travailleurs du Réel," at www. Cairn.info.

41. Maupassant, *Fort comme la mort*, in *Romans*, 912.

42. Ibid., 884.

43. Ibid., 838.

44. Ibid., 868.

45. Maupassant, introduction to *Au Salon*, 15.

46. Maupassant, *Fort comme la mort*, 910.

47. Ibid., 912.

48. Ibid., 848.

49. Ibid., 878.

50. Alexandre Zviguilsky, "Maupassant et Tourgueniev: La source de *Fort comme la mort*," *Revue de Littérature comparée*, January–March 1973.

51. Maupassant, *Fort comme la mort*, 1002.

52. Ibid., 1000.

53. Ibid., 839.

54. Ibid., 1026–27.

55. Maupassant, *Mont-Oriol*, in *Romans*, 485.

56. Maupassant, *Le masque*, Athena.unige.ch, 1.

57. Maupassant, *Bel-Ami*, in *Romans*, 297.

58. Ibid., 208.

59. Ibid., 241.

60. Maupassant, *La Maison Tellier*, 259.

61. Maupassant, *Bel-Ami*, 295.

62. Ibid., 433.

63. Ibid.

64. Maupassant, *Bel-Ami*, 434.

Chapter 8 — Elstir: Proust's Master

1. Proust quoted in Henri Loyrette, "Proust et l'art moderne," in *Marcel Proust: L'écriture et les arts*, ed. Jean-Paul Tadié (Gallimard, 1999), 15.

2. Antoine Compagnon, "Proust au musée," in *Marcel Proust: L'écriture et les arts*, 69.

3 Marcel Proust, *Correspondance*, ed. Philip Kolb (Plon, 1970–93), 1:424.

4. Proust, *À la recherche du temps perdu* (Bibliothèque de la Pléiade, Gallimard, 1987–89), 1:250.

5. Ibid., 2:182.

6. Ibid., 2:191.

7 Proust, "Rembrandt," in *Contre Sainte-Beuve* (Bibliothèque de la Pléiade, Gallimard, 1971), 659.

8. Proust, *À la recherche*, 2:290.

9. Ibid., 2:184.

10. Ibid., 2:199.

11. Ibid., 2:218–19.

12. Ibid., 4:474.

13. Ibid., 3:179.

14. Ibid., 2:224.

15. Ibid., 2:251.

16. Ibid., 3:334.

17. Ibid., 4:474.

18. Ibid., 2:194.

19. Ibid., 2:192.

20. Ibid., 2:203.

21. Ibid., 2:204.

22. Ibid., 2:205.

23. Emily Eells, *Proust's Cup of Tea: Homoeroticism and Victorian Culture* (Ashgate, 1988), 137.

24. Proust, *À la recherche*, 4:108.

25. Ibid., 2:162.

26. Ibid., 2:860.

27. Ibid., 2:199.

28. Ibid., 3:198.

29. Ibid., 2:439.

30. Ibid., 2:16.

31. Ibid., 2:197.

32. Proust to Reynaldo Hahn, quoted by Kazuyoshi Yoshikawa, *Proust et l'art pictural* (Honoré Champion, 2010), 287.

33. Proust, *À la recherche*, 2:1448

34. Ibid., 2:790.

35. Ibid., 2:251.

36. Ibid., 2:253.

37. Ibid., 2:193.

38. Ibid., 2:195.

39. Ibid., 1:167–68.

40. Ibid., 2: 860.

41. On this topic I owe a great deal to Emily Eells, *Proust's Cup of Tea*.

42. Sophie Bertho, *Proust et ses peintres* (Rodopi, 2004), 40.

43. Proust, *À la recherche*, 2:192–93.

44. Ibid., 2:193.

Chapter 9 — The Painting as a Novelist's Tool

1. Proust, *À la recherche du temps perdu* (Bibliothèque de la Pléiade, Gallimard, 1987–89), 2:221.

2. Ibid., 1:193.

3. Ibid., 1:221.

4. Ibid., 1:221–22.

5. Ibid., 1:263.

6. Ibid., 1:607.

7. Ibid.

8. Ibid., 3:52.

9. Ibid.

10. Ibid., 3:712.

11. Ibid., 4:342.

12. Sophie Bertho, "Le roman pictural d'Albertine," in *Littérature* 123, no. 3 (2001): 101.

13. Proust, *À la recherche,* 1:129.

14. Ibid., 2:241.

15. Ibid., 4:226.

16. Bertho, "Le roman pictural," 114.

17. Ibid., 115.

18. Proust, *À la recherche,* 1:322.

19. Ibid., 1:220.

20. Ibid., 1:219.

21. Ibid., 4:227.

22. Ibid., 1:96.

23. Ibid., 1:172.

24. Ibid., 4:518.

25. Ibid., 2:790.

26. Ibid., 1:52.

27. Ibid., 3:587.

28. Proust, *Correspondance,* ed. Philip Kolb (Plon, 1970–93), 20:226.

29. Proust, *À la recherche,* 3:692.

30. Ibid.

31. Ibid.

32. Nicole Savy, "Jeune roman, jeune peinture," in *Marcel Proust: L'écriture et les arts*, ed. Jean-Paul Tadié (Gallimard, 1999), 36.

33. Proust, *Correspondance*, 21:376.

34. Savy, "Jeune roman," 59.

35. Proust, *À la recherche*, 2:148.

36. Ibid., 2:581.

37. Ibid., 1:194.

38. Ibid., 1:65.

39. Ibid., 1:66.

40. Ibid., 1:178–79.

41. Ibid., 2:660.

42. Guillaume Apollinaire, "La peinture moderne," *Der Sturm*, February 1913, quoted by Savy, "Jeune roman," 60.

43. Virginia Woolf, *Pictures*, 173, quoted in Camille-Yvette Welsch, *Virginia Woolf* (Bloom's Biocritiques) (Chelsea House, 2004), 112.

Conclusion

1. Quoted by Jules Claretie, "Le mouvement parisien: L'exposition des impressionnistes," *L'Indépendance Belge*, April 15, 1877, 1.

2. Ernest Hemingway, *A Moveable Feast* (Scribner, 2003), 13.

Credits

ANKA MUHLSTEIN has written biographies of Queen Victoria, James de Rothschild, Cavelier de La Salle, and Astolphe de Custine; studies on Catherine de Médicis, Marie de Médicis, and Anne of Austria; a double biography, *Elizabeth I and Mary Stuart*; and most recently, *Balzac's Omelette* and *Monsieur Proust's Library*. She has won two prizes from the Académie française and the Goncourt Prize for Biography. She and her husband, Louis Begley, have written a book on Venice, *Venice for Lovers*. They live in New York City.

ADRIANA HUNTER studied French and Drama at the University of London. She has translated more than fifty books including *Couple Mechanics*, *The Travels of Daniel Ascher*, *Balzac's Omelette*, and *Eléctrico W* (winner of the French-American Foundation's 2013 Translation Prize in Fiction). She won the 2011 Scott Moncrieff Prize, and her work has been short-listed twice for the Independent Foreign Fiction Prize. She lives in Norfolk, England.

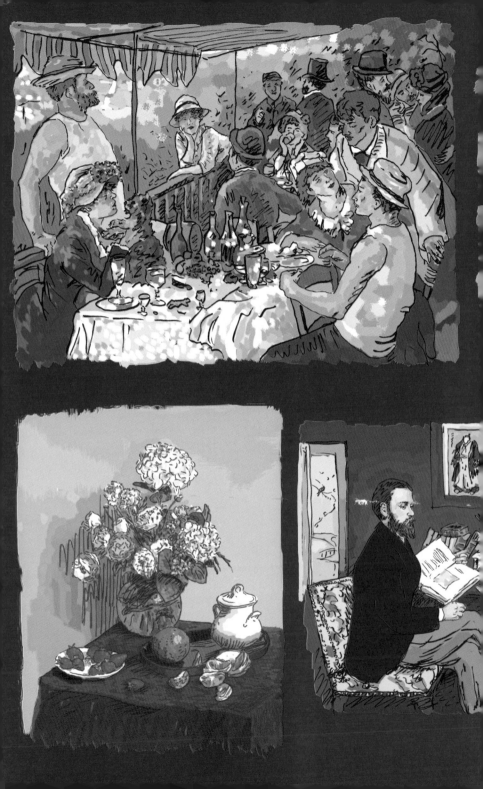